Spirit of the Wild Things

the art of

SANDY SCOTT

Michael _____

Words cannot express how much I appreciate the
care I received from you in the ICU during
my recent ordeal. You are a "SUPER-NURSE"
& a friend & I'll never forget you.

Fond Regards _____

Sandy

JAN-FEB 2020 · LANDER

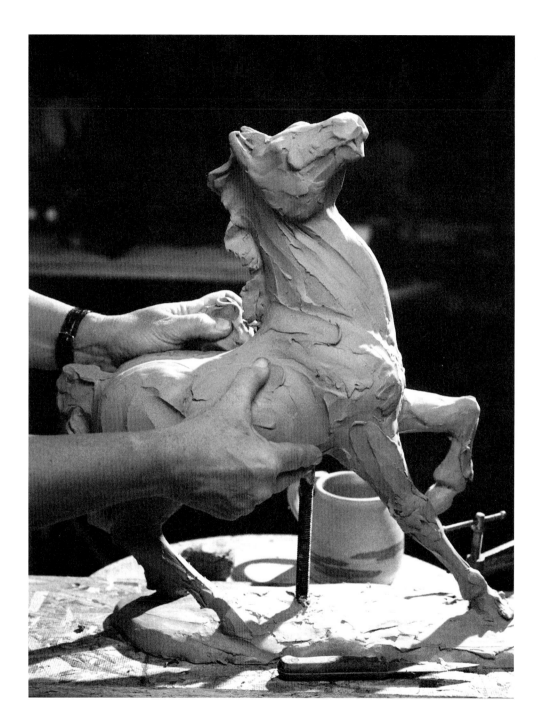

Spirit of the Wild Things

the art of
SANDY SCOTT

FOREWORDS BY
Bob Kuhn
Bill Kerr

PREFACE BY
Brooks Joyner

ESSAYS BY
Robin Salmon
Susan Hallsten McGarry

COMMENTARY AND NOTES BY
Sandy Scott

S·T·O·N·Y
PRESS

Published on the occasion of
Rendezvous '98 for
Sandy Scott and Steve Hanks,
Gilcrease Museum, Tulsa, Oklahoma,
June 26 - September 7, 1998

Stony Press
P.O. Box 1715
Ft. Collins, Colorado 80522-1715
Phone and Fax 970.224.9899

Library of Congress Catalog Card
Number 98-84930

ISBN 0-9663850-0-4

Printed in Canada by Friesens Corporation

Note on illustrations: All dimensions are stated in
inches, height preceding, length and depth. The
letter "h" indicates height and "d" diameter. Etching
dimensions are image size. Photography credits,
edition sizes and dates of execution are indicated in
the List of Illustrations, page 182.

FIGURE 1
Preceding page
Sandy Scott working on *Stars*, clay, h 15.

PLATE 1
Following page
Spirit of the Wild Things, bronze, h 84.

To my mother, Dolly, who by example

showed me how to enjoy life and do my own thing.

To my father, Jim, who taught me how to make a fire in the rain.

And to my best friend, Trish, who truly loves to fish and who,

like my mother, is always there with unconditional love.

Sandy Scott

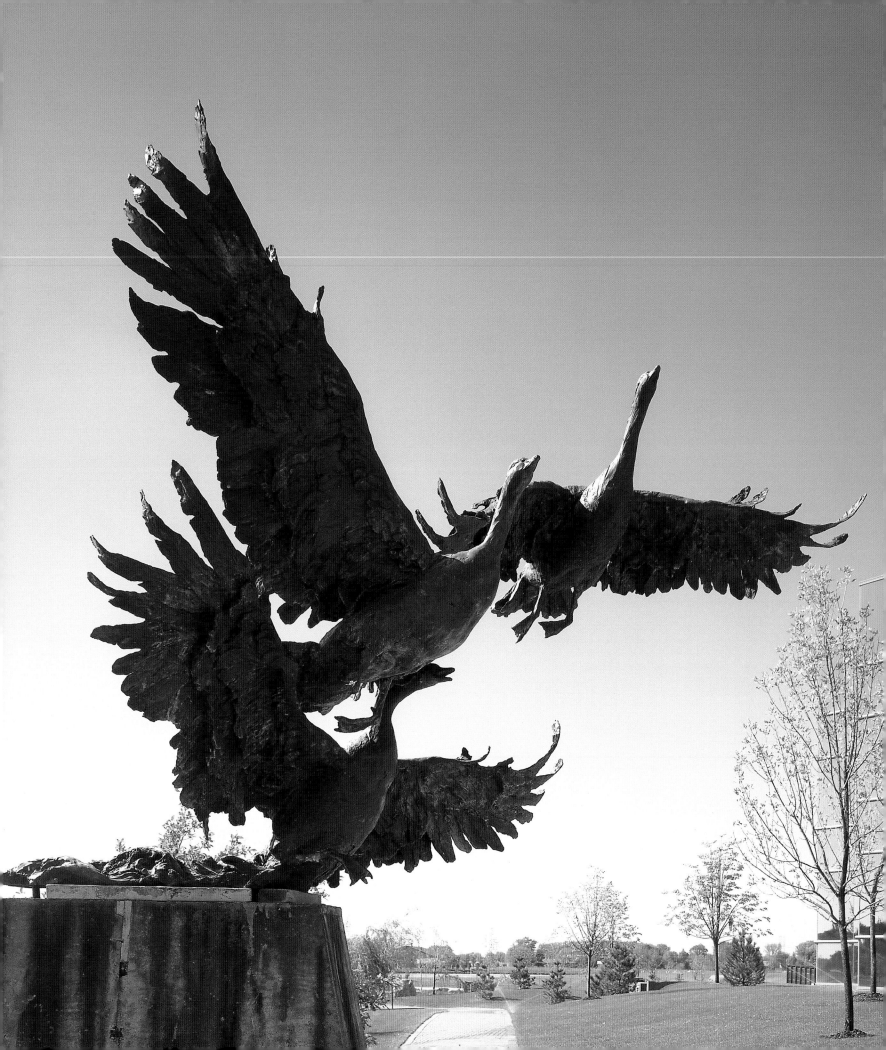

Contents

FOREWORD BY *Bob Kuhn* **9**

FOREWORD BY *Bill Kerr* **11**

PREFACE BY *Brooks Joyner* **13**

PART I

WOMEN SCULPTORS AND THE ANIMALIER TRADITION

BY *Robin Salmon* **19**

WHERE WILDERNESS AND CIVILIZATION MEET

BY *Susan Hallsten McGarry* **25**

PART II

JOURNAL NOTES BY *Sandy Scott*

CHAPTER INTRODUCTIONS BY *Susan Hallsten McGarry*

Chapter 1 – SEEING **37**

Chapter 2 – FEELING **69**

Chapter 3 – UNDERSTANDING **97**

Chapter 4 – EXPRESSING **135**

PART III

EPILOGUE BY *Susan Hallsten McGarry* **171**

CHRONOLOGY **177**

SELECTED COLLECTIONS **181**

LIST OF ILLUSTRATIONS **182**

CREDITS AND ACKNOWLEGMENTS **187**

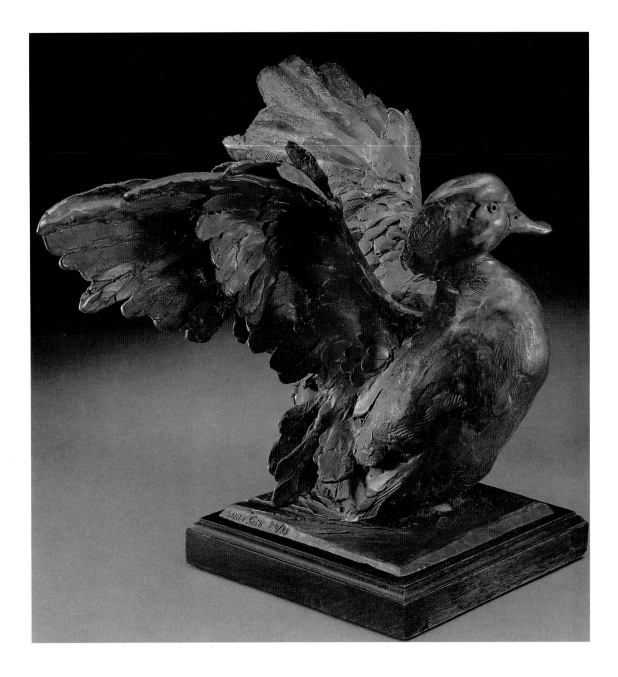

PLATE 2
Green-winged Teal, bronze, h 11.
This early study set the stage for studying bird anatomy,
feather groupings and wing movement.

FOREWORD

Bob Kuhn

I've been a friend of Sandy Scott and an admirer of her energy and talent for quite a spell. My acquaintance became a friendship during a cruise along the coast of Southeast Alaska nine years ago, along with a group of wildlife portrayers and one magazine editor, Susan McGarry of *Southwest Art*. Some of us were there for laughs and some for work, but all of us enjoyed the rich fare and congenial company under the tender guidance of the skipper, Dr. Bob White. We had all logged plenty of time in the boonies. Sandy was as wood-wise as anyone, and maybe a little more than some.

Artists are addicted to each other's work, I among them. I bartered her for an etching and a couple of bronzes. The bronzes are both birds, which are her prime subject, in my opinion. She often shows them preening or flying. I find the way she dramatizes the excitement of intricate feather patterns at work to be novel and very effective.

Sculpture is a language that is foreign to most painters. Though I have admired and collected pieces of animal sculpture for years, I never produced a piece until my friend George Northup, a wildlife sculptor who joined us on that Alaska trip, conned me into it. I drew a plan showing elk entering water, and he built an armature to support the clay, then I stepped in and did a substantial share of the modeling. Both our names are on the finished piece.

With Sandy, it's not a team effort. It's just one spirited lady working the clay, managing the foundry operation and seeing to it that the finished pieces find a home. Sandy's place, a renovated cherry mill, is a work of art in itself. It is the ideal facility for a committed collector, with its convoluted arrangement of rooms, hallways, stairways, galleries, atriums and other sorts of unnamed spaces. It is full of goodies, fondly accumulated and displayed with a curator's eye. In fact, the atelier is now so rich with elegant booty that it is a badge of merit to have one's work in the collection.

So I say, here's to Sandy Scott. May her energy and enthusiasm and aesthetic impulses never flag. Our little company of animal interpreters will be the poorer if that day ever comes.

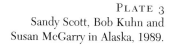

PLATE 3
Sandy Scott, Bob Kuhn and
Susan McGarry in Alaska, 1989.

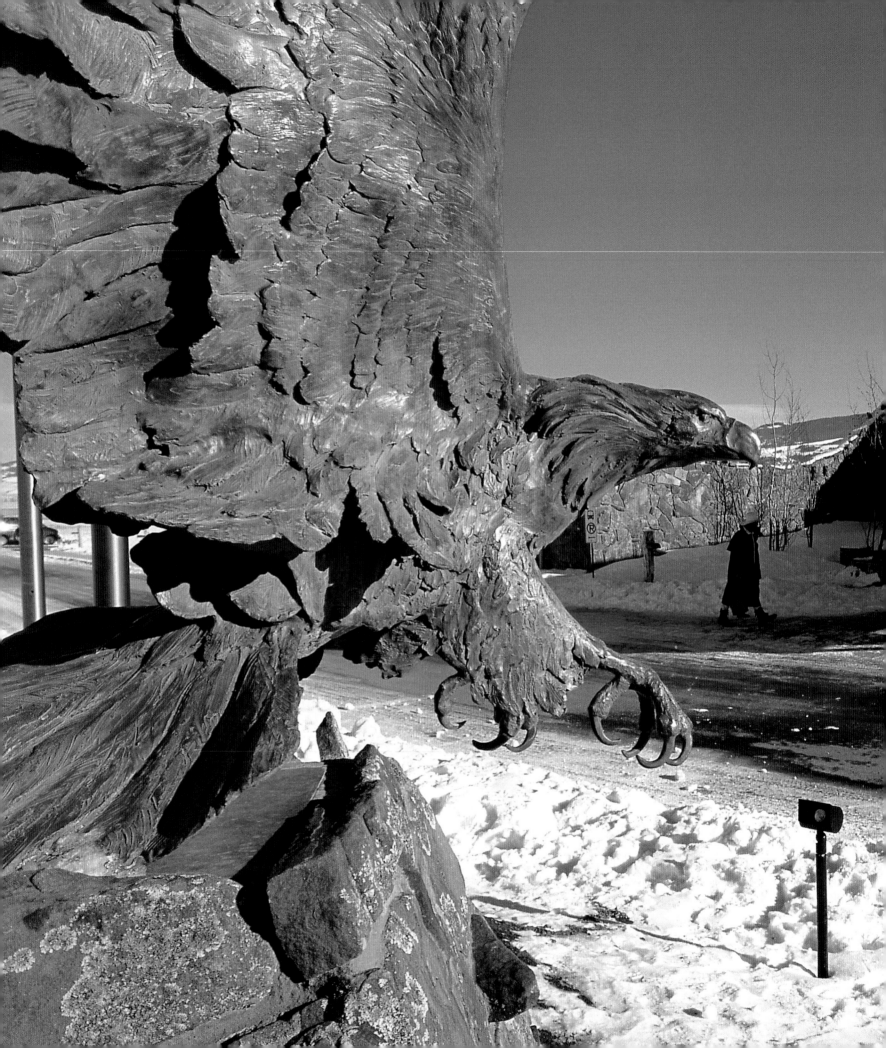

Bill Kerr

There is something about the North Country. Once it is in your blood you are typed for life. I met Sandy Scott through her etchings of pike and rushes, choppy water and mallards. Those images were alive with the spirit of a place I love above all others. Long before we crossed trails at a wildlife art gathering in Ft. Collins, I was hooked on the lady and her art. She was my kind of woman—able to row, shoot and bait her own line.

Getting to know Sandy was even better, and watching her art grow and evolve over the past fifteen years has been a joy. She is not shy in work or personality and both exude a liveliness that captivates the eye of collectors as well as the heart of a friend. Her circle of both of the preceding is diverse. Collectors range over a wide area of subject matter that reflects Sandy's own ranch-life background, sporting pursuits and urbane affiliations. Her group of friends is everywhere. If you ride horses, enjoy the outdoors or simply admire sophisticated sculpture, you are at home with Sandy.

The emerging equality of women who sculpt and paint is the result of their exceptional skills and amazing tenacity, as well as societal maturity. During the entire span of her career Sandy has been a force in the efforts of contemporary women artists to achieve parity of recognition, acceptance and critical evaluation with male colleagues. However, being bold can be risky for an artist, especially a female, and similar to the experience of other pioneers, progress has not been easy. Frustration as well as significant obstacles had to be overcome. The show invitations and prestigious awards that are now hers did not come effortlessly.

This wonderful book represents another milestone for the artist/pilot who is soaring higher than ever. As always, her vision shows the vitality and inspiration that distinguish the artist from a craftsman, and while I am not positive where Sandy will go with her art in the future, I am confident that it will be fresh and exciting. It will engage your eye with the spirit of her subject and take your heart out to where that spirit finds home.

Before my last sunset, I hope to spend a day with Sandy, on a lake up north somewhere, to watch, listen and share the pleasure of her company. She is an artist who lives with what she loves and creates, who knows the ways of the wild. Sandy Scott captures those ways in her art and brings them back to us for our homes, offices and museums. She brings them back alive, uniquely so.

PLATE 4
Sovereign Wings, bronze, h 90. True patrons of the arts endure today, and I know two of the finest: Bill and Joffa Kerr. They created one of America's treasures, the National Museum of Wildlife Art in Jackson, Wyoming. I am honored to have my eagle at the entrance.

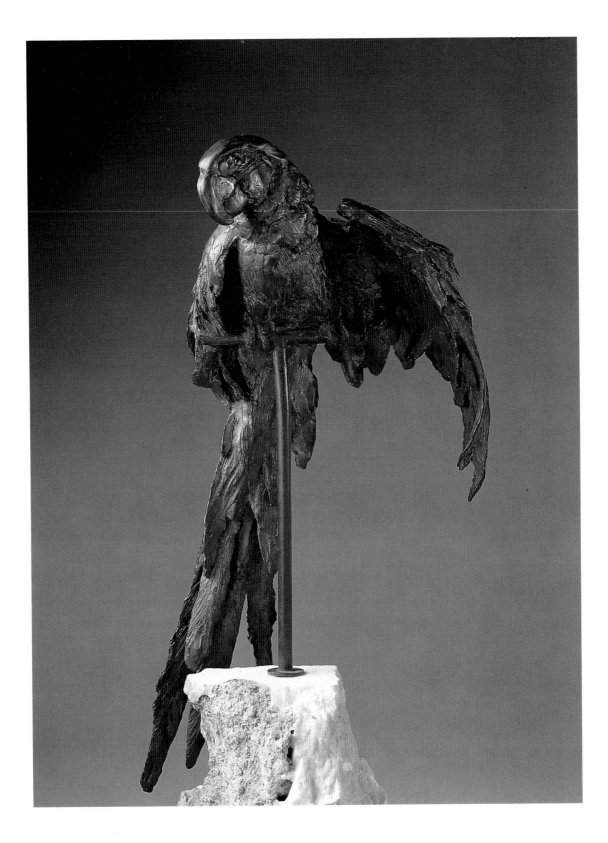

PLATE 5
Macaw II, bronze, h 21.
I sculpted this early work of a blue and gold macaw
using a model on loan from the El Paso Zoo.

Brooks Joyner

Gilcrease Museum's *Rendezvous* '98 will mark the twentieth year of continuous annual retrospective exhibitions of distinguished contemporary American artists. During these past two decades, the *Rendezvous* retrospectives have examined the achievements of 34 major sculptors and painters. The list reads like a who's who of mid- to late-20th-century American art.

Since the inaugural *Rendezvous* exhibition in 1979, there have been sixteen prominent sculptors. The list includes such noteworthy and critically acclaimed personalities as Joe Beeler, Glenna Goodacre, Grant Speed, Tony Angell, Fritz White, Hollis Williford, Terry Kelsey, Doug Hyde, Kent Ullberg, Kenneth Bunn, Ed Fraughton, Geroge Carlson, Sherry Sander, Gerald Balciar and, in 1997, Steve Kestrel.

FIGURE 2
Sandy Scott working
on the *Gilcrease Eagle*.

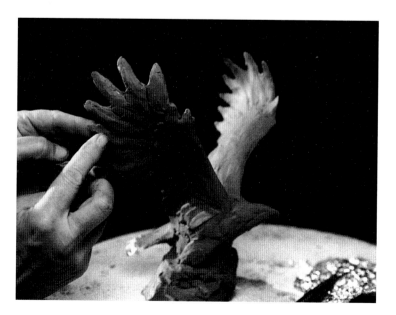

It is commonly agreed, within the circle of contemporary western American artists and throughout the American museum community, that Gilcrease Museum's *Rendezvous* retrospectives represent the ultimate tribute to individual achievement. In that context the Gilcrease Museum honors the remarkable artistic achievement of artist Sandy Scott at *Rendezvous* '98. She will be represented by more than 50 sculptural works, many completed within the last two years.

As we celebrate the fascinating and prolific body of work created by Scott over the past twenty years, so convincingly captured in this beautiful publication and explored firsthand at *Rendezvous* '98, we seek to better understand her unique contribution to the tradition of animal sculpture in American art of the past century. We also recognize her place in the future histories of American art.

By her uncompromising diligence in studying her subject and through her strict dedication to the craftsmanship of her work, Scott has already been recognized by her peers. Stylistically and technically her art is based upon a keen observation of nature and not the elusive world of appearances. She combines her outstanding formal art training and professional experience with a sense of playfulness, experimentation and honesty. For these reasons and others, Scott has assumed for herself a place among a distinguished group of American animal sculptors of the last century, a group dominated in large measure by male personalities.

By 1900 most of America's great sculptors

of animals were also well-trained modelers of the human figure. Such men as Edward Kemeys, Edward C. Potter, A. Phimister Proctor, Solon H. Borglum, Eli Harvey, Henry M. Shrady, Paul Bartlett and Frederic Remington are among that group. Foremost in the early 20th century were Philadelphia-born Albert Laessle, who was known especially for his powerful bronze eagle *Victory* of 1918 and his exuberant *Chanticleer* of 1912, to which Scott's treatment of similar subjects compares admirably; and Herbert Haseltine, son of landscape watercolorist William Stanley Haseltine, who is best remembered for his stone and bronze sculptures of British champion animals, including his famous *Middlewhite Boar: Wharfedale Deliverance* of 1922-24.

The early women sculptors of America distinguished themselves more through classical and romantic subjects where animals served, for the most part, to support a larger narrative theme. Harriet Hosmer, best known of this group, Edmonia Lewis, Vinnie Ream, Blanche Nevin, Emma Stebbins, Margaret Foley, Anne Whitney and Elizabeth Ney all worked prior to the great Centennial Exposition.

In the face of many professional roadblocks in a male dominated profession, a substantial number of women entered the field of sculpture after 1900. They became successful professionals and several achieved significance in the development of American art in the first half of the 20th century. This illustrious group included Malvina Cornell Hoffman, Edith Woodman Burroughs, Harriet W. Frishmuth,

Anna Hyatt Huntington, Carol Brooks MacNeil, Gertrude Vanderbilt Whitney, Enid Yandell, Abastenia St. Leger Eberle, Janet Scudder and Bessie Potter Vonnoh (many of whom you will learn more about in Robin Salmon's essay).

Scott proudly acknowledges the influence that both her art library and museums have had on her artistic development, recognizing among others the great French *animaliers* Antoine-Louis Barye and Emmanuel Frémiet. However, it is to the figural work of American Anna Hyatt Huntington, different in background and scale of work but similar in passion and intensity, that the closest parallels emerge.

Like Scott, Huntington had an early curiosity and love for animals that was nurtured by devoted parents, her amateur artist mother Audella Beebe and her father, Alpheus Hyatt II, a distinguished professor of paleontology and zoology at M.I.T. and Boston University. Scott's childhood enchantment with Lake of the Woods, where she first discovered the birds and wildlife that have become her lifework, corresponds to Huntington's family nature laboratory at their summer retreat in Annisquam, Massachusetts.

There are other parallels. Like Huntington, Scott possesses a remarkable capacity for and commitment to the direct observation of nature and an abiding interest in animal anatomy and the principles of animal locomotion. Both are classicists in approach, naturalists in outlook and uncompromising in their objectivity. Scott speaks of her foundation in

academy aestheticism and her avoidance of sentimentalism in the depiction of her subject matter. This can also be said of Huntington's work that graces the grounds of Brookgreen Gardens on the coast of South Carolina.

Conversely, Huntington spent little time at art school, while Scott undertook a formal art education at the Kansas City Art Institute. Scott's observations are field experiences set in the animal's habitats, where Huntington's are often drawn from zoo animals. At the risk of overstating the comparison, it is fair to say that Huntington left an indelible legacy in her creation of animal sculpture in America in the first half of the 20th century and that Scott will leave her legacy in the second half.

It is within the special genre of bird sculpture that Scott has raised her art form to a new interpretive plateau in contemporary American art. Her eagles, roosters, pelican, loon, mallard and raven are unmistakably genius and are among the most accomplished works of our day. Scott speaks easily and eloquently in her book of the importance of art, of the vital role of observation and analysis, but she also identifies the role of spontaneity in shaping forms and how this can deliver an ordinary sculpture from obscurity to critical recognition.

Because Scott has embraced both essential qualities in her work, studied craftsmanship and playful experimentation, she has brought a renewed vigor and joy to American animal sculpture in our time. Scott rightfully joins the ranks of America's outstanding animal sculptors and for equally compelling reasons is Gilcrease Museum's *Rendezvous '98* artist.

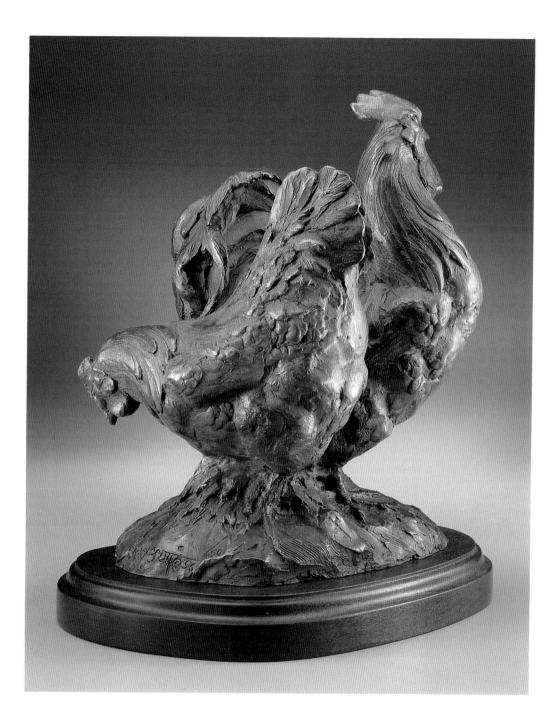

PLATE 6
Country Couple (Hen View), bronze, h 11.
I can't imagine a world without the lowly, common chicken.
No eggs benedict, no chicken a la king, no one to wake me up each new day.

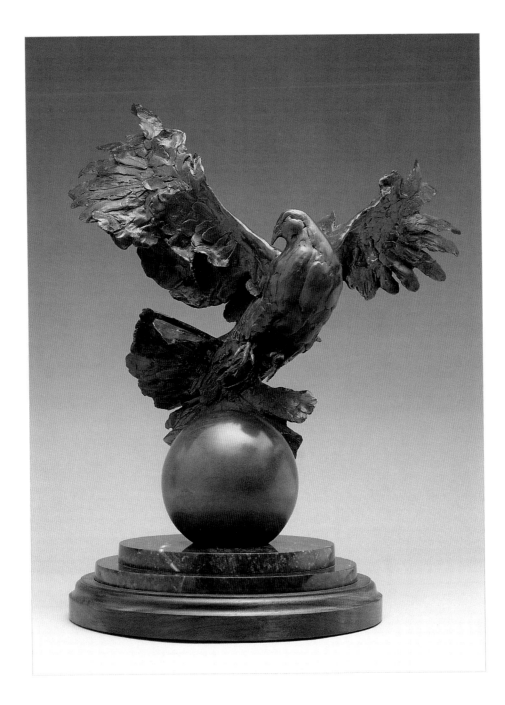

PLATE 7
The *Fount* from *Peace Fountain*, bronze, h 19.

PART I

WOMEN SCULPTORS AND
THE ANIMALIER TRADITION
IN AMERICAN ART
BY *Robin Salmon*

WHERE WILDERNESS AND
CIVILIZATION MEET
BY *Susan Hallsten McGarry*

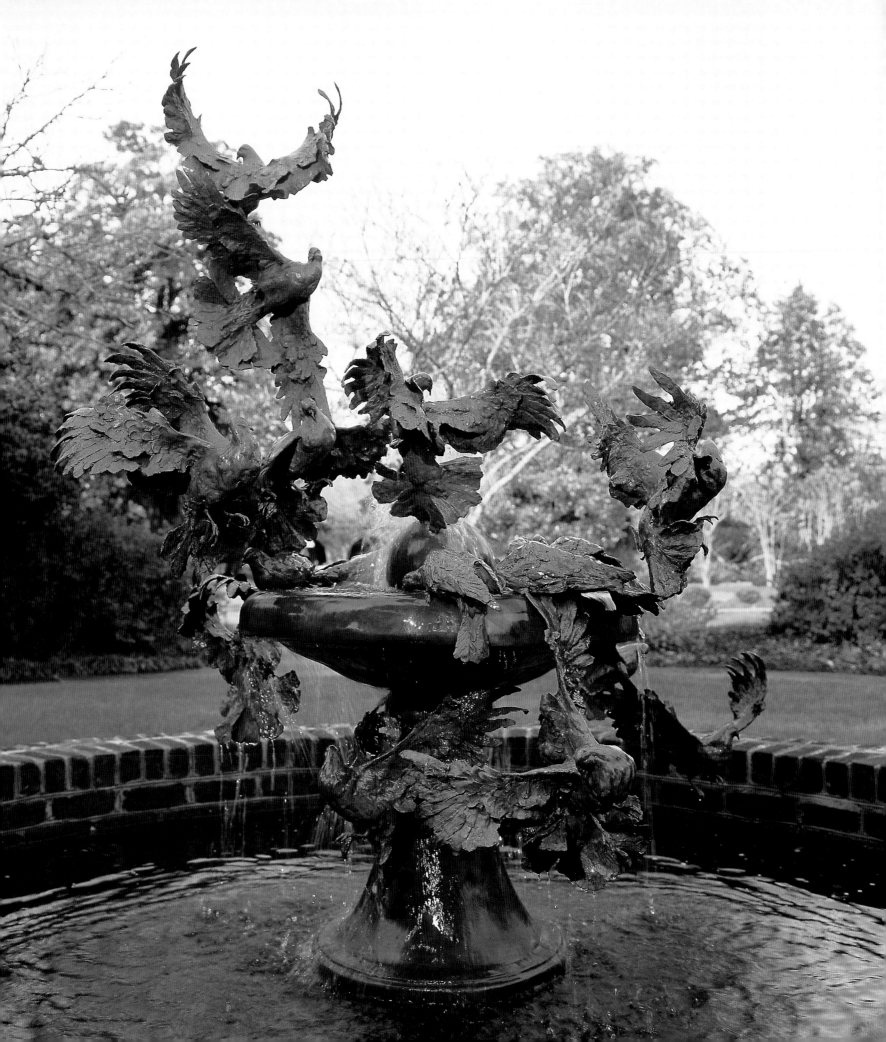

WOMEN SCULPTORS AND THE ANIMALIER TRADITION IN AMERICAN ART

Robin Salmon

Women have long been practitioners of the fine arts and crafts in America. From the earliest days of the nation, needlework and painting were deemed activities suitable for feminine pursuit. Victorian mores foisted upon 19th-century society dictated a rigid cultural protocol for the American woman. At a time when a leg of a chair was referred to as a limb to circumvent what could be an unseemly reference to specific anatomy, the field of animal sculpture allowed the woman artist a way to avoid any unladylike depictions of the human body. Shielded by the canon of this polite art form, women created what was perceived to be nonthreatening images in keeping with their customary roles as family nurturer and obedient wife or daughter. Or so thought the male population. Within this structure and despite it, women began to produce some of the finest sculpture of the time.

The *animalier*, or sculptor of animal subjects, appeared in 19th-century France rather late in the history of sculpture. The new type of sculpture he created—the small statue of an animal—received immediate public recognition. The animal, as a subject representing its own self, was an innovative concept. Although animals had previously existed in sculpture, they had always been elements of greater themes or symbols in religious works. Another difference in this art form was the *animalier's* realistic vision of the sculpture in contrast to the formalism of his time. The smaller size of the artwork, yet another innovation, was a result of society's evolution of class and the lifestyle it reflected. For the first time, art no longer was created only for royalty. The rise of industrialism and the wealth and status it brought to a new ruling class required the creation of art for the mansions of millionaires which took the place of kings' palaces.

Concurrently, the emergence of Darwin's theory of evolution rocked the public's view of life and ushered in a wider context for scientific thought. The way was paved for the rise of animal sculpture as it paralleled the study of the animal world and society's return to nature for recreation and relaxation. The term *animalier*, first used by an art critic in 1830, eventually was used in reference to any sculptor of animals. The *animalier* chose to depict both wild and domestic species that were familiar within his or his audience's world. Most of the subjects— horses, dogs, cats, deer, birds—could be seen on farms, at zoos and on hunting forays in the wild. They were represented in tender family groups, in dramatic situations of predator and prey, or in idyllic woodland scenes. The foremost French *animalier*, Antoine-Louis Barye, was followed by Emmanuel Frémiet and Pierre Jules Mène.

In the United States, the art of the *animalier* enjoyed an enthusiastic reception. In the last decade of the 19th century, the dwindling numbers of hunters and trappers

PLATE 8
Peace Fountain (Doves), bronze, h 84. I was inspired by the flurry of pigeons against the classic architecture at St. Mark's Cathedral in Venice.

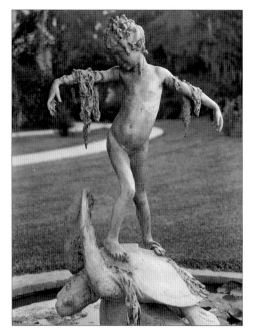

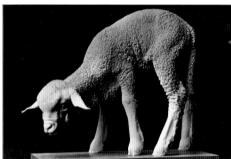

FIGURE 3
Seaweed Fountain by Beatrice Fenton, bronze, 1920, collection of Brookgreen Gardens, Murrells Inlet, South Carolina.

FIGURE 4
Little Lamb by Gertrude Katherine Lathrop, Benedict nickel, circa 1931, collection of Brookgreen Gardens.

FIGURE 5
Tete-a-Tete by Charlotte Dunwiddie, bronze, 1984, collection of Brookgreen Gardens, gift of the sculptor, photo Gurdon L. Tarbox Jr.

in the American West foreshadowed the demise of a way of life. Some of these individuals, such as Edward Kemeys, turned to sculpture as a means of depicting and preserving old ways. Considered to be the first American *animalier*, Kemeys interpreted his intimate knowledge of the subject—his "oneness" with the animal—in three-dimensional form.

Simultaneously, naturalists, photographers and big-game hunters were roaming the world's remote areas in search of wild animals. Museums of natural history were founded, and explorers who became curators were sent out to acquire specimens for their collections. The appearance of the naturalist/taxidermist in the museum world gave rise to a new group of sculptors who based their work purely on animal anatomy. Among this group were Carl Akeley, James L. Clark and Louis Paul Jonas.

Later, Robert Henry Rockwell took this kind of work to a higher level of realism by adding a measure of animal character to his meticulous depictions of animal anatomy. Other sculptors followed the romantic lead of Barye and depicted animal life in all its violence, grace and natural beauty. The presentation of animal personality—the essence of the animal—was an American innovation that resulted in works reflecting something akin to an animal societal structure replete with human attributes. Albert Laessle, Gertrude Lathrop and Anna Hyatt Huntington were masters in this sculptural realm.

The great expositions of the 19th century

brought to public prominence not only sculpture as an important art, but the occupation of women as sculptors. For the first time, women's work was hailed as art, standing separate from the work of their male counterparts. The 1893 World's Columbian Exposition in Chicago, a landmark in the history of American sculpture, saw the rise of the White Rabbits, a group of women sculptors hired by Lorado Taft to help create and complete the ornamentation of beaux-arts buildings and other sculptural forms. The term *White Rabbits* came about through purported conversation between Taft and Daniel Burnham, chief architect of the fair. To Taft's inquiry about hiring women to help complete the work on time, Burnham supposedly replied, "Hire anyone who can do the work—white rabbits, if they will help out."[1] Among those in the group were Janet Scudder, Bessie Potter Vonnoh, Edith Woodman Burroughs, Enid Yandell, Caroline Brooks and Julia Bracken. Each woman traveled a difficult route to individual prominence.

Recognized as the foremost American *animalier* of the 20th century, Anna Hyatt Huntington (1876-1973) was primarily a self-taught sculptor although she had brief instruction from Henry Hudson Kitson and a short period of study at the Art Students' League. At the turn of the century, Huntington modeled domestic animals on her brother's farm near Leonardtown, Maryland, and wild animals at the New York Zoological Park. Studies made in 1907 of

Señor Lopez, a particularly fierce jaguar at the zoo, were praised for correct anatomy and a powerful yet elegant feline grace. Lorado Taft later wrote, "Verily they are among the most original things in American art…. If she had done nothing in this line other than her pair of 'Jaguars' her reputaion would have been assured."[2]

Three of these studies—*Reaching Jaguar, Jaguar* and *Jaguar Eating*—are among her finest creations. Her favorite animal, the horse, is featured prominently in the hundreds of works in her oeuvre, including the award-winning equestrian monument, *Joan of Arc*. She never considered herself to be a good sculptor of the human figure and always attempted to depict a human being in relation to an animal subject. *Fighting Stallions* [Figure 7], the massive landmark created for Brookgreen Gardens in 1950, exemplifies her remark: "I suppose the strongest characteristic of my work is that I like movement and motion. I don't care for the still sort of studies or single subjects. I like groups that make a design and pattern." The largest casting ever made in aluminum, it makes a bold and effective statement at the entrance to the sculpture garden she founded with her husband in South Carolina.

Eugenie Shonnard (1886-1978) initially studied painting with Alphonse Mucha. After developing an interest in sculpture, she received instruction from James Earle Fraser, then went to Paris in 1911 where Antoine Bourdelle and Auguste Rodin gave

her criticism. Her first works, portrait reliefs, were abandoned when her focus shifted to animals as subjects. Two charming depictions of a small rabbit, both entitled *Co-Co*, were modeled during her years in Paris. The compact lines of these studies are characteristic of Shonnard's work. But she also was fascinated with the elongated forms of wading birds that afforded her a different kind of interpretive challenge. *Marabou* [Figure 6] from 1915 is a fine example of the simplified contours she adopted early on to present the subject's essential form and temperament. Shonnard's vision of bird anatomy reduced the form to its most fundamental, a refinement necessary for her preferred medium of direct stone carving. In 1926, she was invited to visit New Mexico and model the Pueblo Indians. Enchanted by the land and the myriad opportunities that the landscape provided for art, she decided to stay and made her home in Santa Fe. About 1954, Shonnard developed a sandstonelike material she called Keenstone and used it exclusively in her direct-carved scenes of Native American culture and regional wildlife.

Other direct carvers of the first half of the 20th century who depicted animals with sleek, elegant curves were Dorothea Greenbaum (1893-1986) and Cornelia Chapin (1893-1973), though both sculptors were versatile in a variety of media. Laura Gardin Fraser (1889-1966), the student who married her teacher, James Earle Fraser, was an animal sculptor better known for her

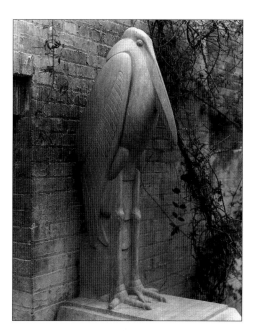

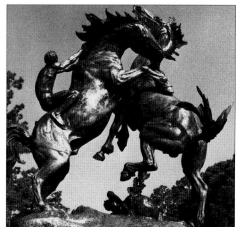

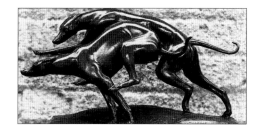

Figure 6
Marabou by Eugenie Shonnard, Napoleon gray marble, circa 1915, collection of Brookgreen Gardens.

Figure 7
Fighting Stallions by Anna Hyatt Huntington, aluminum on limestone base, 1907, collection of Brookgreen Gardens.

Figure 8
Greyhounds Unleashed by Katharine Lane Weems, bronze, 1928, collection of Brookgreen Gardens, photo by Gurdon L. Tarbox Jr.

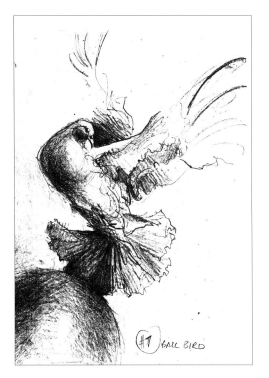

FIGURE 9
Working drawing for the *Fount* of
Peace Fountain, pencil, 12 x 9.

work in designing medals and coins. Among her favorite subjects was the horse, particularly racehorses.

Gertrude Lathrop (1886-1986) made studies of animals, especially young creatures, her specialty. This special interest later evolved into commissions for portraits and medallic art that incorporated images of the animals that she loved. Lathrop studied at the Art Student's League, at Solon Borglum's School of American Sculpture and with Charles Grafly. In her work *Little Lamb* [Figure 4], the newborn animal's uncertainty, bony shape and nubbly fleece are charmingly rendered. Amused by the oddities of pets, she often used as models the Pekinese dogs that she and her sister raised, since she was fascinated by the natural patterns created by their hair. Lathrop wrote, "I think that I chose to model animals because of their infinite variety of form and texture and their great beauty, for even the homeliest of them have beauty, yes, even the wart hog with his magnificent tusks."[3]

Born into a life of privilege in Boston, Katharine Lane Weems (1899-1989) had to fight a dual battle to achieve acceptance from her colleagues and approval from her family. In her youth, she frequented the nearby summer studio of Anna Hyatt Huntington for encouragement and took lessons from Charles Grafly at the Boston Museum School. Later, Weems visited the New York studio shared by Huntington and Brenda Putnam. The two older sculptors expanded her artistic experience, serving as

mentor and friend to the budding *animalier*. Soon her sculpture was winning awards in important exhibitions and her career was launched. She wrote, "When an outspoken friend asked, 'But, Kay, why animals?' My answer was spontaneous: 'Because when you're doing a human figure you're always working on the same fundamental chassis; but with an animal the variation in composition is infinite; an animal is forever in movement, in different unconscious grace.'"[4] Depicting that "unconscious grace" was Weems' specialty. Her elegant animals literally exude tranquilty, excitement, playfulness—whatever the subject was engaged in at the time she began to interpret its action.

As did many of her fellow sculptors, Philadelphian Beatrice Fenton (1887-1983) began working with portraits, but she soon discovered the singular combination of sculpture and water that gave her creations a special liveliness. In this particular branch of sculpture, whimsy and fantasy come to the fore in a marriage of pure delight. Considered among her principal works is *Seaweed Fountain* [Figure 3]—a fanciful composition of a young girl awkwardly standing on the back of a sea turtle, her outstretched arms draped with dripping seaweed. Fenton's excellent studies of animals won her numerous awards.

The second half of the 20th century brought new interpretations of animal sculpture such as assemblages of horses from found materials by Deborah Butterfield, representing a kind of a bridge between the real

and the abstract. As the mania for abstract interpretations in American sculpture settled, figurative works, which had been dismissed previously by critics as old-fashioned, passé or dated, suddenly began to be rediscovered. Although women sculptors all over America had been working continuously in the figurative tradition, it was the animal artist who vaulted into the public spotlight. On the East Coast, Charlotte Dunwiddie, Marilyn Newmark and Jane Armstrong were among those who won recognition with their distinctive animal sculptures.

In the West, the region around Loveland, Colorado, became a hotbed of activity as foundries were opened to provide sculptural services and artists established studios and homes. A new group of women emerged whose focus in sculpture was western themes and native wildlife. One of these sculptors is Sandy Scott, who began her career in art as an animation background artist for the motion picture industry. Her art techniques were learned at the Kansas City Art Institute. However, it is her passion for the outdoors and its myriad recreational opportunities that provides the subject matter for her etchings and her sculpture.

Scott's fountain sculptures, featuring multilayered groups of birds in flight, coming in to land and rising from the water, set new heights for environmental fantasy. In a manner reminiscent of Beatrice Fenton's work, Scott's birds are iridescently feathered and whimsically animated. Each bird has its own avian personality; taken as a whole, the entire composition has great life and spirit.

Brookgreen Gardens acquired her *Peace Fountain* [Plate 8] in 1997, depicting a flock of doves spiraling above and around an elevated pedestal water basin. The Trammel Crowe Company of Chicago commissioned *Spirit of the Wild Things* [Plate 1] depicting a lofting flight of over-size Canada geese. *Fountain of the Rain Forest* [Plate 69] features a complex design of macaws, toucans, and hummingbirds drinking and feeding upon multileveled, water-filled basins.

Whether her sculptural subject is a beloved Labrador retriever, an exotic game animal or a majestic American bald eagle, Sandy Scott not only makes it realistic: She invests it with life. Spirit and passion permeate her work. Anna Hyatt Huntington was described as being a spiritual descendant of Antoine-Louis Barye. Sandy Scott may be termed a spiritual descendant of Anna Hyatt Huntington, continuing the thread of the *animalier*, interweaving the fabric of American women in sculpture.

[1] Janet Scudder, *Modeling My Life* (New York: Harcourt, Brace & Co., 1925), 58.
[2] Lorado Taft, *Modern Tendencies in Sculpture* (Chicago: University of Chicago Press, 1921).
[3] Gertrude Lathrop, "Animals in Sculpture," National Sculpture Review, No. 3 (Fall 1966), 8.
[4] Katharine Lane Weems, *Odds Were Against Me* (New York: Vantage Press, 1985) 67.

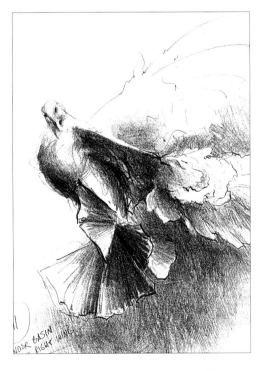

FIGURE 10
Working drawing for the *Basin Bird* of *Peace Fountain*, pencil, 12 x 9.

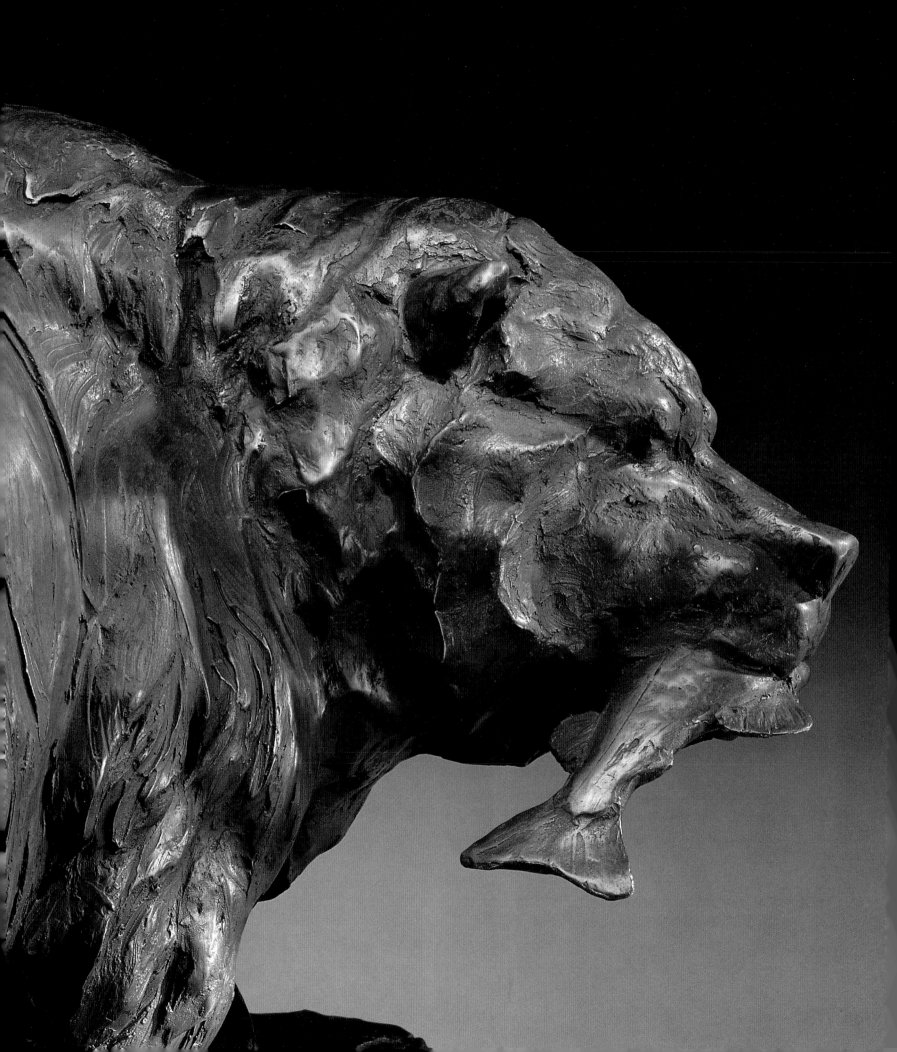

WHERE WILDERNESS AND CIVILIZATION MEET

Susan Hallsten McGarry

As paradoxical as it may seem, a great

sculptor is as much a colorist as the best

painter, or, rather, the best engraver.

He plays so skillfully with all the resources

of relief, he blends so well the boldness

of light with the modesty of shadow,

that his sculptures please one as much

as the most charming etchings.

Pierre-Auguste Rodin

Sandy Scott is synonymous with art. She makes art, and she collects art. She finds art in the wings of a landing loon and in the seductive curves of the neck of a vase. She turns the anatomical structure of a horse into art and surrounds herself with books that document the art of the ages. She lives life as if it were art, using her home in Fort Collins as an ever-changing sculpture, remodeled through endless renovation and construction.

Art is a compulsion for which Scott makes no apologies. It's on her mind when she is trolling for walleyed pike at her cabin on Lake of the Woods, serving up eggs she pickled from her chickens out back or talking with collectors at a gallery show or museum exhibition. I know this, but I didn't know how deep the obsession ran until I agreed to work with Sandy on a book commemorating the Gilcrease Museum's retrospective exhibition in June through September 1998.

The phone call came in August 1997, peppered with the irrepressible excitement that Sandy brings to her summers in the north woods. It was followed by photocopies of workbooks—pages and pages of thoughts, declarations, maxims and guides to understanding. These were short, abrupt manifestos describing the way she works and the values and commandments by which she makes art. They were clearly infused with both knowledge of her own working process and with an understanding of where she fits in the scheme of things. Indeed, they revealed the two primary sources for her art—participating in and experiencing the natural world from land, air and water, and expressing that experience as an artist carrying on aesthetic traditions from the beginning of time.

Since I've known Sandy for years and traveled with her to Alaska in 1989 where I spent a week watching her hunt, fish and bear-watch with the best of them, I wasn't surprised by the infusion of animal involvement that she brings to each of her sculptures. (Although I was disappointed that she never did a bronze of the halibut she helped me snag, but *Chum Run* [Plate 10] is a worthy concession, since it was inspired by a grizzly we saw crawling on our hind ends through rushes at Irish Creek off Big John Bay.)

What amazed me are Scott's knowledge of art history and her passion for sculptors from the Greeks to contemporary times. While she was already in the process of writing a book on how to sculpt birds, she was also eager to write an art history book. I discouraged her. "Well, how about including a chart or a schematic that shows how art history has evolved over the centuries," she persevered. "Let's leave it to Brooks and Robin," I countered. You'll enjoy Sandy's perspective on art history in the stories that follow.

Of all the thoughts dashed off in her workbooks, three lines—some in irregular script or block letters, others in capitals, all with a feeling of urgency—stood out as the corps of Sandy Scott's art:

SCULPTURE *is an experience
rather than an object.*
STYLE *is personal truth.*
ARTIST *is seeing, feeling,
understanding, expressing.*

I mulled these lines over and over during a day hike in Rocky Mountain National Park. That night (the day Princess Diana died) I visited with Sandy over several glasses of fine wine selected from her wine cellar. I approached her with the four areas listed under Artist as the possible organization of a book about her and her work. She was surprised at first, not sure that she remembered writing them down. The next day, those simple, yet complex words became the mantra for the tome you hold in your hands.

The words *seeing, feeling, understanding* and *expressing* spell out Scott's artistic process from inception to finish. Although the journey is specific to Sandy, they are universal terms that describe how most great art comes into being. I elaborate on them at the beginning of each chapter, so I'll leave your discovery of their subtle meanings to those pages and to the tales and musings of Scott, a raconteur whose storytelling rivals that of her heroes, naturalist Sigurd Olson and outdoorsman Gene Hill.

The remaining two lines deserve to be examined in light of Scott's work, however. The first is *Style is personal truth*.

Sandy Scott is a student of style. Her personal style has changed greatly over the more than two decades she has been producing fine art. Much of that evolution has to do with her response to her own work and her exposure to historical artworks.

During her early years working in the art studio of Calvin Motion Pictures, she put into practice the rendering skills she had learned at the Kansas City Art Institute. While others created animation cells, Scott painted the backgrounds that were panned behind the characters. Using traditional brushes and airbrushes, she followed guidelines set out by the art director, and chief among them were precision and accuracy.

While precision and accuracy do not describe a style, they do describe a technique of working that Scott transferred to her drawings and hand-tinted etchings, which she began producing in the mid-1970s. Her early vignettes and animal portraits relied primarily on a variety of lines, some fine and sharp, others broad and deep. They enlivened compositions that contrasted tight, busy areas against open, uncluttered space. Using line as a means of conveying value and color, Scott didn't need to tint her etchings, but in many cases she chose to add watercolor pigments that turned etchings into paintings.

Her technique of blurring or eliminating the background in order to focus upon a

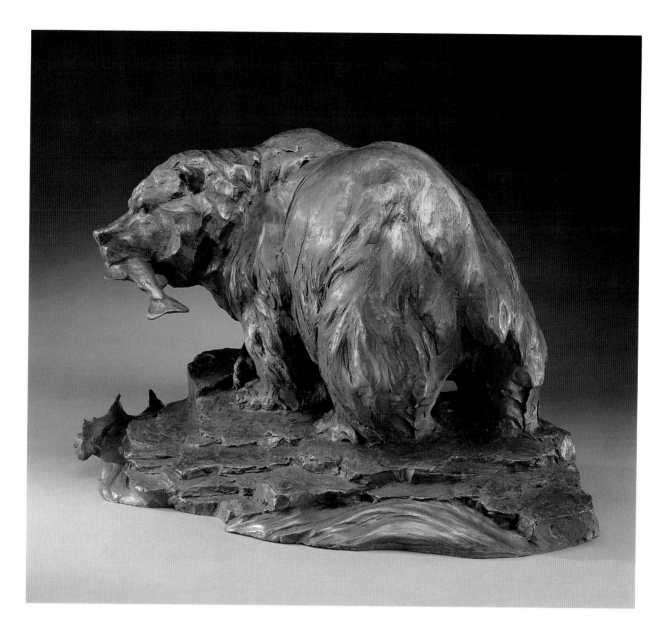

Chum Run at Irish Creek, bronze, h 19.
Observing bears emerging from water gave me an opportunity
to see and understand anatomical features normally obscured by fur.

sharply delineated subject was extremely popular in the 1970s. But Scott's tremendous success in marketing a new portfolio of etchings every year from 1975 to 1983 had less to do with the taste of the times than it did her strident commitment to see fine-art graphics elevated into the category of Fine Art. She continues to champion the media of etching and stone lithography despite the indifference it receives in museum communities and at art shows.

By the early 1980s, her more impressionistic style was beginning to emerge in subtler treatments of line and more dramatic contrasts of tone. The etching *Sleeping Cat* [Plate 11] was a turning point. The mood of

quiet softness conveyed in dissolving tones and curving lines caught the attention of judges, and the print won medals at the 1983 American Artists Professional League Grand National Exhibition and at the 1984 Salmagundi Open Art Exhibit.

Simmering below the surface of her etchings, however, was the craving to add another dimension to her art. A trip to China with a group of artists in 1981 expanded Scott's aesthetic horizons. It was followed by a visit in early 1982 to the Denver home/studio of sculptor Veryl Goodnight, where Scott was captivated by the pipes and wires of armatures. Shortly thereafter she stared into the window of a downtown Denver gallery, enraptured by Kenneth Bunn's animal sculptures. Scott had no alternative but to pick up a block of clay. It was a commitment that moved her from her newly acquired farm in Maine, where she had set up her etching studio, back to Texas where she created her first bronze, *Fantail* [Plate 12], which garnered three awards in 1982-83.

Although her media changed, Scott's subject matter did not. Tied to the wilderness experience and particularly birds, she modeled bluebills, spoonies, loons, quail, toucans, flamingos, cockatoos, macaws, ravens, eagles and mallards. Accuracy continued to be the foundation of her efforts, but aesthetics was the driving force. Articulated surface textures and exaggerated designs suggesting movement were common motifs. *Mallard Duet* [Plate 80] crystallized the style of contrasting wings that shout with baroque energy against

PLATE 11
Sleeping Cat, etching, 8 x 10.

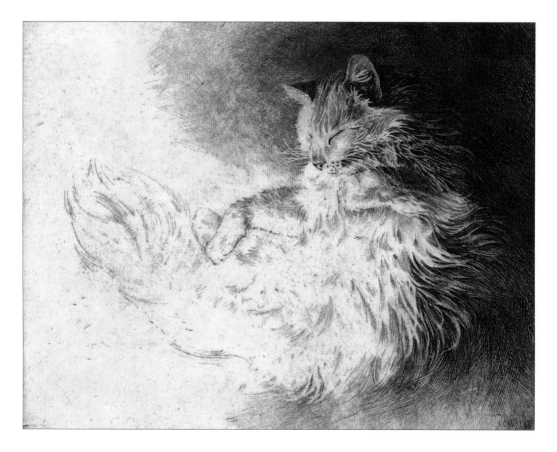

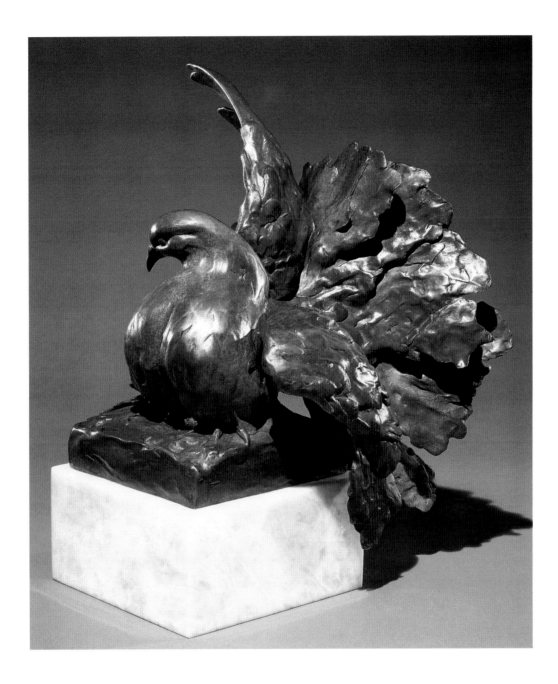

PLATE 12
Fantail (Pigeon), bronze, h 12.
The model for my first sculpture was one of the pigeons
that I raised on my patio in El Paso.

quiet elements such as heads and feet. It won the 1988 Ellen P. Speyer Prize at the National Academy of Design.

By the mid- to late 1980s, Scott was adding mammals to her repertoire of subjects. Elephants, horses, bears, dogs, cats and human torsos took on more classical proportions, influenced no doubt by two trips throughout Europe in 1985. During this time she also spent several summers in Alaska with Dr. Robert White, a dentist whose pastimes are collecting art and providing tours of Southeast Alaska on his trawler yacht Sea Comber. It was also at this time that Scott began to teach workshops. Having to articulate her methods and help students understand art history forced Scott to study the past and scrutinize what she did and why. It was in her classes that she came up with CUSS—an acronym for clarify, unify, simplify and solidify—which summarizes her method of modeling forms into meaningful shapes.

In reaction to her focus on birds bursting in movement, Scott has made simplicity and solidity the cornerstones of her most recent work. As she told Myrna Zanetell in an interview for *Inform Art*, "The older I get … the more I tend to simplify. Solidifying my pieces into nice shapes and designs has become more important than ever. I definitely adhere to the concept that less is more."

The undulating masses of Rodin, the animals caught in typical poses by the French *animaliers* and the classical lines of Greek horses have influenced Scott's work in the 1990s. "As an artist matures in her field, she finds that she doesn't have to shout, that she can whisper and still be heard," Scott related to Zanetell.

There is considerable evidence of typical poses that whisper in the Gilcrease exhibition. Elegant whippets, restful deer and preening cats make quiet statements recognizable from across the room as capturing the essence of the creatures as they would be seen in their natural habitats.

Where will Scott go from here? She doesn't waste time projecting into the future, short of recognizing that she'll need at least a year to recoup from the more than thirty new works she has created specifically for the Gilcrease show. Knowing Sandy, however, I can guarantee there will be travel involved—and that she won't stay away from her sculpture studios in Ontario or Colorado for long. Who knows, she may clean up that etching press and create a new portfolio, and of course, there's always another room to reclaim or a new foundation to be poured at the Cherry Mill.

That leaves us with a final note on *Sculpture is an experience rather than an object*. Nothing could better summarize both the artist's involvement with her work as well as that of her collectors and appreciators.

Art is an experience for Scott. It is a happening, an event, an emotion. More than anything else, she endeavors to infuse those emotions and happenings into the clay. She is equally adamant that art appreciators view her work as actively as she does when she creates it. To this end, Scott holds an idiosyncratic opinion about placing a sculpture on a turntable—she hates the idea. Rather than having the viewer static with the sculpture spinning before him, she wants you to walk around her sculptures, to see them in a variety of light situations and at different visual perspectives.

It isn't simply the visual senses that Scott hopes to trigger. She wants you to hear the hoot of an owl, feel the strength of a horse's withers, smell the water dripping from a grizzly's back and taste shore-lunch trout cooked over an open fire. Beyond these five organ senses, Scott endeavors to excite yet a sixth sense that has more meaning today as the millenium draws to a close, taking with it thousands of species of animals through human pollution and natural extinction.

A firm believer that humankind and animals can share this planet, Scott compels those of us who rarely see beyond the four walls of an office or the boundaries of a backyard to take the time to look up, to walk into a garden, to stop and consider the menagerie of critters that animates our existence. Her message is not political or didactic. Rather it suggests that civilization and wilderness share common ground. She reminds us that, as Chief Seattle implored, without animals we would be poorer in companionship and in understanding our role as guardians of this organism we call Earth.

PLATE 13
Little Nipper, bronze, h 12.
This giraffelike pose is typical of young horses, which eventually grow into their legs.

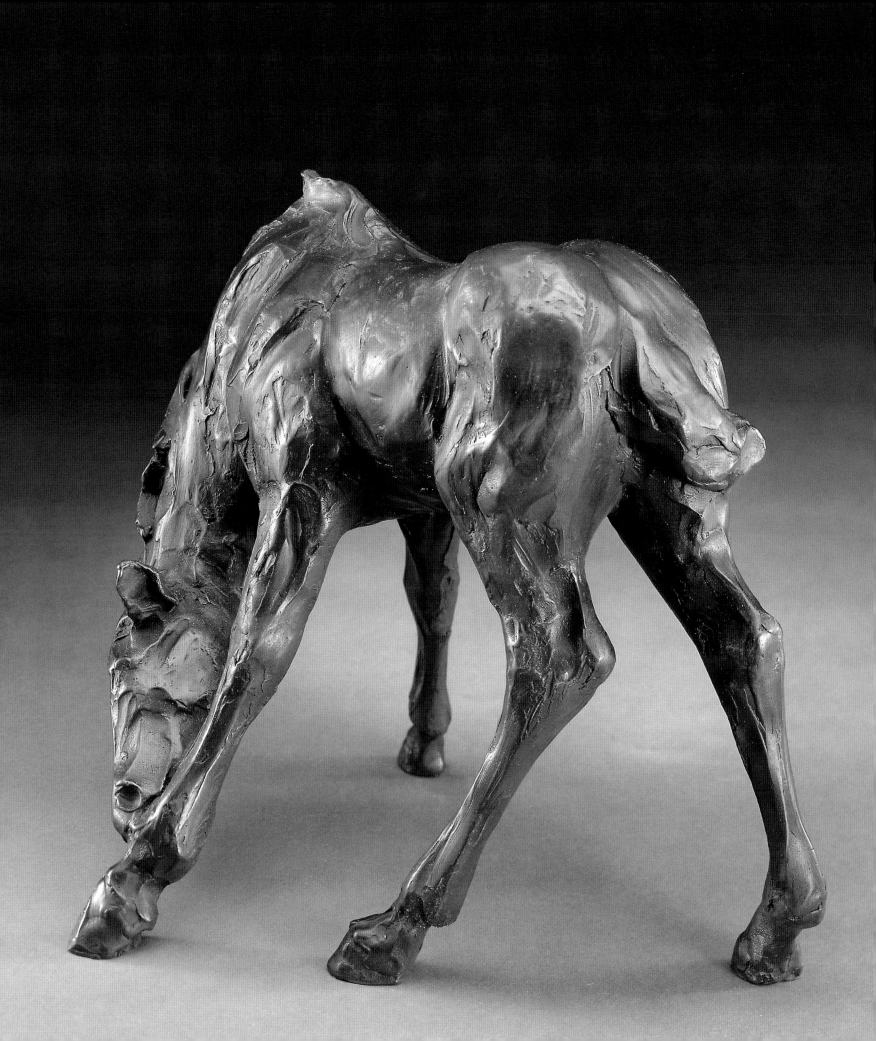

FIGURE 11
Winter Birds, etching, 6 x 7½.

More than twenty years ago I started keeping spiral-bound daybooks or journals that I refer to as my workbooks. These lined binders are of the type used in school and are filled with routine daily business information as well as ideas, notes to myself, appointments, gallery orders, phone numbers, figures, addresses and sketches — thousands of pages of information.

Wherever I go, my workbook is with me. I have stacks and stacks of them that I've filed in chronological order, and if I can remember a general date or year something happened, I can refer to that workbook and look up what I need. Included in this blizzard of paperwork are dog-grooming appointments, grocery lists and catalog orders for Christmas gifts—a plethora of data.

Liberally sprinkled throughout the workbooks are sketches for future sculpture projects, ideas for poses and designs as well as thoughts and facts about art, history, my work, other artists' works, profundities, old perceptions and the seeds of new sculpture projects that were or were not actualized.

Since childhood I have had to know how things—nature, history, animals, geography—fit into the grand scheme, and if it interests me I have a compulsion to write it down. I'm curious, always have been, and my incentive to travel is inexhaustible.

My workbooks were the source for the commentary in this book. It's been a soul-stirring and reflective experience to scan bits and pieces of writing that represent twenty years of living.

Sandy Scott

PART II

JOURNAL NOTES

BY *Sandy Scott*

CHAPTER INTRODUCTIONS

BY *Susan Hallsten McGarry*

Chapter 1

SEEING

INTRODUCTION **37**

MY ISLAND **38**

PELICANS **40**

THE CHERRY MILL **42**

CAMP BAY **46**

BRIGHT ANGEL MULES **50**

MOOSE CHILI **52**

DIRTY DAYS **56**

FAVORITE FISHING SPOT **58**

GRIZZLIES AND GOOSEBERRY PIE **60**

ON THE TRAIL **64**

■

Chapter 2

FEELING

INTRODUCTION **69**

FIRSTS **70**

HEIGHT OF LAND **72**

IT'S A BEAUTIFUL DAY **74**

WINTER BIRDS **76**

SEEING RED **78**

SYLVAN **80**

TRAIL CREEK **82**

IF IT LOOKS LIKE A PIG **86**

TOO CUTE **88**

SHORE-LUNCH EAGLE **90**

DUSKING DUCKS **92**

RUSSIAN BEAUTY **94**

Chapter 3

UNDERSTANDING

INTRODUCTION **97**

EARLY PERCEPTIONS **98**

EX LIBRIS **100**

SOURCE **102**

SKY PASSAGE **104**

BONES **108**

BIRD ANATOMY 101 **112**

BIRD SHAPES **116**

MASTERPIECE **120**

ARKY **124**

GOOSE-NESS **128**

SEA COMBER **130**

■

Chapter 4

EXPRESSING

INTRODUCTION **135**

LOST AND FOUND **136**

CLAY **138**

LOOSE **140**

EGGS AND LEGS **144**

DOTS **146**

THAT'S A NEGATIVE **148**

WHISPER **150**

MORE ON SHAPE **152**

STYLE **156**

IMPARA L'ARTE **158**

THE BIG PICTURE **162**

TOUCH **164**

SIGNING **166**

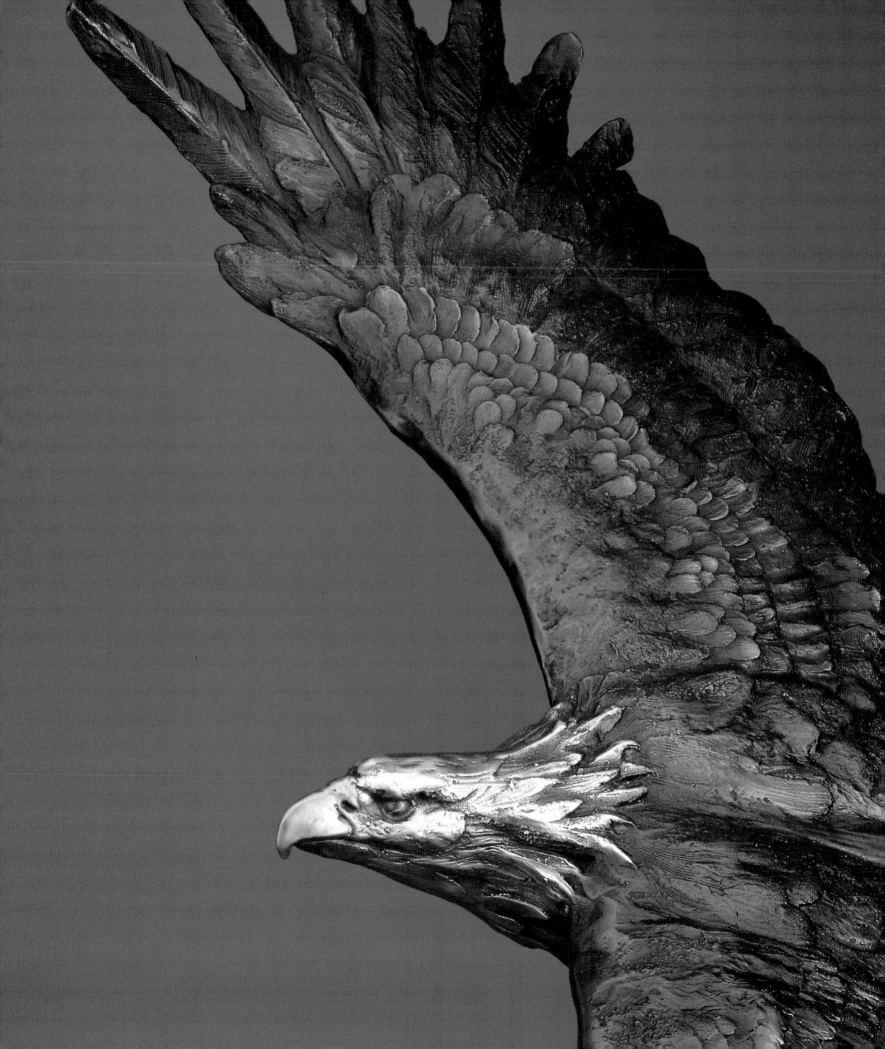

Chapter 1

S E E I N G

Put five plein-air painters in front of a Colorado landscape and watch them paint what they see. Amazingly, each comes up with a variation on the scene: One might show the mountains as huge and forbidding, while another focuses on the indomitable blue sky. I say blue, but you'll find that one artist will see the sky as gray and another might see it as pale turquoise. Each will interpret for him- or herself the prominence of a dilapidated wooden shed or the size of a grassy field dotted with wildflowers.

Artists view the world through their own peculiar lenses, but more significant than how they see is getting out there to make the seeing experience happen. Seeing is experiencing. Seeing is being there and absorbing everything that surrounds you. Seeing is being sensitive to the nuances that make every moment unique.

For Sandy Scott, seeing is a vital act. It is the foundation of her creativity—indeed, it is synonymous with the act of making something, whether it be a meal, a boat dock, a sculpture or an etching.

As you will see in this chapter, Scott's life as a maker of things revolves around her homesteads in Canada and Colorado and the many places she has visited throughout the world, including numerous summers spent in Alaska. Wherever she is, Scott opens her senses to her surroundings, absorbing everything with a profound curiosity.

Being in the moment drove her as a young woman to cherish the camaraderie of her father and his hunting buddies. Surrounded by wilderness and electrified by the pursuit of deer, moose or ducks set the stage for her pursuits as an artist. Today, she captures from memory and with every nerve in her body the subtle expression of a Labrador dog looking into the twilight for the silhouette of wings or the ponderous weight of a rack of moose horns lifting out of a bog.

In truth, the "studio" for Scott is the outdoors. She brings it into her indoor working spaces through extensive collections of taxidermy mounts, bones and anatomical study mounts. Photographs litter her work stands reminding her of weeks spent studying (and eating) geese in Alaska.

When such connections fall short of "being there," Scott need only walk out to the tack room, soak up the smell of leather and mount her Arabian horse Hisan for a ride around the fields of her nine-acre spread. If that doesn't do it, she hops in her motor home and heads for her Trail Creek, Bull Mountain and Chimney Rock wilderness properties in northern Colorado where she connects with the earth by wading into clear trout streams and watching a blazing fire burn into the night.

Seeing is an adventure for Scott, and through her art she brings us along for the thrill of the ride! —SHM

MY ISLAND

The most important days of one's life are spent when one is young for that is when the foundation of what comes later is laid. My parents laid that foundation by taking me to Canada. Later in life I bought a cabin on the north end of an island across the bay from Red Deer Lodge which we had visited many years earlier.

My island on Lake of the Woods in Ontario, Canada, holds a special place in my heart. It represents a place of solitude where loons call, eagles cry from high pine limbs and moose thrive in bog and muskeg. It is flooded with memories of spring portages, of summers fishing for walleyed pike and warm autumn days hunting ruffed grouse on lonely logging roads.

Above all, this place is my source: Ravens, jays, pelicans, partridge, ducks, geese, beaver, fox, squirrel, wolf, deer, kingfishers, otter, mink, mergansers, cormorants, osprey, herons, gulls, woodpeckers, black bear, and the ever-present loons and eagles are common in this rugged, watery wilderness. I've experienced these creatures in their domain as the seasons change, for my island has given me a choice seat from which to observe them and the wonders of the great Northland.

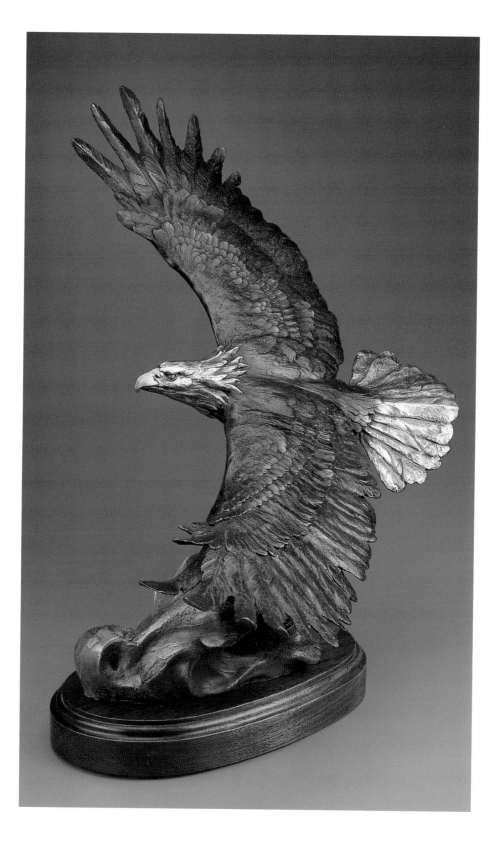

PLATES 14 AND 15
Wind Master, multipatinaed bronze, h 32.
Bald eagles don't achieve their white head and tail until they are five years old.
The immatures are brown and from a distance can be confused with the golden eagle.

From May to mid-October I live and work at the studio in my cabin. I load up supplies and books and head north when the ice goes out—I go to my source where new and familiar adventure waits. What anticipation!

When summer days of exploring are gone I'm always overwhelmed by memories of younger times, yet I know that the past is as vital as the leaves that break down into the soil.

I note the pelican's absence and the loon's rich black color change to a dull gray ... whispering wings fly overhead. The beautiful Colorado winter is waiting and there's work to be realized in the studio there.

The golden days are to be savored. Every yellow birch leaf reminds me it's autumn ... it's time to close up and go south.

Spring will come.

FIGURE 12
Sound of the North Country
(Common Loon), etching, 4¼ x 8.

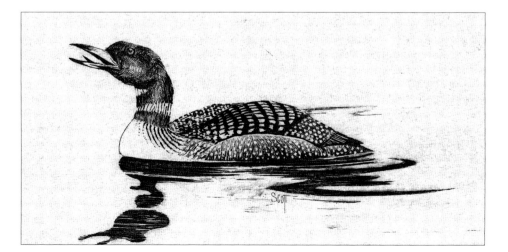

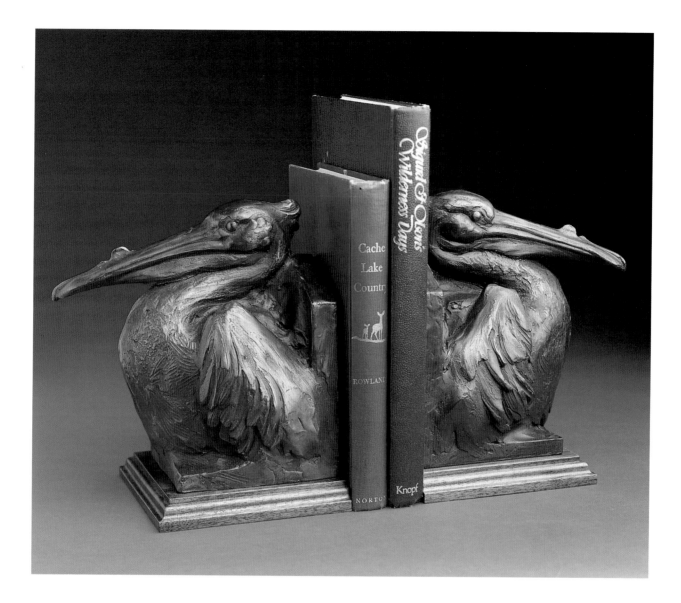

PLATE 16
Pelican Bookends, bronze, h 9.
Unlike brown pelicans which dive into the water to feed, white pelicans
seen on Lake of the Woods herd fish, then scoop them up with their beaks.

A house is a machine to live in.

Le Corbusier

I have two studios and two places of residence: One on Lake of the Woods and the other in Fort Collins, Colorado, at the Cherry Mill. I moved to Fort Collins from El Paso, Texas, to be near the foundries that cast my sculpture. The Colorado Front Range area has several foundries and I, like more then 100 professional sculptors who live and work in the area, am tethered to the foundries like spacewalkers attached to a mother ship.

FIGURE 13
The Cherry Mill East Studio.

In late August of 1985, I drove through the gates of a property called the Cherry Mill. As I walked through a tangle of shrubby growth to see the place for the first time, a flock of geese flew low overhead. They had just taken off from a lake across the road. I know this sounds corny, but it's true and I took it as an omen that this was where I should live.

The Cherry Mill had been a cherry canning factory at the turn of the century. A ramp led under the south end of the building where horses pulling carts were led to deposit the fruit—the stanchions where the horses were stabled and fed were still intact. The cherries were boiled, then moved by conveyor belt upstairs for canning. The old machinery still littered the property.

Later, in the 1950s and '60s, the buildings were used as a commercial pottery-making facility with gigantic brick firing and glazing kilns that were still in good repair. The pottery was made in a two-story brick building adjacent to the tin-roofed, tin-sided, colossal canning factory.

Finding a suitable residence and a place for a sculpture studio was my goal, but I was hopelessly enraptured by the enormous, dilapidated old building, the fascinating outbuildings, loading dock, orchard, pasture and horse barn ... an endless source of discoveries and possibilities.

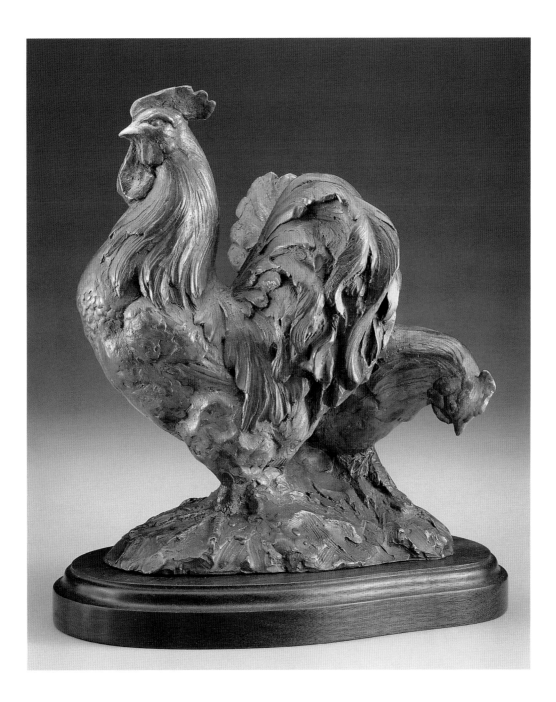

PLATE 17
Country Couple (Rooster View), bronze, h 11.
One of life's greatest pleasures is my morning routine
of feeding the chickens and gathering eggs at the Cherry Mill.

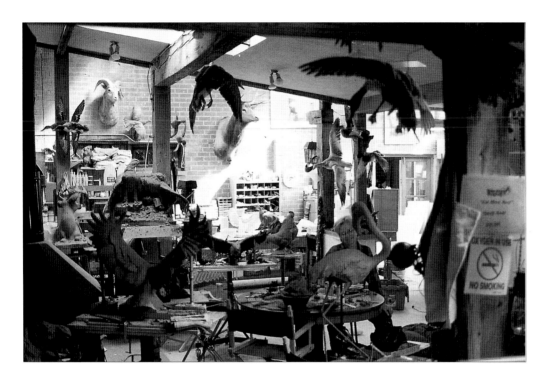

The massive boiler that had been used to process the cherries had been converted into a freestanding fireplace located in the only plumbed and livable room. During my first winter there, my bed was placed in front of the boiler-fireplace for warmth. My friends and family made it clear that they thought I had lost mind.

Owning the Cherry Mill has been more rebuilding than restoration. As the 20,000-square-foot mark was surpassed, my contractor Bill Connelly observed, "It can probably be seen from the moon now."

Renovation had been started and abandoned when I entered the picture, but to say the least, the greatest ongoing project of my life was and still is the Cherry Mill. At last count, I've added a wax pouring and chasing room, an etching studio, a monument facility, woodworking and basing shop, several storage rooms, a shipping room, a study, gallery, office, a sculpture garden, animal modeling pens, a library and a maquette studio—all used to facilitate the creation, production and dispersing of sculpture.

Over the years, the vintage structure has become a hospitable home and functions as an incredibly flexible studio and workplace. Trish Smith runs the business routine and oversees mold making and studio production. And within a few minutes drive, I can be fishing on one of Colorado's premier trout streams, the Poudre River. The setting is secluded, idyllic and conducive to creativity.

When I'm not on Lake of the Woods, I belong at the Cherry Mill, where I feel what Southerners call "a sense of place."

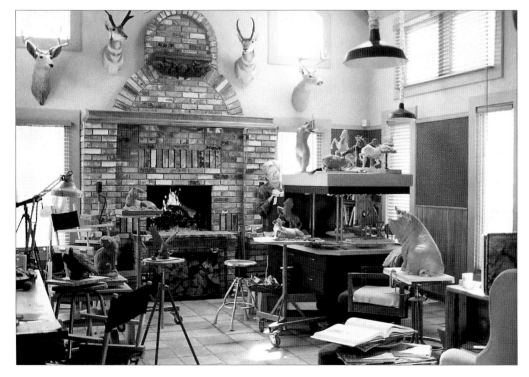

FIGURES 14 AND 15
Interiors of the north (top) and east Cherry Mill studios.

PLATE 18
Dominick, etching, 9 x 6¾.
My grandmother raised these chickens and always
referred to them as her 'domineckers.'

The most beautiful thing we can

experience is the mysterious.

It is the source of all art and science.

Albert Einstein

Camp Bay—or Three Fingers Bay as it is called—is a small arm of the larger Sabaskong Bay, one of four segments of Lake of the Woods. Two thirds of Lake of the Woods lies in Ontario and Manitoba and the remainder is in Minnesota. The lake is immense: 65,000 miles of shoreline (more than Lake Superior) with 14,000 islands (more than any lake on the North American continent). It measures 65 miles long from north to south and 55 miles wide from east to west.

During my 35-plus years there, I've never been beyond Sabaskong Bay by boat. When and if I do venture further, I would need to take extra fuel and plan to camp out overnight. Due to the size of the lake, aluminum fishing boats of 14 feet in length or more are standard, and canoes are rarely used on the larger expanses as rough water could cause them to capsize.

Camp Bay is my favorite place to cook shore-lunch because the secluded inlets are protected from wind in every direction. There are several places to build a fire, and my choice depends on weather and the time of year, as each of the three fingers has unique characteristics.

If the day is sunny and warm I opt for the cove with a deep pool sided by polished granite rock because it is a choice place to swim. When the weather is cold and wet, there's another finger of the bay that is protected, providing a little niche in which to start a fire. We named this spot Merganser Point because every spring flotillas of mergansers can be seen there.

PLATE 19
Red Canoe (Ruffed Grouse),
etching, 6½ x 11.

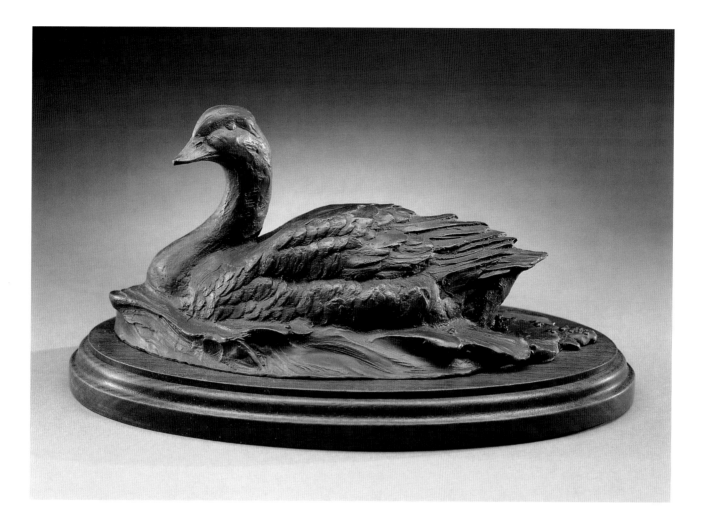

PLATE 20
Camp Bay, bronze, h 6.
The controlled modeling here is the result of a quiet pose
—just as you would see it in nature.

The third finger, or the one that lies to the north, is shallow and fed by a stream. The land is reclaiming it, and wild rice now grows in places where my father and I fished years ago.

One golden and glorious fall afternoon, Trish and I prepared a walleyed pike shore-lunch at Merganser Point. While relaxing by the fire and watching the gulls clean up scraps, we heard the distant honking of geese. We scanned the horizon but could see nothing. We broke camp, loaded the boat and slowly cruised northwest toward the sound.

At the entrance to the grassy north finger, we cut and raised the motor and noiselessly paddled in. Directly in front of us, gliding slowly through the rice was a handsome Canada goose, resplendent in the brilliant sun.

We sat in silence, drinking in the grandeur of the moment. Far-off, upstream in the rice beds we heard the cackling and foraging of what must have been hundreds of geese. We could go no further in the deep-keeled boat so we paddled out of the shallow water.

At the cabin that night I pored over a detailed topographical map of the area and discovered that the little stream snaked far back into the rugged bush. I had to figure out a way to get into what seemed to be a huge, open marsh and experience the birds in their hideaway.

That winter I devised a plan. For years I had taken pleasure in the sculptural shape of canoes. I had admired and coveted the romance and design of the boat but could not come up with a justifiable reason for owning one on the big lake.

The next season when I returned to Lake of the Woods, the voyageur spirit possessed me as I slipped up the north finger of Camp Bay in my Old Town canoe.

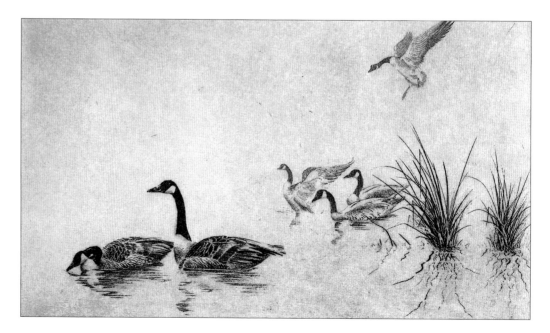

FIGURE 16
Late Arrival (Canada Geese),
etching, 8½ x 12.

SPIRIT OF THE WILD THINGS #2
JUNE - 1986

FIGURE 17
Working drawing for *Spirit of the Wild Things*,
pencil, 11 x 13.

Several years ago in late September I accompanied Trish on a sculpture delivery to the Grand Canyon. John and Liz Siebold own a flying service there and had purchased my eagle sculpture, *Sovereign Wings* [Plate 4], for the entrance to the airport. They paid expenses for delivery and promised a great time if we would both make the trip.

We pulled into the airport parking lot and before we could unload, John escorted us out onto the tarmac to a waiting airplane. We were treated to a breathtaking flight over the canyon. Below us I noticed a pack-string of mules headed up a trail. John explained that they were coming from the canyon floor where they had spent the night at Phantom Ranch and would go back down the next day. That's what I wanted to do, and he said he knew the outfitters and might be able to get us lined up to go down the next morning.

He was successful, so that night we assembled our suggested gear: sun hat, sun block, rain gear, a water bottle and overnight items to take on the adventure down the Bright Angel Trail.

The next morning, a wave of nostalgia gripped me as I approached the animals. My grandparents and their parents had homesteaded and farmed in northwestern Arkansas. My grandfather had a team of mules named Pete and Bud, and childhood memories rushed back as I remembered him calling, "Gee, Pete!" and "Haw, Bud!" while he reared back on the brake to keep the wagon wheels from overtaking the animals as they rumbled down the hilly, rutted road.

We mounted and started down the trail, and I looked straight down at the ribbon of Colorado River below me. I'm afraid of heights and being perched on top of my mule, Ike, gave me an exaggerated feeling of acrophobia. I didn't or couldn't speak for the first few minutes, but gradually the beauty of the experience took over and Ike became my new best friend.

Peering through his big, floppy ears hour after hour gave me an idea for a mule sculpture. When we stopped in a shady flat area by a beautiful stream and ate our box lunch, I took out my cameras and sketchbook and worked with the bored-looking animals.

It would be an understatement to say I was sore that night and that I had stand to eat my well-earned steak dinner. The exhilaration of the day and the excitement of creating a new sculpture added a chapter to my portfolio of experience.

FIGURE 18
Mules of Bright Angel Trail, clay, h 20.

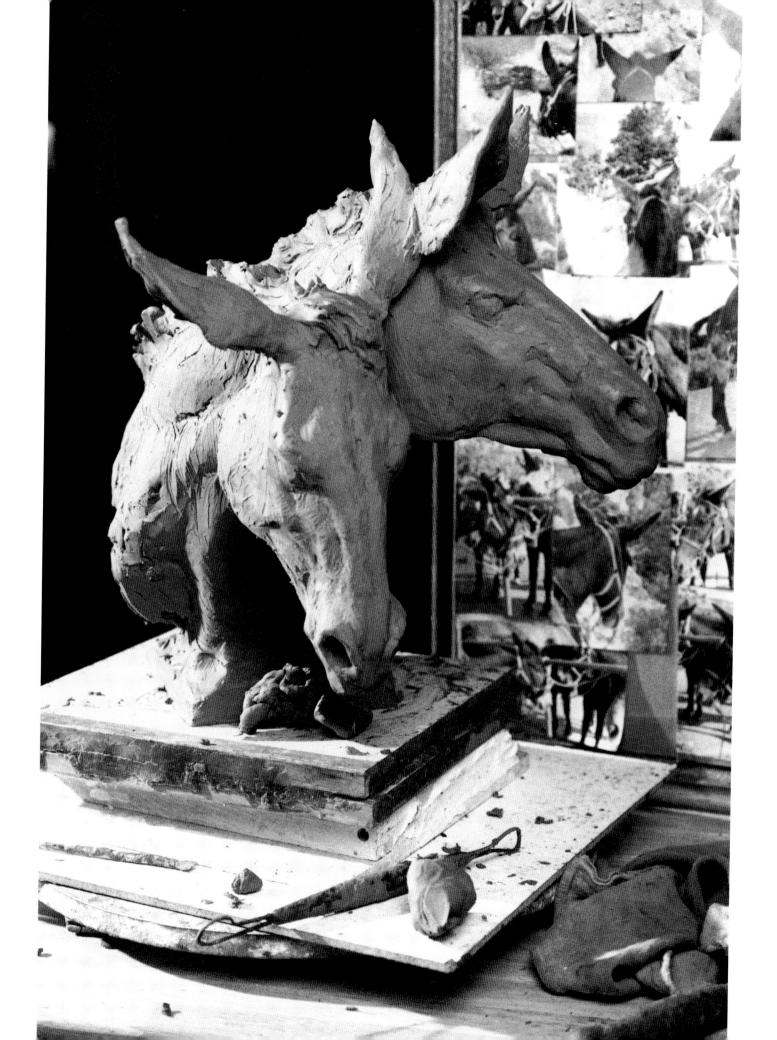

Experience—seeing things firsthand or being there—is vital to the wildlife artist. It's true, some animal artists rarely, if ever, venture into the field for their material and rely on scrap, or clip-files, books, magazines, video, zoos, taxidermy mounts, etc. While all of this is important, somehow the viewer senses in the artist's work if he or she has actually been there.

Sometimes being there causes things to happen—sometimes things happen because you've been there. As a young woman out of art school and undecided about where to go in the arts, I had the privilege of being there by tagging along with my father into the wilds of Canada.

In 1965 my father, our friend Sunny Jenkins and I went moose hunting north of Lake of the Woods in Ontario. I had just gotten my pilot's license and was thrilled to be in the right seat as we flew north in Sunny's Cessna 180 floatplane. Our destination was a full day's flight from Sunny's cabin to Sabourin Lake Lodge, with a stop at the remote town of Red Lake for fuel.

On board we had our normal gear, extra av-gas and a case of Canadian Club that the lodge owner had requested for "medicinal purposes." There were no roads into the place, everything had to be flown in, and they had even cut a jeep into parts and brought it in by De Havilland Otter and reassembled it.

We did not make it to our fuel stop at Red Lake as weather forced us down south of there. We landed on an unidentified tiny lake, built a fire and prepared for the wet, miserable night ahead. We had eaten our

FIGURE 19
Bull Moose, etching, 8 x 13.

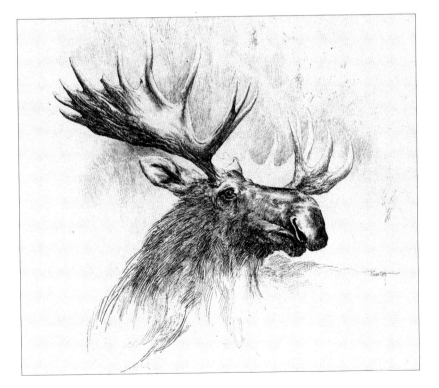

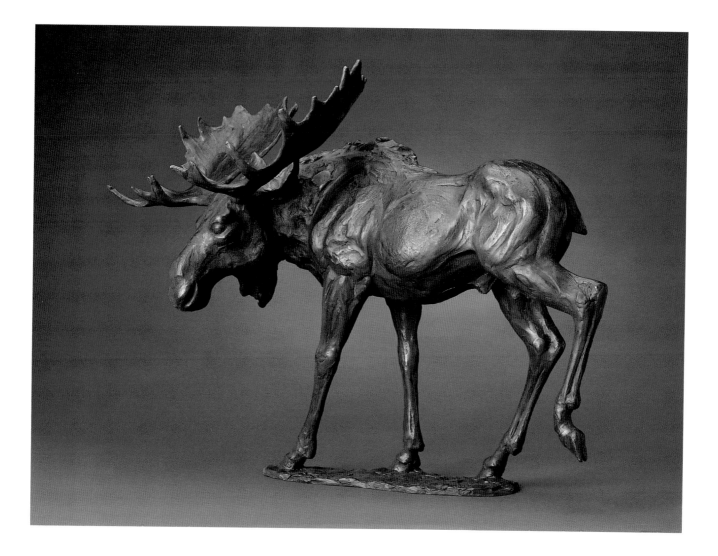

PLATE 21
Moose in Muck, bronze, h 18.
Long, gangling legs, big humped nose, mulelike ears,
enormous antlers—the moose is ugly in a compelling way.

Recipe for Moose Chili

Ground moose meat
(use cow meat if available)

Onion

Chili powder, cumin, garlic, oregano and
pepper and salt to taste

Brown beans (soak and boil your own)

Canned tomato paste, sauce and bits

*Saute onion, brown meat in bacon fat, add
rest of ingredients to pot and bring to boil.
Reduce to low heat and simmer 2 to
6 hours 'til meat is tender. While cooking,
thin with flat beer.*

lunch en route hours before and nothing remained but a couple of apple cores. Sunny had a rusty old can of Spam in his tackle box and, of course, there was the Canadian Club. To this day I can see my father carefully dividing that meat among the three of us with his big hunting knife. While Sunny and my father took turns pulling a few belts from the whiskey bottle, I emptied a Band-aid box filled with jigs and drank mine with lake water.

The next morning we homed in on Red Lake, refueled, ate a breakfast only wheat thrashers relate to, took a bearing and finally arrived at Sabourin before noon. The lodge looked like something from a movie set. The gigantic high-ceilinged structure was built with log timbers, and there was an enormous stone fireplace with birchwood roaring its warmth. Even the fastidious French chef, Pierre, could have been from central casting, and his wild-game cooking was deliciously indescribable. The weather had been bad and no one in camp had yet to bag their moose so the Canadian Club was popular.

After lunch, the three of us went hunting. In those days it was legal to spot from the air and within an hour the hunting gods were with us. We saw a cow feeding in the shallows of a weedy bay below us, figured the wind and set the 180 down some distance away where we unstrapped the canoe from the pontoon. Paddling around a point we spotted her. She hadn't seen us and was feeding with her head completely underwater. When her head came up she heard us,

whirled and crashed off through the muck, sending out sheets of spray. I stood up and fired my 30.06. The recoil catapulted me backwards and my father grabbed my jeans to keep me from going overboard. She was down, and in a few hours we had the succulent dark meat quartered, loaded and took off for the lodge in the fading light.

I admit I was puffed up in a young girl way as again that day no one got a moose. That night the camp enjoyed moose steaks for supper and oh what a feast!

Today, along with treasured memories, a Band-aid can sits on the mantel of my cabin on Lake of the Woods to remind me of being there.

PLATE 22
Monarch of the Boreal, bronze, h 19.
The odd looking banjo-nosed moose is the
largest of all American deer.

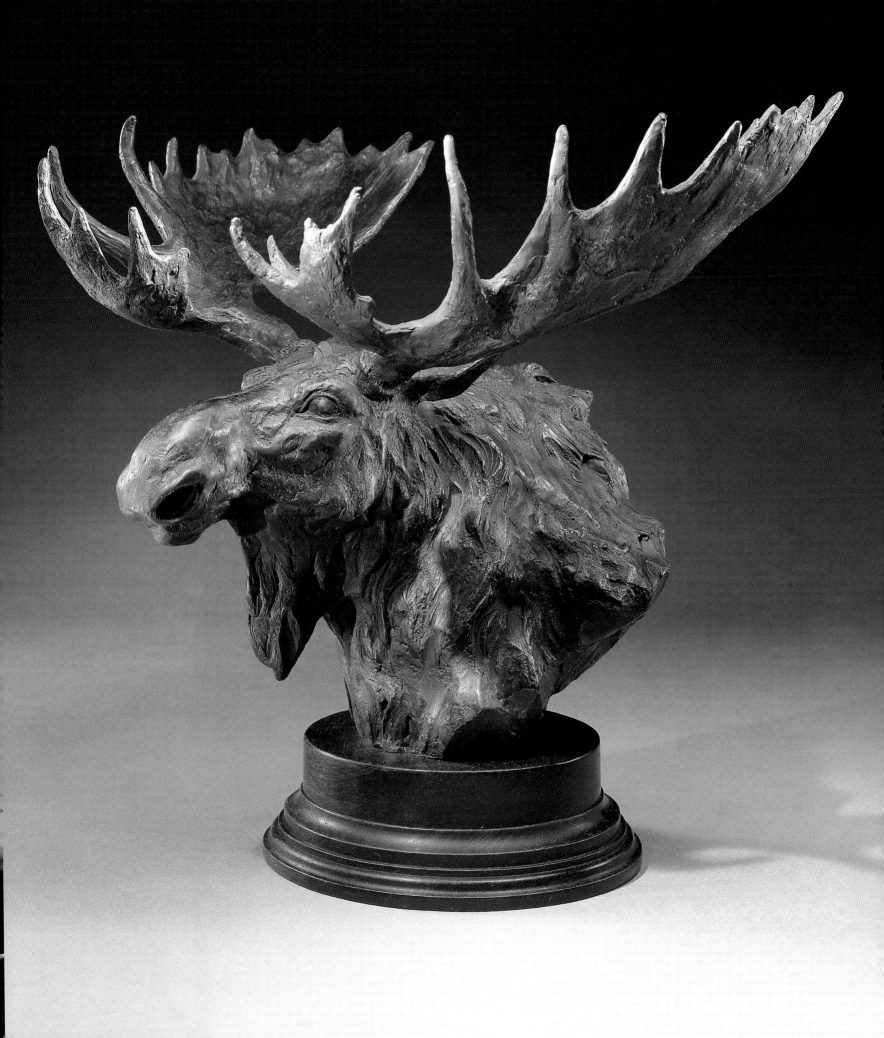

The guide on our early fall trips to Lake of the Woods was not an Ojibway Indian as most lodges provided but a Swede by the name of Lloyd Antoneson. That was a glorious time as I was immersed in Sigurd Olson's writings about the North Country and was impressed by this man, Lloyd, who could guide us out and back through a bewildering maze of water, shoreline and islands.

As a youngster, I learned that if you wanted to go along you had to be either a bird dog or carry a gun, and that when fall came, hunting took precedence over fishing. Duck hunting by moving boat was legal then, and Lloyd took great delight in zooming in and out of grassy bays on what Canadians call "dirty days" or low-ceiling, cold, drizzly, only-ducks-love-it days. My father would hang onto the back of my belt to balance me while I stood in the bow of the streaking boat, swinging a 12 gauge and blasting away at bluebills, mallards and teal.

One action-packed morning, as the bluebills kept circling back into range, Lloyd was laughing so hard he ran the boat through the bulrushes and up on the bank at full bore.

Randy from these outings, we would return to housekeeping cabin #9 at Red Deer Lodge in the evening. While my father and I sipped Old Charter in front of the birch fire and exaggerated the day's events, my mother prepared delectable feasts of wild duck, walleyed pike, grouse and thick pie made from Jonathan apples that they had brought from Oklahoma.

Those joyous times spent during the early years on the lake are a wealth of precious memories and cherished longings.

FIGURE 20
Dirty Days, etching, 6 x 12.

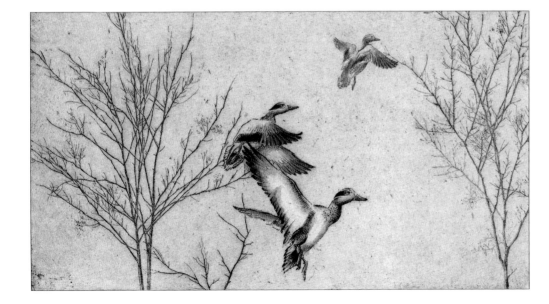

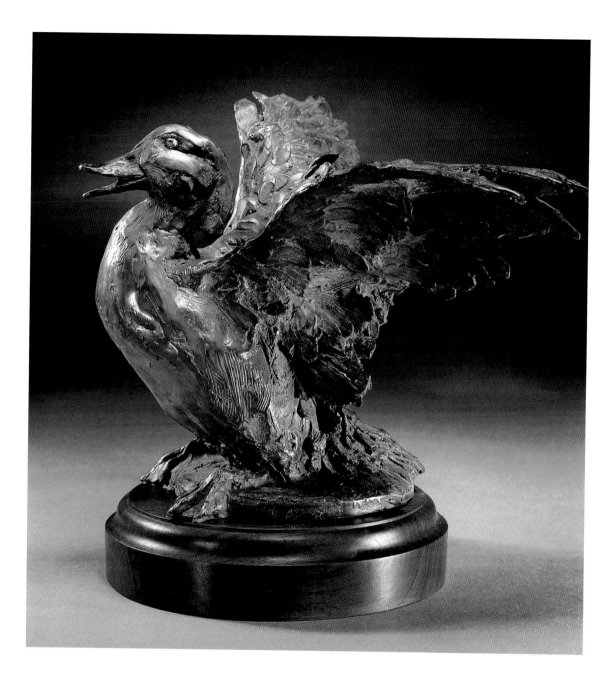

PLATE 23
Stretching Teal, bronze, h 11.
Teal are small, fast flyers that make for great sport and
delicious eating, if you know how to cook them.

My friend, Trish Smith, and I have a favorite fishing spot on Lake of the Woods that we've named Eagle Island. Atop a towering red pine, there's an enormous nest or eyrie, as it's called, and we can be sure of seeing mature and juvenile eagles during certain times of the season.

The eagles return there year after year, and the nest grows bigger and bigger. We are very careful not to venture too close or linger too long because we want the birds to return to the place. Now and then an eagle will scream—whether in rage, warning or threat, we don't know but we vacate immediately.

We've shut the motor down, paddled in and spent hours listening to their mild way of talking to each other in a kind of cackling—*cack - cack - cack*—or crying—*koi - koi - koi*. Sometimes, high in the air, the mates join in a display of aerial gymnastics as they fly upward together, wheeling in ascending spirals. Then they turn and dive—locking talons as they roll and somersault downward—pulling out of their tumbling descent just as it seems they are about to crash into the water. All the while, they cry out to each other over the wind in shrill screams ... and then the whole beautiful game begins again.

The only problem with my favorite fishing spot is I've never caught a fish there.

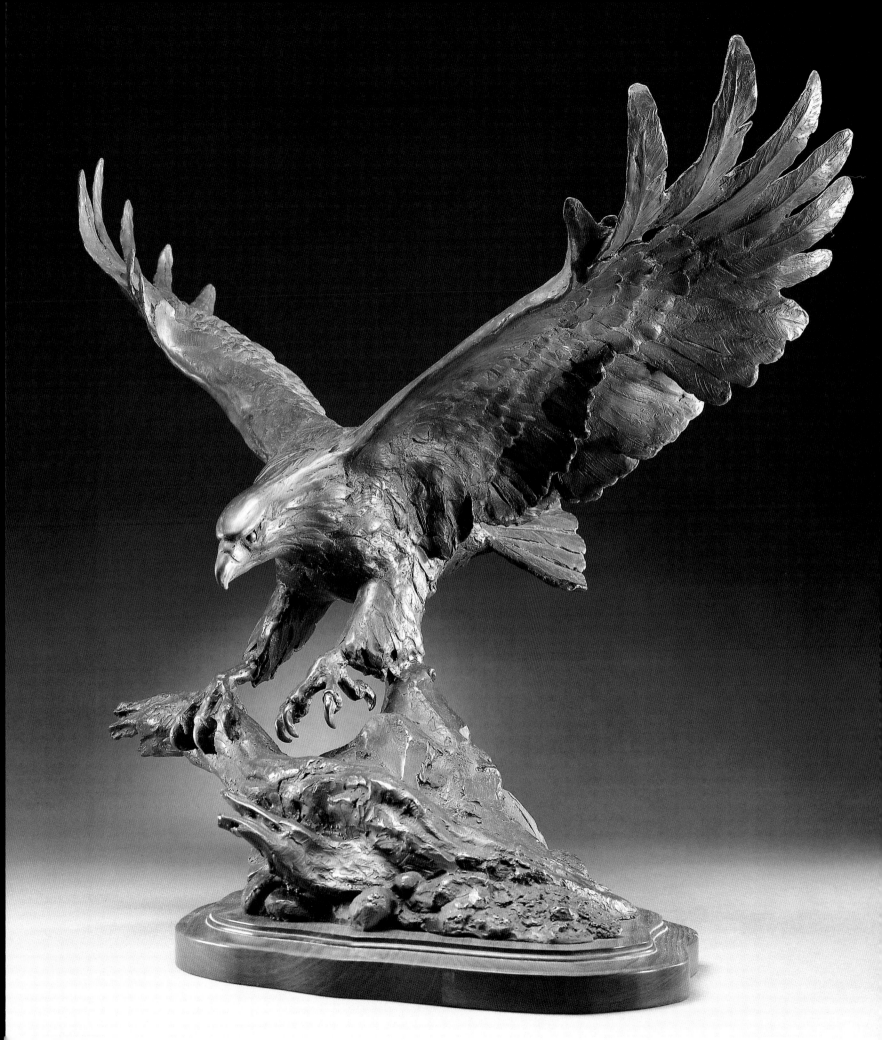

There are two types of grizzly bears: One lives in the western United States, western and northwestern Canada, and throughout Alaska. The other, the larger of the two due to diet, is the Alaskan brown bear, which lives on the Alaska Peninsula and adjacent islands. My firsthand experience is with the latter.

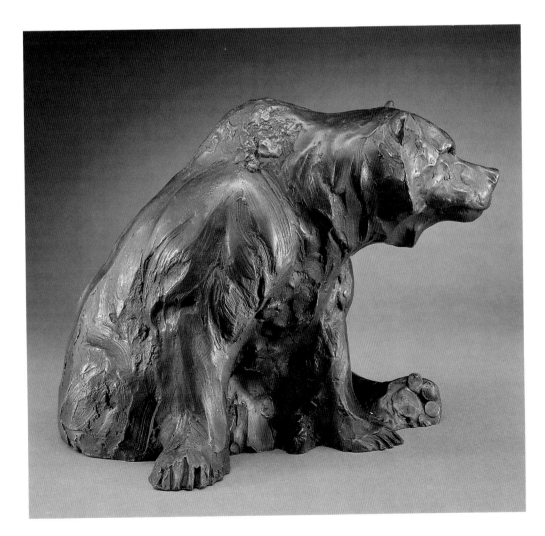

In 1979 a west Texas oil company commissioned me to do a series of etchings depicting two men by the name of Bill Pennell and Morris Talifson who lived and guided bear hunts at Olga Bay on Kodiak Island, Alaska. Bill and Morris had originally traveled to Alaska from the lower forty-eight to prospect for gold in the 1920s. Unsuccessful in that venture, they started a guide service on Kodiak Island. In their time they guided many famous people including the Shah of Iran. Their base of operation was an enormous abandoned salmon-canning factory. The owner, Del Monte, let them live there in exchange for taking care of the place.

In mid August my friend Cheryl Rossi and I flew from El Paso to Kodiak and took a floatplane west to Olga Bay to begin the first of many adventures in Alaska. For safety, a young guide and a packer was provided for two exciting and exhaustive weeks.

My job was to hike from camp in the morning, find the bears feeding on salmon in the streams and photograph and sketch them behind the gun-toting men. My client wanted etchings of the bears, the illustrious old guides, the ancient canning factory, interior scenes and even their dog in an effort to commemorate this extraordinary situation on Olga Bay where he had often hunted.

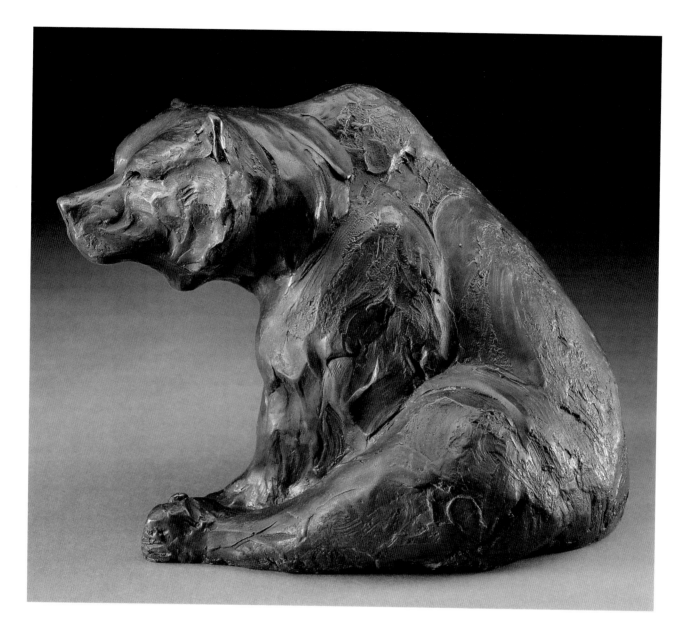

PLATES 25 AND 26
Two views of *Big Bruiser*, bronze, h 10.
In this stylized interpretation I attempted to capture the
forthright nature of the grizzly and the texture of its grizzled coat.

The old codgers didn't like having women in camp, but we ingratiated ourselves to them when Cheryl baked two gooseberry pies. They were great gardeners and the long Alaska summer days had resulted in gooseberries the size of apricots.

While there, we hiked fifteen miles through alders and rugged terrain to remote Karluk Lake and spent three days photographing the bears and trout fishing for the Dolly Varden that were feeding under the spawning salmon. One morning we ventured too far from the old hunter's shack where we made camp and stupidly stumbled upon a sow with three cubs. We cheated death by slowly backing away and didn't make that mistake again.

We spent beautiful days there exploring the old cannery, enjoying steaming pots of Alaskan king crab pulled from the deep bay water, and relaxing in the ingenious alder-fired beach sauna while intoxicated by surreal aurora borealis in the late-summer sky.

From that trip I obtained an enormous quantity of field studies, photography and experience. At that time in my career I was immersed in etching and printmaking and had not yet turned my attention to sculpture. Because etching is essentially line drawings, I was forced to see accurately. Drawing is the foundation of art, and in a drawing the artist defines something that cannot be described in words ... it would be like describing the taste of gooseberry pie.

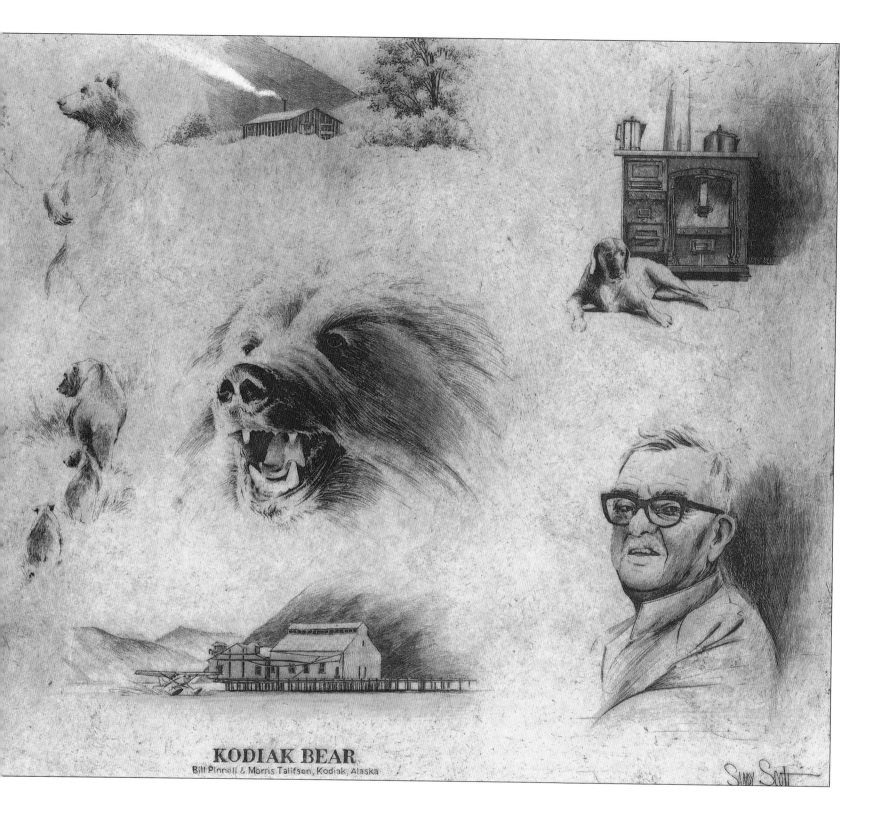

KODIAK BEAR
Bill Pinnell & Morris Talifson, Kodiak, Alaska

PLATE 27
Kodiak Bear, etching, 12½ x 17¾.

My father's friend, Jim Hunsey owned a hunting camp on Arrow Lake. Arrow is northwest of Sabaskong Bay on Lake of the Woods and the only way to get there was and still is by floatplane. The remote lake is ten miles long and very narrow with several islands on which to hunt deer.

In the fall of 1963 my father, Sunny Jenkins, Chuck Rhodes, Jim and our Canadian friend and guide, Lawrence Cottam, planned a weeklong deer hunt at Jim's camp. Although I didn't have a rifle, I was invited along—as if they could keep me from going.

Jim, Chuck and Lawrence arrived a day before us in Jim's floatplane, so when Sunny, my father and I arrived in Sunny's plane, housekeeping was already set up with a birch fire burning merrily in the round barrel-stove. The hunter's camp was everything I had dreamed it would be and I was bursting with expectation. I had been bird hunting for quail, ducks, doves and pheasant with Sunny and my father but this was my first deer hunt and just being there was enough.

That night the men checked the gear and made a final inspection of their guns, then neatly stacked them by the door for the morning's hunt. Chuck noticed that I was listening to the barrage of talk about guns, ammo and hunting, and he sensed that I felt out of the loop because I didn't have a gun. He offered to let me use his old Stevens

12-gauge double-barrel with slugs for shells. I was in heaven, so I polished the shotgun and lined it up next to the rifles.

The next morning I woke up to the smell of boiling coffee and bacon and was eager for the day ahead. Lawrence was considered the best guide in the area, and at breakfast he spelled out the plan for the hunt on a nearby island. We loaded into the boats and headed across the water. The idea was to figure the wind and for half of us to take stands along the game trails while the others drove the deer. The trails were the deer's escape routes to the water. They would run in front of the drivers, then swim the short distance between island and mainland.

Lawrence was a fun-loving Canadian. He had a jaunty way of wearing his cap at an angle making him always appear at ease. He assessed my gun with a quaint wink and reckoned that I had a snowball's chance in hell to get off a shot. He positioned me on the south flank of the island, just below a jack-pine ridge by a trail so thick with hazel-brush that you had to stoop to walk through it. If I moved further than a few feet from the trail I couldn't see anything so I took my stand practically on the trail.

FIGURE 21
From left to right: Lawrence Cottam, his father Harvey Cottam and Chuck Rhodes.

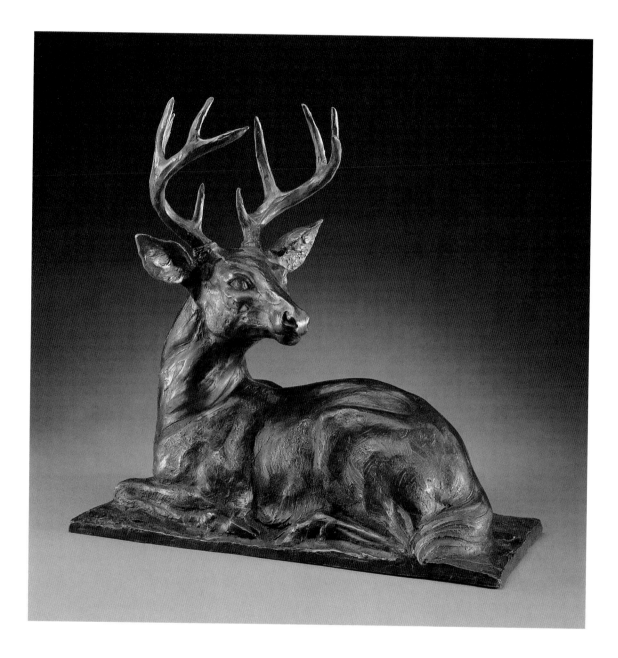

PLATE 28
Downwind, bronze, h 20.
During hunting season, deer hunker down—
you would think they could read a calendar.

Lawrence was amused by the whole situation. As he left, he said, "You could do just as well throwing a rock; same ballistics … the slug will come out of the gun and drop like a rock." I was not amused and sat just off the trail in the thick brush.

My father and Sunny had been placed on the north flank and in the center of the island, respectively, on trails that offered clear shooting. After a couple of hours I heard a snorting and crashing sound coming toward me from higher on the ridge. I backed away from the trail a step. Shaking, I shouldered the shotgun and pointed through the brush at the spot where I knew the deer would have to come down the faint trail. The spot was less than twenty feet in front of me. Here it came … crashing … plunging toward me!

Suddenly, it burst into view and a black shape shocked my senses. It was a bear! I

shot, and in a split second the animal was past me and lumbered down the trail. I could have reached out and touched him! I instantly noticed blood on the trail … I had hit him!

Just then I heard branches crack as Lawrence, Sunny and my father appeared. "Let's go!" I shouted, "I hit a bear!" Lawrence said, "Hold it, you hit him in the foot!" His experience clued him that the clear, red blood, low on the brush meant the critter had a superficial wound on the foot. Down the trail we went, bent over, trailing blood drops all the way to the water's edge. We looked across the water to the mainland just as the bear splashed out on the other side. In a moment, he vanished into the balsam and pine.

"That bear will have a sore foot this winter," Lawrence laughed. "You were on the trail, why didn't you swing at him with your gun?"

That night in camp we settled down to enjoy ourselves in front of the fire with a toddy and to recount the day. The afternoon hunt had been a success, and alongside the cabin a nice buck hung next to a spike and a doe. A venison tenderloin was simmering with wild mushrooms and there was much laughter about my bear. It was a night to be remembered.

The French have a beautiful word for remembrance—*souvenir*. I have a souvenir of my first deer hunt … memories of being on the trail and the feeling I had when I snuggled into my bag that night.

FIGURE 22
Spooked (White-tailed Deer), etching, 9 x 13.

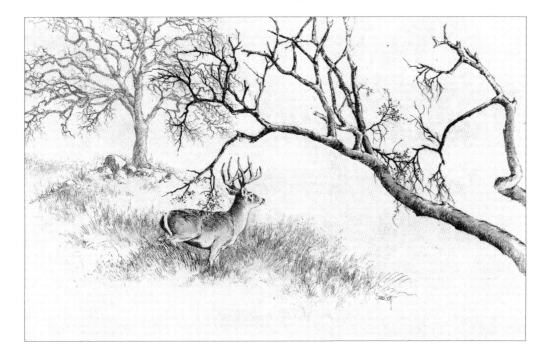

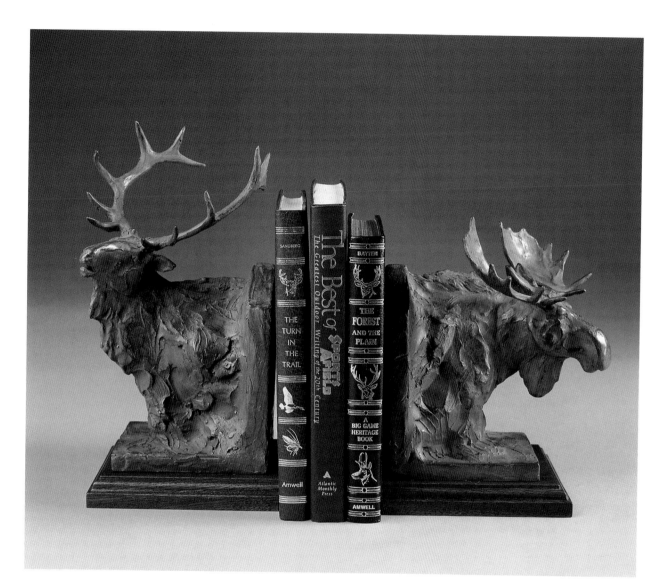

PLATE 29
Trophy Bookends, bronze, h 12.
Many naturalists, conservationists, ornithologists and artists have gotten
their start at the butt-end of a gun ... I'm no exception.

F E E L I N G

The sculptor must, by means of a resumé of the impressions received, communicate whatever has struck his sensibility, so that a person beholding his work may experience in its entirety the emotion felt by the artist while he observed nature.

Medardo Rosso

Look up the word *feeling* in the dictionary and you learn that in addition to describing touch, one of the five senses, it also refers to "the quality of a work of art that embodies and conveys the emotion of the artist." *Passion* is a synonym for a feeling that can be marked by pleasure, pain, attraction or repulsion.

Feeling goes beyond being there. Feeling is connecting with what you are seeing. Feeling recognizes a sound and translates it into a memory or longing that brings a smile, tear or tinge of regret. Feeling is finding a lump in your throat that threatens to suffocate you unless you express your emotions about it.

A work of art cannot communicate to others without feeling. No matter how well-rendered or how perfectly crafted, the artwork rings hollow—a body without a soul—if it is void of feeling. Feeling communicates that this animal, this place, this event *means something*.

For Scott, the word *feeling* begins a dialogue with the subject before her. The dialogue often starts with an irresistible attraction—some fleeting or formidable nugget that plops into the pool of her sensibility sending out ripples that crash into her psyche or massage her heart. It can be as intangible as the croak of a frog or the slippery sound of a boat's name. Or it may be as pre-

dictable as an apple blossom announcing the seasonal cycle of birth, death and resurrection or the proclamation of a freeze that compels Scott to join the birds in migrating from north to south.

For the dialogue to take shape in Scott's mind, feeling must go beyond chit-chat, beyond idle gossip. Layers of meaning have to be plumbed to find the basis of a hummingbird's voracious appetite or a bull elk's instinctive drive to forgo food for sex during the fall rut. When she cuts away the bark to where the pith is stored, Scott begins the process of rebuilding and reshaping the dialogue into forms and relationships that have meaning in nature and in her personal lexicon.

But the dialogue can teeter on a tenuous line of which Scott is constantly aware. She speaks about it directly in Too Cute and If it Looks Like a Pig. Over-sentimentalizing animals or anthropomorphizing them with trenchant eyes or smirking lips is a pitfall Scott avoids. She is ever alert to pruning away any tendrils of nostalgia that might destroy the animal's integrity.

Feeling reveals to us the relationship between the artist and the animal, while preserving the primal difference between animals and humankind. —SHM

The first great event of my life was a summer vacation to Wyoming in 1958 with my parents and sister Nancy. I was fourteen years of age and spending two weeks camping below the wild peaks of the Grand Tetons and in the geyser basins of Yellowstone plunged me into a rich adventure that changed my life forever. It was the beginning of a spell that the West has had on me to this day.

Having never traveled beyond Oklahoma or northwestern Arkansas, this event presented many "firsts" in my young life:

Dear Diary: Slept in a bedroll under a starry sky for the first time; first time in a boat; caught my first fish, a cutthroat trout; saw my first antelope, bear, buffalo, elk, golden eagle and moose.

Pretty heady stuff in retrospect. The experience was of incalculable value because it revealed the treasures and possibilities that lay ahead of me in life.

Periodically, I now travel the United States and Canada in a little motor home—a studio on wheels—and visit the Yellowstone area often. I never fail to reflect upon and realize the meaning of that summer vacation long ago. The vast and wondrous frontiers waiting to be explored were unveiled during my first trip out West.

PLATE 31
Cutthroat Trout, Yellowstone,
watercolor, 5 x 7.

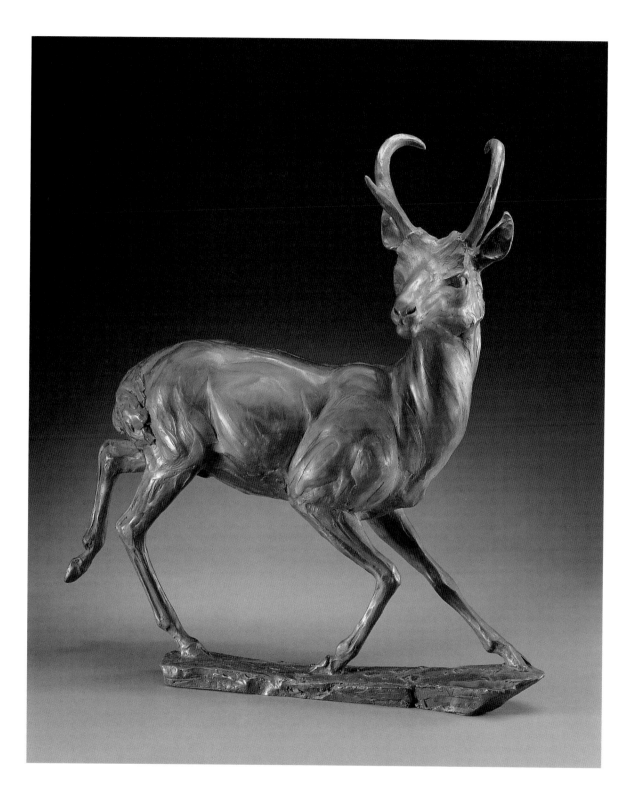

Beyond Wind River, bronze, h 22.
The pronghorn is more than an animal to me. It's an
emotional state that exemplifies my deep affinity for the West.

The wild call of the loon characterizes the spirit of the wilderness and touches something deep inside me. This beautiful, primitive bird has stayed virtually unchanged for over 30 million years and has become the symbol of the Northern experience.

I clearly recall my first encounter with loons. It happened on the first evening of my first trip to Red Deer Lodge. I heard their haunting call, and a bond was formed that has drawn me back to the North Country to this day.

My most vivid experience with loons happened in 1997 on a remote lake east of my cabin called Height of Land. I had been there many times in the 1960s. The Ojibway call the lake Kishkutena, which means high land, and to get there back then, we had to portage up through three small lakes. From Lake of the Woods we put into Pine Lake, then portaged into Wigwam, where I caught my first muskie, then to Marl Lake and finally into Height of Land.

I wanted to do a loon subject for the Gilcrease Retrospective and so the flying service flew Trish and me to an outpost camp for five days of looning. We landed in marginal weather, set up camp in the rustic cabin and prepared for our adventure gathering loon reference. In August loons congregate in groups of eight, twelve or more, to prepare for the coming migration south.

For five days and four nights the weather was blustery and cold with a winterlike northeast wind spitting icy rain. Throughout the trip we had seen loons but the rough chop on the lake prohibited us from venturing out in our tiny boat. We passed our days by staying in the lee shelter of islands and jigging for small-mouth bass. At night in our cozy camp, we cooked the succulent fillets over a birch-wood fire, enjoyed our Crown Royal cocktail hour and played dominoes.

Just before dusk, on our final night, a strong wind blew the low ceiling away. A brilliant orange sunset burst out and the lake became dead calm as we built a fire on the granite rocks in front of the cabin. All of a sudden a chorus of tremolos, hoots and wails startled us as a flotilla of eight loons drifted within casting distance of our camp. The mystical, wild harmony continued to thrill us throughout the evening. As a full moon rose, I felt as though I could touch the stars.

Nothing could possibly have been more beautiful. I was conscious only of the wild beauty before me. Here was a primitive wilderness where time stood still.

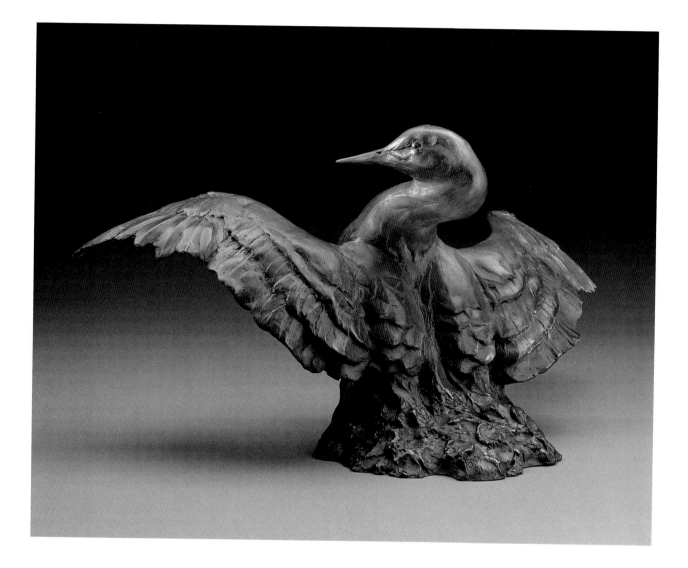

PLATE 33
Height of Land, bronze, h 12.
Only found in the Northern Hemisphere, loons are extremely awkward on land,
but their big, webbed feet make them great swimmers.

Recipe for Canned Fish
Cut fillets into two-inch chunks and soak in
a solution of water, vinegar and lemon juice
for twenty minutes. Drain. Prepare canning
jars. Place one tablespoon each of oil and
tomato paste in each jar with salt to taste.
Fill jars two-thirds full with fish. Put lids on
loosely and place in a preheated 225-degree
oven for four hours. Remove jars and listen
for the lids to secure with a firm pop.

As autumn nears, like many people, I instinctively feel an urge to gather and harvest. In the spring, I'm compelled to plant. Akin to the animals, humans have instincts, and mine are manifested in the land, to which I feel a closeness.

My father and my grandparents on both my father's and mother's sides of the family and their fathers before them made their living by farming. In my own little way I carry on the agrarian tradition in Colorado. I have chickens for eggs, a small orchard and a garden. I have found that I am content in a rural or a wilderness habitat.

My live-off-the-land compulsion extends to draining and closing time as winter nears at my cabin. At the end of the season, using Evelyn Cottam's special technique, I can and put up lake trout and pike in quart jars. For the traditional Canadian Thanksgiving in October, we eat ruffed grouse harvested from my island.

But it is the North Country that I identify with and where I feel at home. There I feel a part of an existence where life is simple. The open horizons and the freedom of the wilderness—since my youth—have given my life meaning and direction.

PLATE 34
Muskie, etching, 7 x 5.

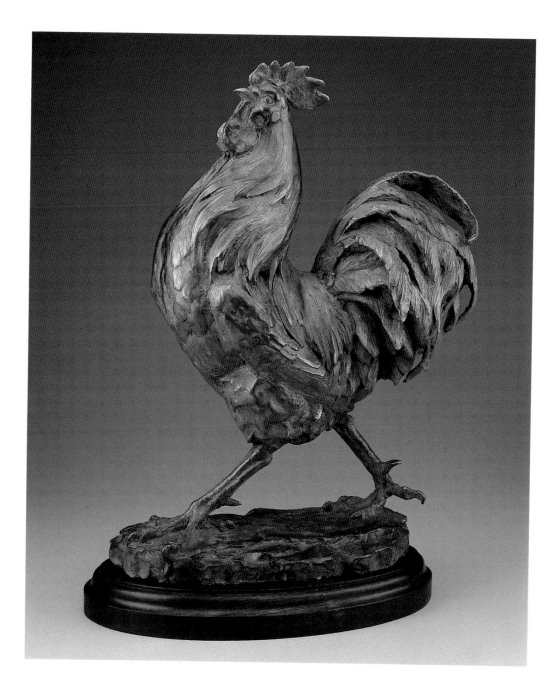

PLATE 35
It's a Beautiful Day, bronze, h 18.
My goal was to present the outrageous arrogance of this common bird.

The boreal chickadee is one of the few small birds that is able to handle the rigors of winter in the North Country. They squirrel away food and raid their stores to stay alive when winter's freeze-up comes.

When I see chickadees in the winter in Colorado, thoughts go to my cabin where everything would be sheathed in glittering ice and snow. I envision sweeping stretches of frozen lake, the howling wind and my cabin buried deep in snow under the big white pines. I remember the chickadees in the dense woods behind the cabin and hope they see some sunny hours.

It is the birds I notice most when the seasons change.

PLATE 36
Chickadee, etching, 4¹⁄₂ x 4¹⁄₄.

PLATE 37
Winter Birds, bronze, h 10.
These chunky little chickadees have fluffed
their feathers to preserve body heat against the cold.

I had a deck built onto the front of my cabin, which sits on a point and is close to the water. When I'm on the deck, I feel as though I'm on the flying bridge of a ship.

When I arrive to open up in May, I can't wait to put geraniums on the deck, and since springtime is for planting, I set out tomatoes in a sunny spot on the south corner.

I place red sugar-water feeders under the eaves and watch ruby-throated humming-birds as they dart from feeder to birch branch then to their wee nest, high in a big poplar tree. They look like jewels flashing in the sun with their red bibs and brilliant metallic sheen.

How I love the deck! Dazzling with splashes of color: cadmium red geraniums, hearty bright tomatoes and sparkling ruby-throated hummers against the complementary greens of summer.

When snow blankets my home in Colorado, I think of summertime at the cabin on Lake of the Woods, and I see red.

PLATE 38
Hummer II, etching, 4 x 7½.

PLATE 39
Hummingbird, bronze, h 10
Some flowers provide nectar while others, like the rose,
catch water and dewdrops for the birds to drink.

When I was looking for a boat, my decision to own a Sylvan was based upon the sound of the beautiful word ... Sylvan. I looked at Lund, Lowe, Alumnacraft, Smokercraft and Crestliner, but why have one of those when you could own a Sylvan?

The word *sylvan* derives from the Latin word, *silva*, which means forest, woods or trees. It signifies something woodsy, timbered or forest-like.

To those who know boats better than I do, I suppose that my reason for owning a Sylvan would be analogous to betting on a horse because you like the color of the jockey's silks. But as I slip into a grassy bay and pintails rise against the wooded shore-line, I know I'm in a Sylvan.

FIGURE 23
Page from a workbook,
pencil, 9 x 11.

PLATE 40
Pintail Rising Bas Relief, bronze, h 11.
I love modeling bas-reliefs, which comes as close to painting as a sculptor gets.

I have 40 acres of land in the mountains of northern Colorado close to the Wyoming border. There's a beautiful little stream called Trail Creek that meanders through and eventually empties into the Poudre River. The place is less than an hour from my Fort Collins studio, and when I need the intangible tonic that can be found only in the wilds, I head for the mountains and to Trail Creek.

I have cleared a level place close to the stream for my little camper. Next to "my cabin on wheels" there is a fire pit surrounded by smooth rocks where I prepare sumptuous meals of brown trout cooked in bacon fat over the open fire. Farther downstream, I am certain to catch rainbows.

PLATE 41
Rainbow Trout at Trail Creek,
watercolor, 5 x 7

Early one fall morning, while driving the dirt road from Trail Creek into Wyoming, I saw an enormous herd of elk. The higher snow had driven them down. The sun wasn't warm yet and the frost was heavy on the grass. There, in a meadow fringed with evergreen and aspen, the herd grazed in the brilliant morning sun. I stopped the truck and sat watching them, lost in thoughts of the beauty that was before me.

The dark pine and spruce formed a backdrop for the trembling aspen—quakies, as aspen are called in Colorado—which fluttered and whispered in the gentle autumn breeze.

Around the campfire after supper that night my thoughts were with the elk that I had seen that morning. I looked into the glowing coals and pulled my jacket tight around me. The chill night air made me shiver as an owl hooted from the timber. I put a few more sticks on the fire, and it gently crackled warmth. Far away in the distance, I swear I could hear the bugling of a bull elk. Behind me, Trail Creek chuckled.

PLATE 42
Down From Bull Mountain, bronze, h 21.
Unlike other deer species, elk like to
gather in large herds. In the fall the shrill
bugling of the bull rings through
the foothills of the Rockies.

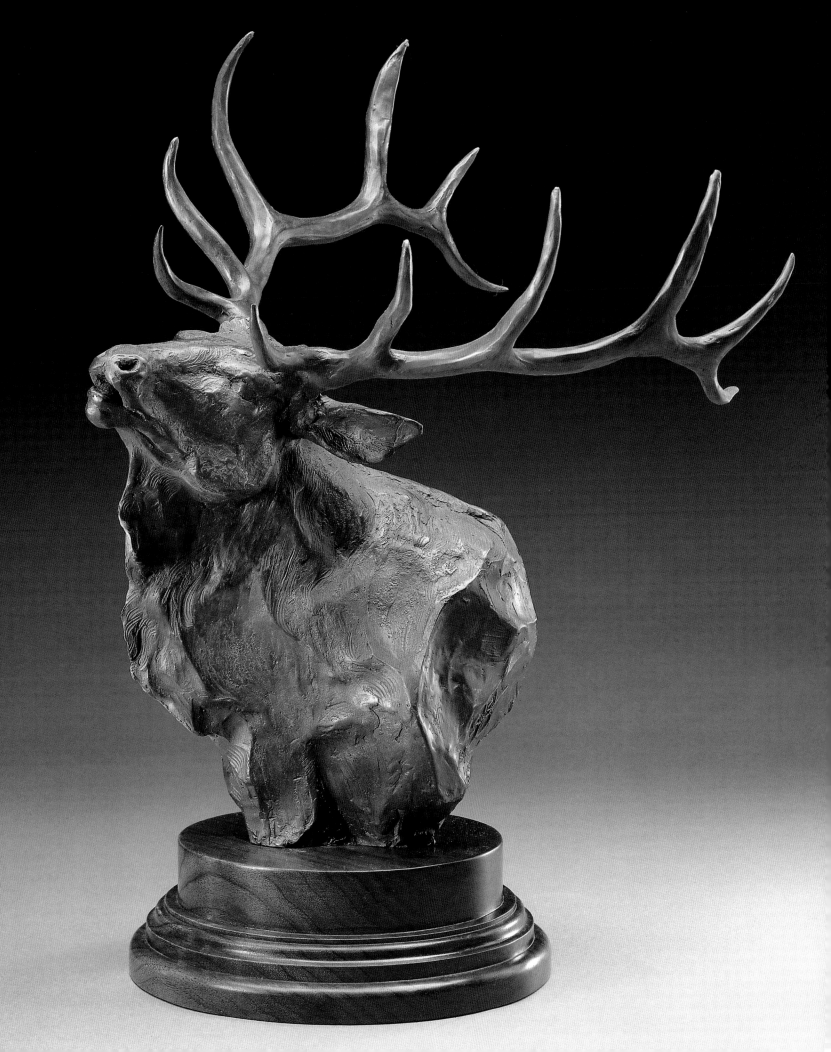

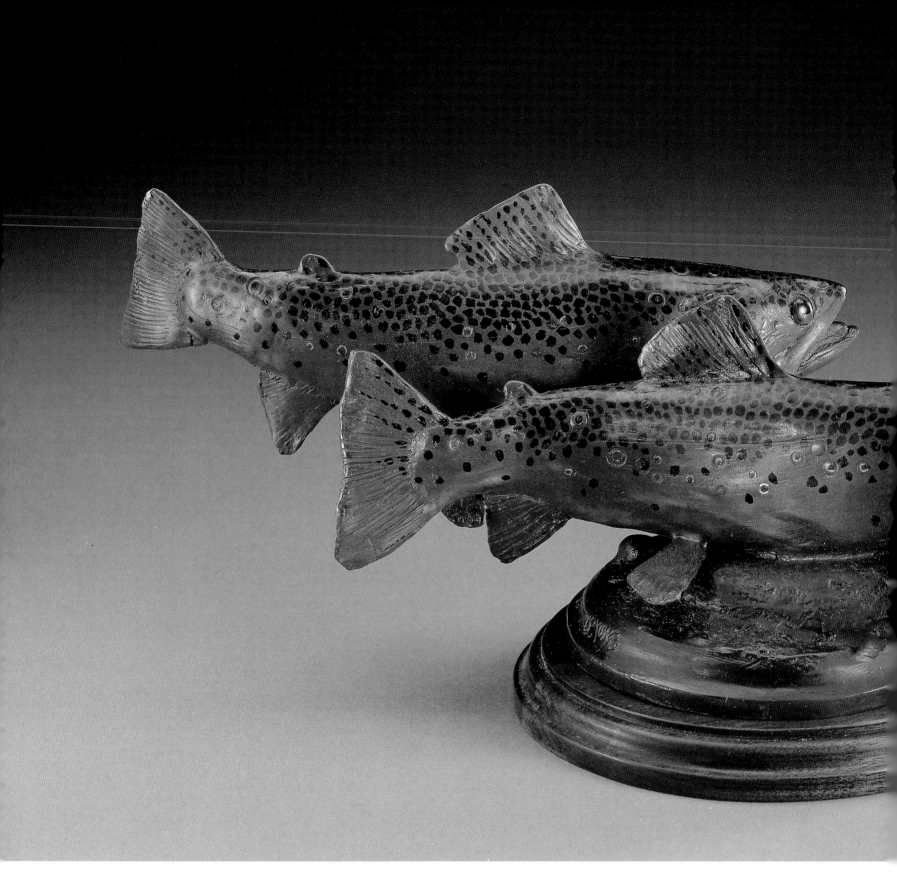

PLATE 43
Trail Creek Brownies, handpainted bronze, h 5.
The hearty brown is native to Europe and was introduced here 100 years ago.
They withstand warmer water than other trout species.

FIGURE 24
Lunch (Brown Trout), etching, 4¾ x 3.

FEELING 85

The moment we think of animals as human, we are lost.

I haven't a clue who said that, but I jotted it down years ago and the words continue to haunt me.

No aspect of animal sculpture seems as misunderstood—by both the viewer and creator—than the deliberate humanization of an animal by the sculptor. How often one hears, "Isn't that animal cute?" or "Look at the adorable expression on that critter's face." Yes, an animal can seem cute and adorable, and certainly, the goal of the artist is to evoke an emotional response. However, the artist who truly knows the animal will avoid sentimentalism and the purposeful exploitation of emotion by humanizing the creature's expression.

The artist's dilemma can be both confusing to himself and to the viewer because the pose or gesture that he chooses may be dignified, clumsy, intelligent, humorous, powerful and so on ... all adjectives that are associated with humans and all subjective!

When the sculptor makes unbiased design decisions about what he thinks is important about his subject, when he's in touch with his reason or motive for sculpting the creature, when he searches for and understands truths about the animal, only then can he breathe life into the facts.

PLATE 44
Expecting, bronze, h 11.

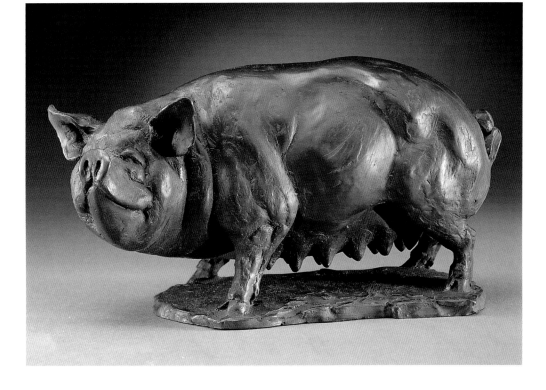

PLATE 45
Eat More Beef, bronze, h 37.
Throughout the centuries, the pig has been defamed, insulted and condemned as morally and physically unworthy, filthy and stupid. It's been my best selling subject.

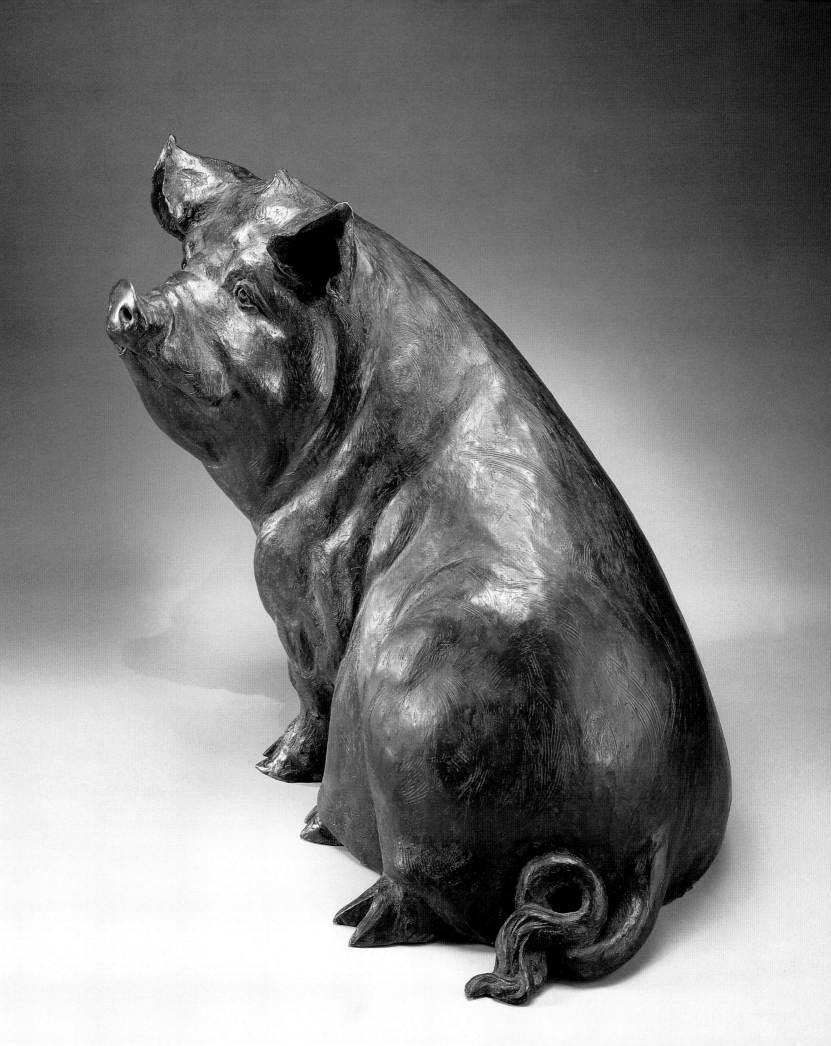

My dog is a twelve-pound, small-for-her-breed, West Highland Terrier named Toby. Before Toby, I had a Westie named Kate, who was as mellow as any dog I have ever been around. When Kate died at age fourteen, I grieved so much that friends talked me into getting another Westie. I wasn't ready for any dog, especially one that reminded me of Kate.

After a winter of no dog in the house I reconsidered. Paul and Peg O'Neil, our friends and fellow Westie owners, introduced us to their breeder in Scottsdale, Arizona. Trish drove there to pick up the seven-week-old female pup that we had decided to call Daisy. On the way home to Colorado Trish called and said, "I don't think this dog is a Daisy ... let's wait and name her after living with her for a while." Trish was right. This dog was no feminine, flowery Daisy, so we settled on the name Toby.

FIGURE 25
Eager, pencil, 10 x 9.

Toby is two years old at this writing, very small, and when she barks her feet leave the ground. She loves to swim in the duck pond and spa, therefore stays dirty, and she growls when animals appear on television. Her tiny stature is deceiving, and she's not to be confused with a lap dog. Pound for pound, she's tough, brave and sturdy. She is overconfident for her size, and if she were as big as a sheep dog, she would come across as something short of a grizzly. She is obstreperous and incorrigible. She is not a biter, but she growls incessantly. It's useless to try to make her stop. She has the small-dog syndrome.

I love dogs, and when I use my own dogs as models for sculpture I try to be objective about depicting them for what they are. I have an aversion to humanizing any animal, especially dogs, in my quest for reality.

Before Toby matured into a small but fine example of a West Highland Terrier, I decided to model her portrait. I wanted the sculpture to be of her and not a piece of work that depicts her breed.

My conviction that artists must not sentimentalize or humanize their subjects were put to a severe test. On one hand I feel that I've contradicted myself, but on the other, the sculpture looks like her, and therefore I consider it a successful work.

The fault lies with Toby, and it's just another one of her problems: She's too cute.

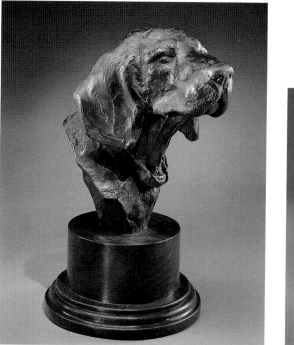

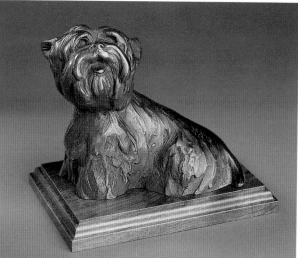

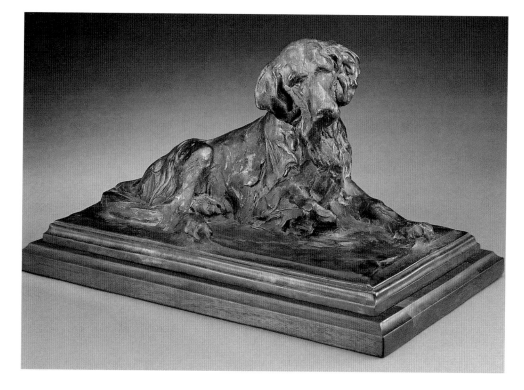

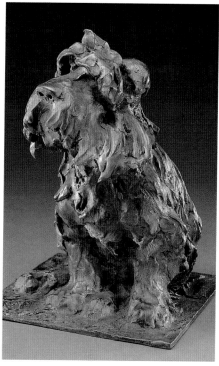

PLATE 46
Foxhound Study, bronze, h 8.

PLATE 47
Too Cute, bronze, h 6.

PLATE 48
Kate, bronze, h 12.

PLATE 49
Setter, bronze, h 7.

Dogs—what a banquet of diverse shapes for the sculptor!

When I first visited Lake of the Woods in the 1960s, the bald eagle was never seen in that vast area. Due to the ban of DDT in the 1970s, the great bird is now a common sight and has been for over ten years.

My most memorable encounter with an eagle occurred when my father and I were walleye fishing and I spotted a mature bald eagle in full glory at the top of an enormous white pine on a small island. We beached our boat on the granite under the pine, started a fire and put on the coffee water. My father, using the paddle as a cutting board, cleaned the fish while I sketched and photographed the bird. The eagle was obviously interested in the fish cleaning below and watched intently from its towering perch.

As we ate our lunch in the warm sunshine, the fish entrails proved too inviting for the bird to resist, and swooping down, he seized the fish remains with a fierceness and grace that was astonishing. Wings spread, flaring to brake himself, he reached out with powerful talons, then in an instant, snatched his catch and climbed higher and higher, until he disappeared over the next point. The magic of the event was so potent that neither of us spoke.

I've passed that same island and pine many times in the ensuing years, and that shining moment persists in my memory as a vivid image of the shore-lunch eagle.

FIGURE 26
Eagle talon.

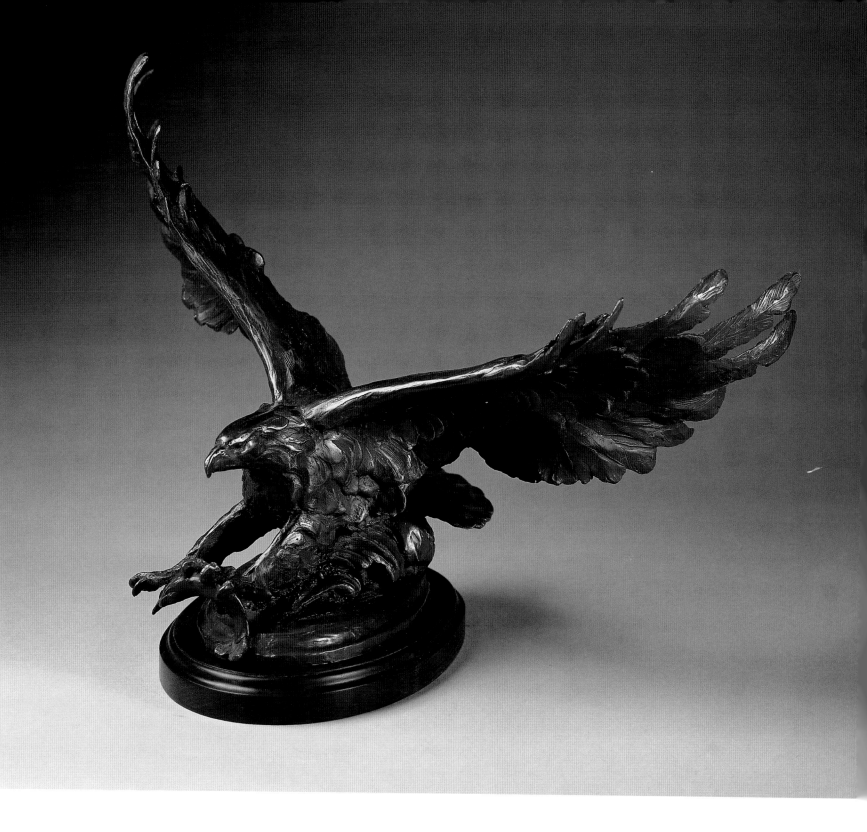

PLATE 50
Nice Catch, bronze, h 15.
In Canada, eagles have joined gulls as the cleanup crew for our shore lunches.

DUSKING DUCKS

Everyone knows of and some have met a man like Chuck Rhodes. Pipe-smoking, old timer, outdoors hunter-type, dog loving, gruff yet gentle, a confirmed bachelor and loner—a crusty old man of few words, until he liked you. I met the original. He lived in a small log cabin across from and within sight of Red Deer Lodge.

In the early 1960s, Red Deer was our base camp on Lake of the Woods. Chuck was a hunter ... he did not fish. He hunted bears and an occasional grouse—or chickens for the pot, as he called them.

During the twenty some-odd years that I knew him, he had three black labs, all of them named Tipper. When one passed on, he would name the next pup Tipper and so on. They were all grossly overweight from eating at the table and were terrible hunting dogs because they were too fat which probably affected their incentive.

Sometimes I would visit Chuck in his disorderly, cozy cabin and listen to his endless tales in front of a birch fire. He knew that his black bearskin rugs impressed me, and he knew that I wanted to own one. My time arrived one fall morning when he drove me to a garbage dump back in the bush. I took a sack lunch, my 30.06 and sat there until dusk seeing nothing but gulls. I had given up when I heard crashing branches and saw a dark form emerge from the woods. My

rug was before me. I half-stood, and with my heart pounding, I took aim.

But I couldn't shoot! I don't know if I couldn't or wouldn't ... I just know that I didn't.

I sat there and watched the bear rummage in the trash until I heard Chuck's old truck rattling up the road. I saw the lights through the trees, turned and the bear was gone. "Where's your bear?" Chuck asked. I started to lie and say that I hadn't seen one, but blurted out, "I couldn't shoot it!"

Chuck didn't speak, and we started down the road. After a few minutes he said, "You know, Sandy, that's happened to me and I know why you couldn't shoot." That ended the discussion.

I was on the dock the next morning when Chuck and Tipper came across the lake. He tossed a big bundle onto the dock, and with a thud a beautiful bearskin rug lay glistening in the morning sun. "There's a bear for you, Scotty." He called both my father and me that on occasion.

That afternoon Chuck, Tipper and I went to Hay Bay in his old wooden Dryden loaded down with decoys. As usual, Tipper sat in the bow with his big head pointed into the wind like a figurehead on an ancient boat. With Tipper dusking ducks in the fading light, we bagged our limit and talked about good sport and what it means to be a hunter.

FIGURE 27
Descending Ducks.

PLATE 51
Dusking Ducks, bronze, h 10.
In the fading light, the retriever sits motionless for the hunter, tracking
ducks as they set their wings for landing.

Art is a human activity, whose purpose

is the transmission of the highest

and best feelings to which human

beings have attained.

Leo Tolstoy

Like most artists, my work is the sum total of my life experiences. Travel always seems to have a profound impact on my work and view of the world.

In 1994, I traveled to Russia and much was put into focus regarding my knowledge and perception of western civilization, as well as world geography in general. I had been to China in 1981 and this journey filled an enormous blank—West meets East, so to speak.

Travel represents continuing education, and when I returned home I devoured everything Russian that I could get my hands on. I read Anton Chekhov's short stories and even waded through Tolstoy's *War and Peace*.

Under the spell of Russia, I felt a great need to somehow represent Russia through my sculpture. While a painter creates an illusion, the sculptor actually makes a form that exists in space like a rock or a tree or a person. Obviously, I could not model a landscape or a scene, so I settled upon a magnificent breed of dog—the Russian wolfhound or borzoi, as it's called.

A friend of mine in Denver raises and breeds borzois and whippets so I had a splendid model. I chose a recumbent pose as I wanted the horizontal movement to suggest rest and calm. I focused on the regal bearing of this dramatic animal and depicted the dog crossing its great front paws which is typical of large breeds.

This beauty is a constant reminder and my ultimate souvenir of mysterious Russia.

PLATE 52
Russian Beauty (Borzoi), bronze, h 10.
A borzoi is a gazehound. Nature designed this elegant,
long-legged breed to see its prey and chase it down.

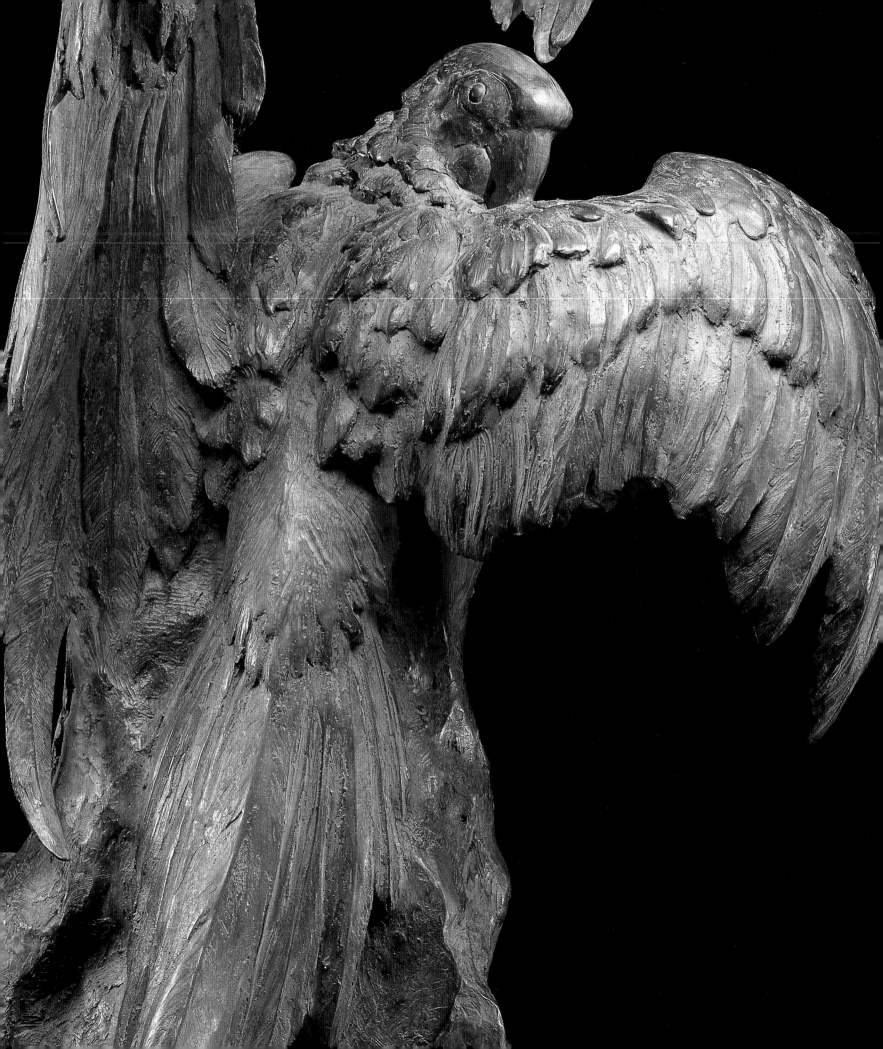

Chapter 3

UNDERSTANDING

Take any man and develop his mind

and soul and heart to the fullest by the

right work and the right study and

then let him find through this training

the utmost freedom of expression.

For a man ceases to imitate when

he has achieved the power to express

fully and freely his own ideas.

Robert Henri

There was a time, somewhere during your years as a student, when you declared, "I just don't get it, I don't understand." It was a hard admission, but not surprisingly, it probably heralded the road to understanding. Once it is clear that a fundamental building block is not in place, shoring up the walls is less desirable than going to the foundation of the problem and filling in the missing beam or block.

Understanding is an essential ingredient in Scott's recipe for making a sculpture. She hesitates to even build an armature without knowing that she understands everything about her subject, whether it is the aerodynamics of a macaw's wing, the diet of a fox or the number of rib bones in a fish.

But understanding doesn't stop with the immediacy of the encounter with the animal. Rather, understanding demands that the present be built on a foundation of the past. Not only does she gather zoological or biological information, Scott wants to know how other artists—past and present—have dealt with the subject and solved its sculptural problems.

"Go figure it out!" she exhorts her students in workshops on sculpting birds. And it's not a command she takes lightly. One look at her library is proof enough that Scott is a bookworm who not only lives experiences in the wild but loves to read the stories and view the art of others as well.

This rich blending of analytical and experiential is epitomized in artworks such as *Sky Passage* [Plate 59] where fantasy and reality meet. It is not surprising that Scott, whose first love is birds, would add wings to a horse. But here we have not a specific animal, rather we see the "idea" of a horse—the perfect specimen—joined to the mythological belief that natural forces have an innate capacity for converting evil into good.

It's fun to let the mind wander over such thoughts, whether or not they are the musings that tumble through Scott's head while she lays awake staring at the stars on a clear night at Lake of the Woods.

Understanding is a powerful brew of sources ancient and contemporary, accurate and exaggerated, primary and secondary. The artist imbibes the brew in order to declare her communion with her subject as well as her independence from it.

Thorough understanding allows Scott the freedom to express herself without fearing the recrimination of the biologist or art critic. It is her ticket for using animals as the source from which she makes art. —SHM

I hear, and I forget;

I see, and I remember;

I do, and I understand

This Old Chinese proverb was my credo when I was younger, and at one time it was printed on a decorative poster in my studio. Soon after I involved myself in the plastic arts, I learned to disagree with and reject the last line of these ancient words. I've found that I cannot *do* until I *understand*.

I'm convinced that meaningful sculpture is 90 percent knowledge and understanding of the subject, and 10 percent, if that much, is the technical ability to model clay.

FIGURE 28
Macaw, pencil, 7¹/₂ x 8.

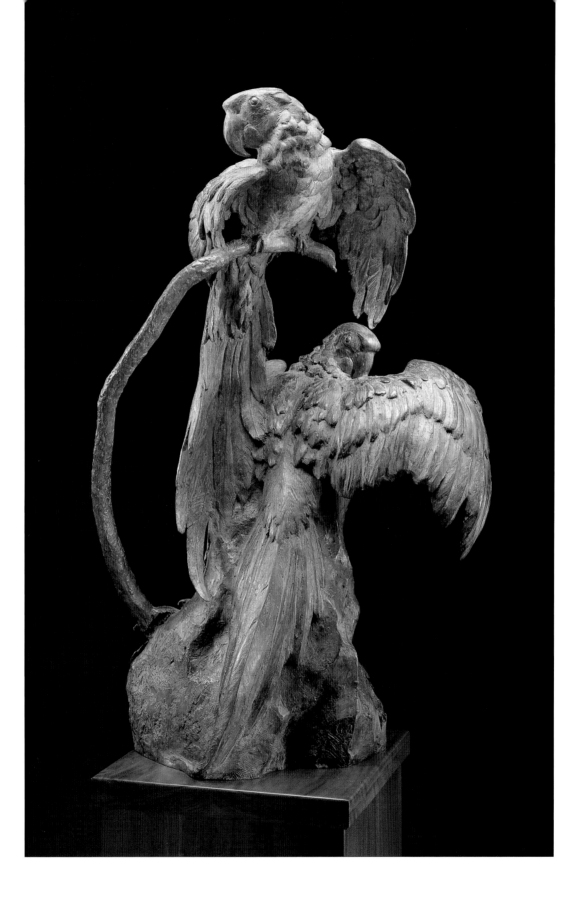

Takers of Anasazi Sun, bronze, h 52.
The macaw was sacred to the Anasazi Indians who believed that
the bird took the sun south to its winter home and returned it in the spring.

I love books. I collect books and I have a real library filled floor to ceiling with books arranged in a peculiar system that only I know but cannot explain.

I love the feel, the weight, the smell—everything—about books. I love ripping cellophane off of new books and the sound of a book being opened for the first time. I love the pictures and maps in books. I love the bindings, marbling, bookplates and pressed flowers that I find in old books.

My library is a baronial-sized room that is my sanctuary, and when I enter it, adventure is imminent. I love the reassurance of having a book nearby, and I'm uncomfortable in a room where there are no books.

I love to read.

PLATE 55
Owl Bookend, bronze, h 12.

PLATE 56
A still life from Scott's library.

When the realistic portrayal of animals became fashionable in the 18th century, it was a grand time for both the artists and patrons who loved animals. The romanticism of the 18th and 19th century produced *les animaliers*, as the animal sculptors were called, and the sculptural presentation of animals became a respectable form of art.

The *animaliers* would often depict exotic, tormented animals in violent poses as adornments for parlors and mantels. Antoine-Louis Barye (1796-1875) and Emmanuel Frémiet (1824-1910) were two of the most celebrated of the French *animaliers*. These two artists were known for humanizing their subjects by attributing to the beasts the emotions of sympathy and compassion.

Revival of the lost-wax process in casting in the early 19th century made the casting of a number of reproductions, called "editions," possible and kept the unit cost down. The small scale multiples were inexpensive, plentiful and popular.

The *animalier* tradition continued into the 20th century and ended with the work of Anna Hyatt Huntington who died in 1973. The genre evolved in the 20th century into the masterful sculpture of Gaston Lachaise and Paul Manship, whose avant-garde and stylized designs are delightful to behold.

Animals continue to hold a fascination for sculptors and collectors today. I never cease learning from the distinctive styles of the animal sculptors of the past and am fascinated by their captivating interpretations.

With today's technology—photography, video and film—an enormous amount of material is available that was not available to sculptors of the past. Photography and video have revealed the secret of motion about which the *animaliers* could only speculate. Furthermore, artists working today have access in books to almost all the animal artworks that have gone before them, if they only take the time to research and seek out the work.

Awareness of the latter is a must. But, the artist must also experience the creatures in their habitats—for the ability to create animal sculpture is impossible unless the animal is observed and understood. The creature is the artist's source—the design source—and the artist must go to the source.

PLATE 57
Ram of Mendes, bronze, h 13.
Like the *animaliers*, I go back to ancient sources such as the Egyptians who represented animals as symbols rather than imitations.

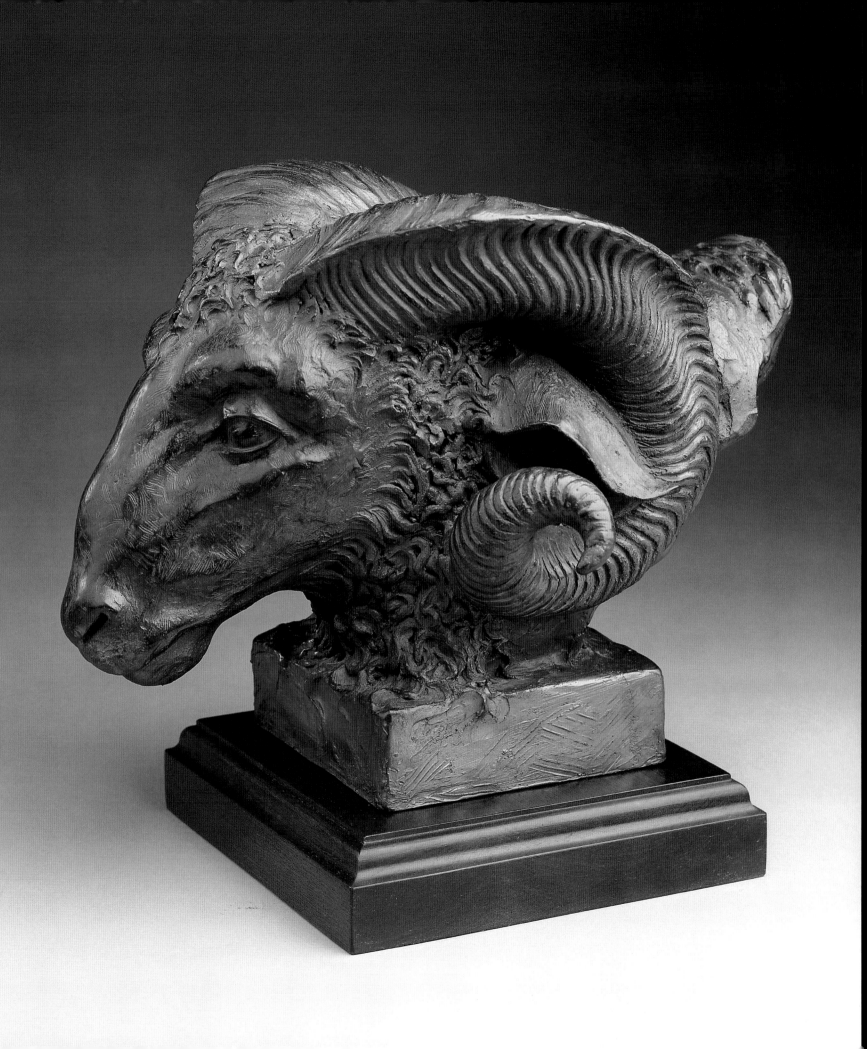

As magnificent as a horse is, the animal itself is not art. The sculptor must select, arrange and simplify—transform the creature into a visual expression. The animal is the design source, and the artist turns that source into art.

It is inexcusable for an artist working today not to know and study the finest examples of sculpture handed down through the ages—to be aware of what was done before. Basic and time-honored artistic principles will always stand up as the taste of the times and look of the day change.

I am influenced and fascinated by archaic equestrian Greek sculpture and by formal composition. This traditional motif has been used by many sculptors depicting the horse and dates back to the Greeks and Romans and succeeding periods including the Renaissance and the grand age of the Beaux-Arts style of the late 1800s.

I am preoccupied with modeling horses and consciously stylize my designs. My obsession with modeling horses continues to lay a thorough foundation for my art, just as playing scales does for a musician.

PLATE 58
Equus Caballus Tondo, bronze, h 16.

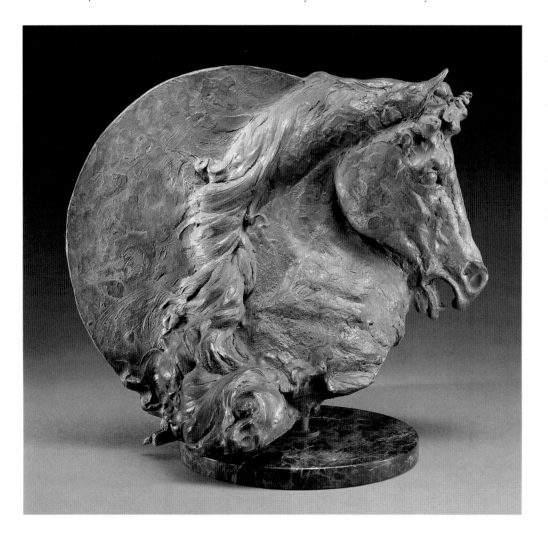

PLATE 59
Sky Passage, bronze, h 16.
Modeling wings on a horse was more fun than a sculptor should be allowed to have.

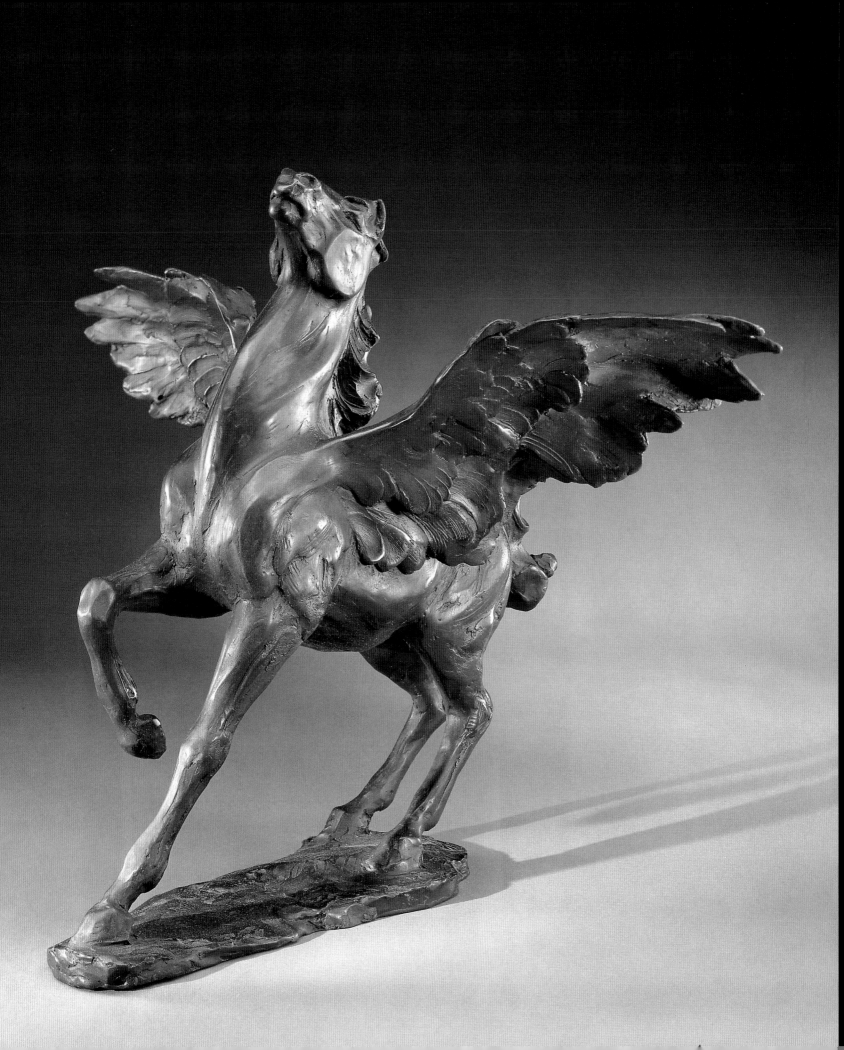

Let the gods curse

the first man who set up

a sundial in this city.

When I was young

there was no other clock

but my belly. Now I have

to eat only when it

pleases the sun.

Plautus

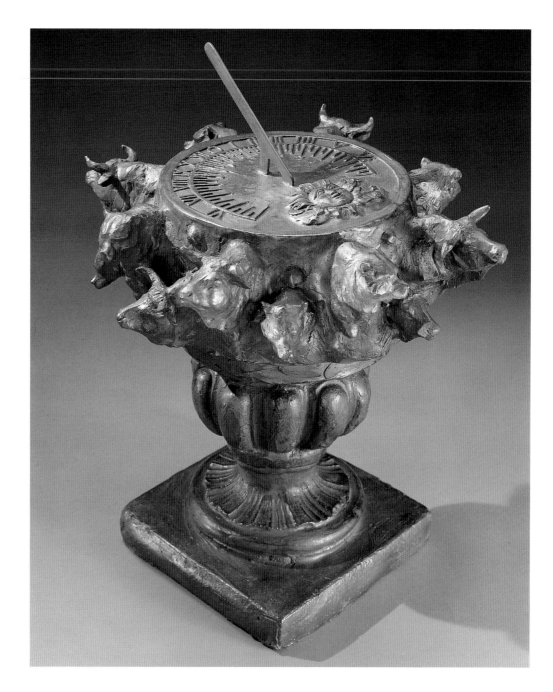

PLATE 60
Bull and Bear Sundial, bronze, h 20.
The sundial is an ancient instrument that eloquently displays the
relationship between sun and earth by a gnomon or arrow that casts a shadow.

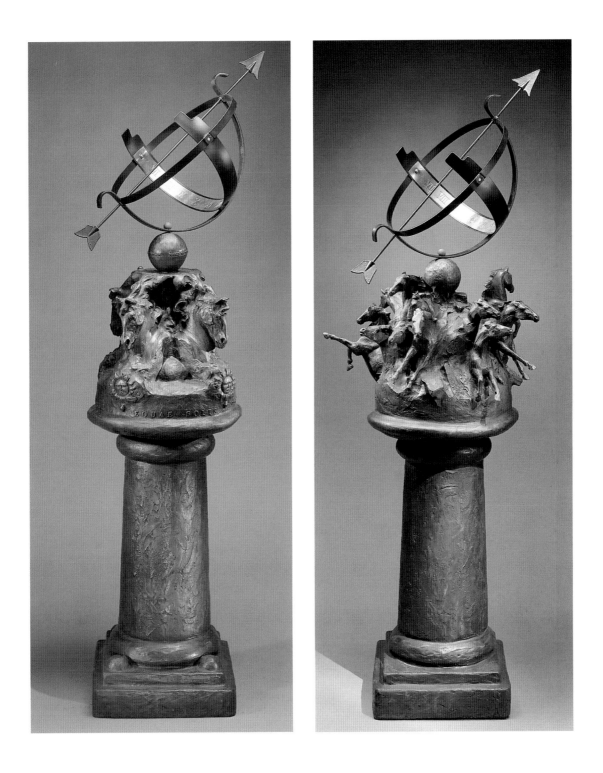

PLATE 61
Mares of the Sun, bronze, h 62.

PLATE 62
Stallions of the Sun, bronze, h 62.
A sculptor should present a strong idea. The Egyptians understood this and the Greeks perfected it.
I continue to learn from their sublimely simple and natural sculptures.

From a bird sculptor's point of view the skeleton is the most important part of the anatomy. The sculptor must know how bones are arranged and how they articulate before attempting to define muscles or feathers. The sculptor must make the viewer sense the animal's movement of bone and muscle.

Flying demands a rigid airframe, therefore, the bird's rib cage and backbone are fused together. Only the neck, tail and wings are flexible. All mammals, even giraffes, have seven neck vertebrae. Birds need a flexible neck to preen and see danger and have from eleven to twenty-five vertebrae.

The bird's bones are hollow, light and remarkably strong. For instance, a pelican weighs twenty pounds and the skeleton weighs only twenty-three ounces. The breastbone or keel serves as an anchor for the enormous pectoral or flight muscles. Birds have very light skulls, no jaw bone and no teeth; chewing is done by the gizzard. A bird's skull weighs less than one percent of its total weight. Nature has sluffed off weight to enable flight.

The skeleton of the bird's wing is more easily understood when compared to the

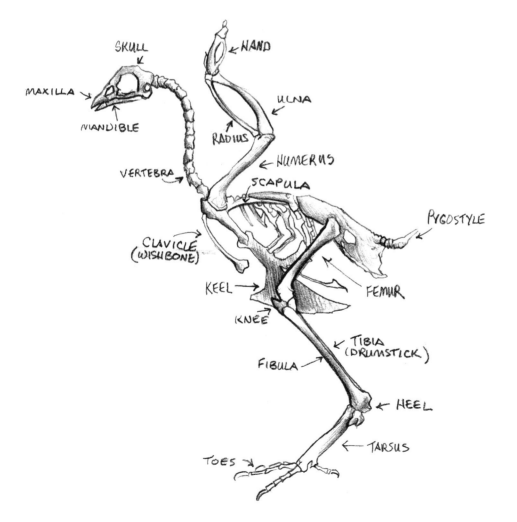

FIGURE 29
Bones of a chicken.

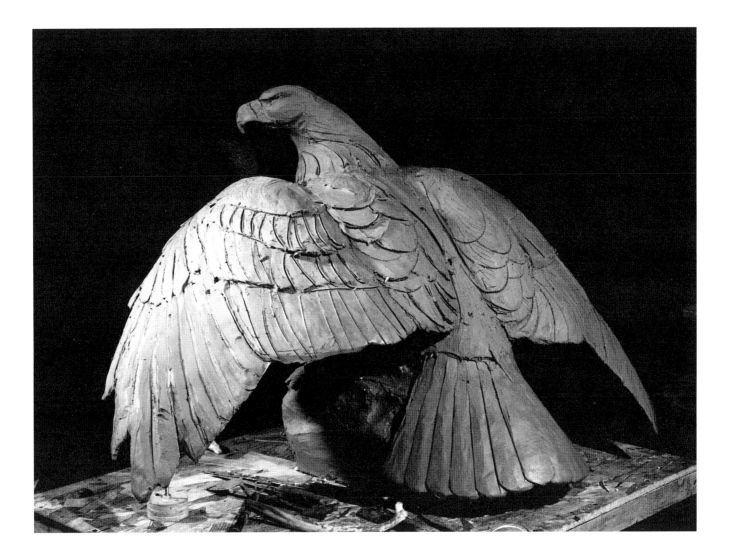

FIGURE 30
Golden on Chimney Rock, clay, h 16.
Feathers emanate from logical tracks ... nothing random here!

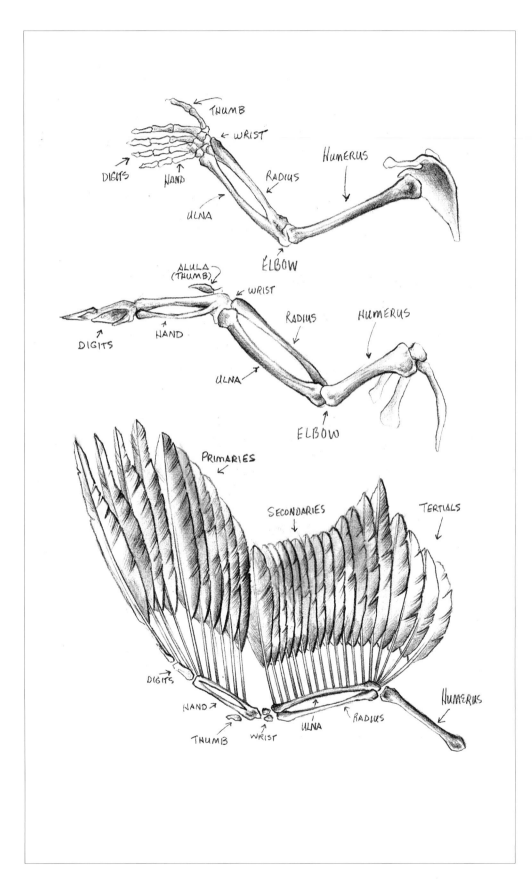

Figure labels (top arm): THUMB, WRIST, DIGITS, HAND, HUMERUS, RADIUS, ULNA, ELBOW

Figure labels (middle): ALULA (THUMB), WRIST, DIGITS, HAND, RADIUS, HUMERUS, ULNA, ELBOW

Figure labels (wing): PRIMARIES, SECONDARIES, TERTIALS, DIGITS, HAND, THUMB, WRIST, ULNA, RADIUS, HUMERUS

skeleton of a human arm. Divide the wing into three segments, which correspond to the human arm:

Humerus—Innermost bone, between body and elbow.

Ulna and Radius—Middle or forearm bones, between elbow and wrist. The secondary feathers are attached to the ulna.

Hand—Outermost bone, some metacarpals are missing, some are fused together. One of the digits is the thumb or alula, a small group of three feathers are attached to this bone. The ten primary flight feathers are attached to the hand.

Excluding the figure-eight wing movement of hummingbirds, all bird wings articulate the same. Using an aviation analogy: The hummingbird is a helicopter while all others are fixed-winged aircraft.

The bird sculptor must know how the skeleton articulates and recognize that the joints of the "hand" can only bend inward toward the body, not up and down, and that the pectoral girdle is part of the wing and forms a tripod to support the humerus. The bird sculptor must know the skeleton and the limitations of skeletal movement.

FIGURE 31
The wing compared to the
human hand and arm.

PLATE 63
Above It All, bronze, h 57.
An artist's function is not to improve
upon the sublime beauties of nature but
to analyze, arrange and reconstruct.

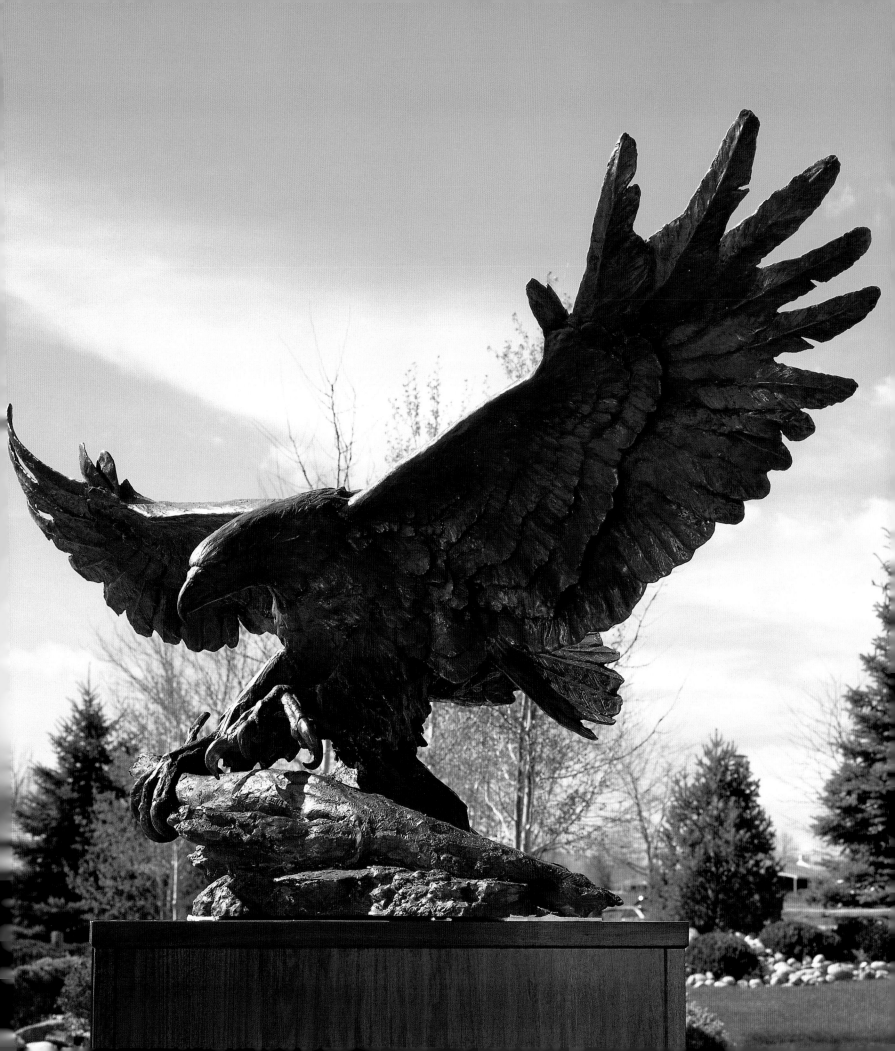

There is nothing random in nature; everything is structured. Though an animal sculptor does not need to be a scientist he must know and understand the important bones, joints and muscles, not only where they attach but how they articulate. In addition to this knowledge the bird sculptor must know the major feather groups, individual feather construction and the mechanics of flight. Birds in flight don't pose, therefore this understanding is a must.

The feather sets are basic and every bird has the same groupings, from the tiny hummingbird to the gigantic albatross. Much can be learned from buying a whole frying chicken from the supermarket and studying the feather tracts on the skin. Note the little holes on the wing where the feathers emerge in a pattern, they are alike on most birds. Length, shape, size and number of feathers vary according to the bird's needs, but once you know the sets you can adapt them to any species.

FIGURE 32
A roasting hen from the local grocery.

PLATE 64
Morning, bronze, h 24.
I tell participants in my workshops that once bird anatomy is understood, they will never again look at a bird in the same way.

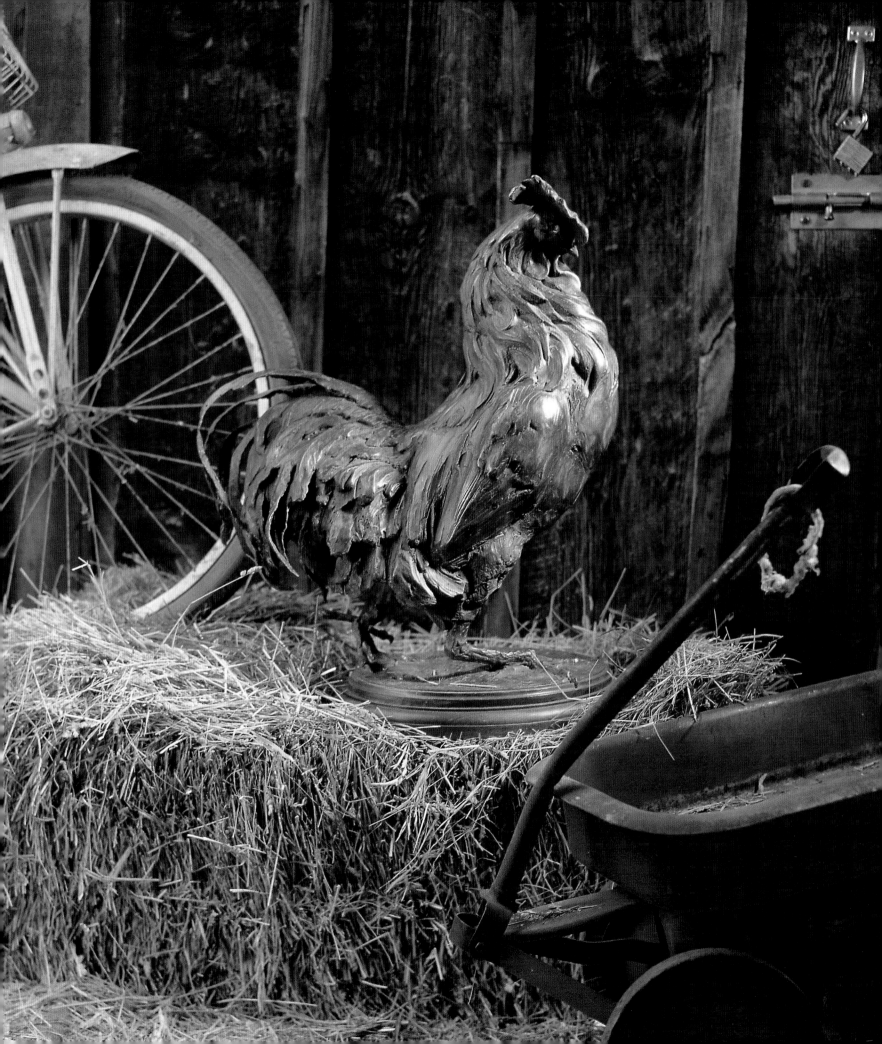

Wing flight-feathers are divided into three groups: Primaries, secondaries and tertials. These groups are attached to what corresponds to the arm and hand of a human.

Most birds have ten primaries and these feathers are attached to the "hand" part of the wing. The primaries are individually controlled by muscles and are the propellers that provide thrust and move the bird through the air.

The secondaries are attached to the region between and correspond to the human elbow and wrist. They are not individually controlled and act more like an airplane wing providing lift. Individual species have different numbers of secondaries: perching birds have nine or ten, eagles have sixteen and albatross have thirty-two.

The tertials are a continuation, moving inward from the secondaries, and like them the number varies among species. They attach to the elbow region and can be elongated and colorful among some waterfowl species.

In addition to the flight feathers, every bird has the following:

Scapulars attach to the shoulder area, overlap the tertials and help streamline the wing-body intersection. Sculptors should take note of the scapular grouping as they present a strong sculptural shape.

Alula, or the three feathers attached to the "thumb," assists the bird in landing by reducing the stalling speed of the wing. Look at the supermarket chicken and note the little bone at the wrist where this group is attached. Look for the beautiful, flared group at the bend of the wrist when you see a bird takeoff and land. This is yet another wonderful shape to design with.

The axillar group of fan-shaped feathers is on the underside of the wing in the "armpit" area and helps close the inboard gap during flight.

Wing coverts on upper and lower surfaces are arranged in rows and overlap like shingles on a roof. Primary coverts overlap the ten primaries—thus ten primary coverts, secondary coverts overlap secondaries, greater coverts are overlapped by middle coverts and middle coverts by lesser coverts. The coverts impart a definite shape and thickness to the wing's leading edge.

Most birds have twelve tail feathers attached to the pope's nose (think of the supermarket chicken) and all birds have an even number of tail feathers.

There it is: Bird Anatomy 101 simplified. All birds have a basic and predictable structure. Once you research each bird's behavior to perceive gesture and pose, know the basics of the skeleton and the sets of feathers inherent to all birds, you simply assemble shapes.

Begin by thinking of the sets of feathers as individual shapes. For it is shapes and the arrangement of shapes that make sculpture. Sculpting birds is assembling shapes.

As you approach your sculpture stand and embark upon modeling a bird in flight, you will find that knowing this information is far more important than the technical ability to sculpt.

FIGURE 33
Gull Wing.

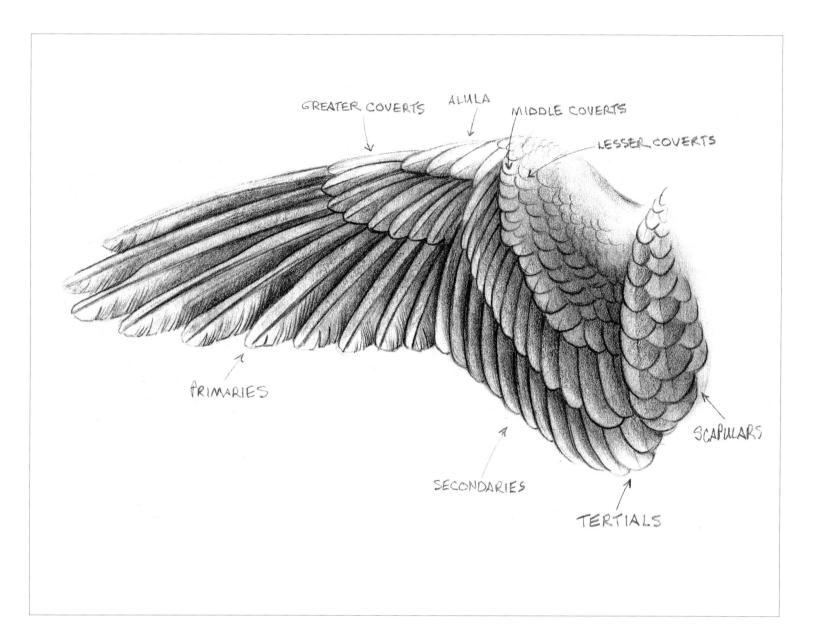

FIGURE 34
Wing Feather Groups.

FIGURE 35
Four basic wing shapes.

All birds—from the tiny hummingbird to the giant albatross—have the same basic feather groupings. Once these are known, the sculptor simply researches the individual bird to be modeled to establish relative proportions.

There are four basic wing shapes and all birds fall into a semblance of one of the four configurations. The size and shape of wings give clues to how the bird lives:

1. Long and wide wings are used by soaring birds such as hawks, eagles and ravens. A wing is considered long when it exceeds the length of the bird's body.

2. Narrow and pointed wings are used by fast flying birds such as swallows, swifts and many migratory birds such as ducks and geese.

3. Long and narrow wings are used by gliding birds such as albatrosses, gulls, fulmars and shearwaters.

4. Wide and rounded wings are used for short, fast and quick-escape flight by birds such as grouse, pheasants, pigeons and owls.

Wings, body, bill, feet and a myriad of other shapes are assembled after the sculptor understands how nature, the master designer, intended the bird to fly, feed and function.

These shapes also reflect the way the creature lives on earth; how they feed and how they fit into their surroundings. When the bird sculptor considers modeling a particular species the first concern is choosing the pose and gesture. What does a bird do?

Typical bird activities include preening, displaying, courting, nesting, roosting, hunting, feeding, drinking, food gathering, caring for young, nest building, being sociable, flying, taking off and landing. All of these activities represent shape.

Birds were the first warm-blooded animals to fly, and they have evolved over the millennia into a wide variety of species that take advantage of all habitats on earth. They eat all types of food. Some specialize in plant foods: seeds, nuts and fruit; while some eat honey and nectar. Others eat only insects and yet others are hunters, feeding on other animals. Every region of the world has bird life. Some birds are flightless but they all share the common feature of laying eggs.

Some birds have all-purpose beaks and feed on many foods while others specialize in just one type of food and the beak or bill is fully adapted and shaped to do this vital task. The long, strong beak of a woodpecker can

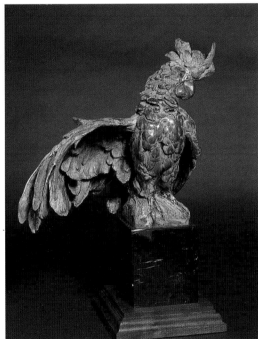

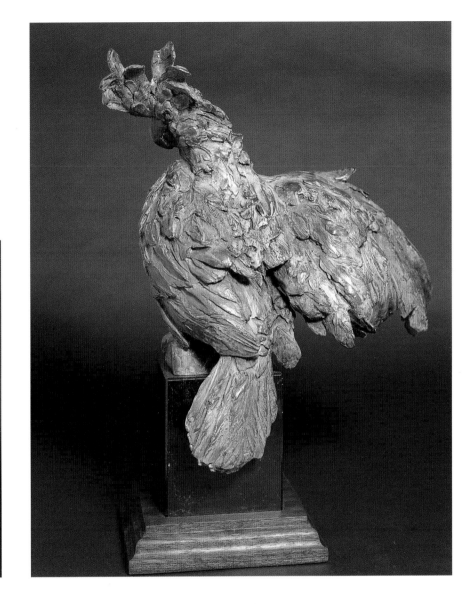

PLATES 65 AND 66
Front and Back of *Cockatoo*, bronze, h 17.
The shape of a cockatoo's wing is similar
to that of a chicken or pheasant.

drill a hole in bark and probe for insects while the oddly shaped beak of the crossbill can extract seed from the cones of firs and pines.

Within the same order there is often a great deal of variety in shapes of bills and feet. For instance the long-legged waders include about 120 species; among them, egrets, herons, ibises, avocets, curlews and flamingos and while some of them have long necks for reaching down below the water's surface and stiltlike legs for moving in shallow water, their bills are of many shapes. The shape may be upturned like an avocet, downturned like a curlew, both shaped to probe for different food; or spearlike, spoonlike, daggerlike and so on. The flamingo has

a bent shaped bill with fringes to the outside—a perfect design for straining tiny edible organisms from the soupy mud.

Many birds that wade need to spread their weight to keep from sinking into the mud. Some have long toes or webbing between the toes. Water birds such as ducks, geese, loons and gulls are strong swimmers and have toes joined by webbing.

The shapes of the beak and feet of the birds of prey—eagles, hawks, vultures and owls—also reflect the way they live. Sharp, strong talons are used for clutching prey while hook-shaped beaks tear flesh.

Fowl-like birds, such as pheasants, quail, grouse, turkeys and chickens, have strong legs and feet like birds of prey, but there the similarity ends. Fowl-like birds do not kill and tear their food. They use the shape of their feet to scratch and must walk to feed.

The shape of a bird's foot reflects its way of life, and bill shapes reveal different ways that birds gather food. Each individual bird must be researched and its unique characteristics and shapes understood.

Bird sculptors must understand how their subjects function on this planet. Only then can shapes be assembled to define logic.

FIGURE 36
Bird bones in relationship to body and wing.

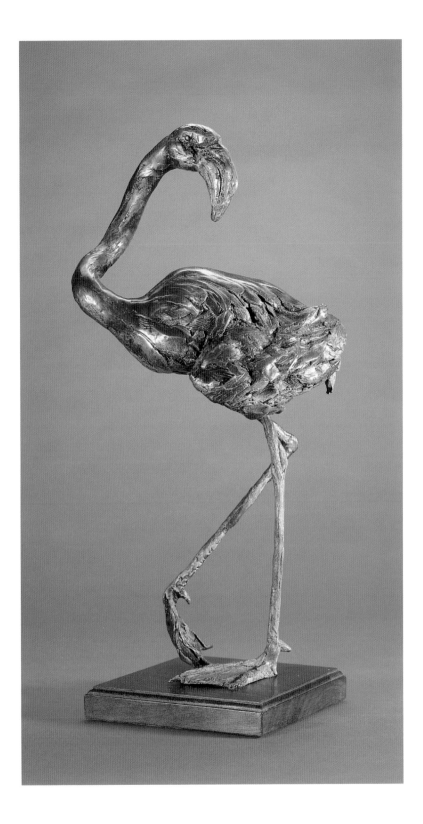

PLATE 67
Flamingo, bronze, h 19.
A bird is shaped by the world it inhabits.

Flight—or more specifically, the feather—is nature's masterpiece. The design of the feather is the single most important factor enabling a bird to fly. The feather is a supreme example of natural engineering.

The feather developed from the reptilian scale as birds evolved from reptiles, and to this day birds still have scales on their legs and feet. In addition to making flight possible, feathers are insulators and protectors, as well as embellishments that attract birds to one another.

How many times have you sat in an airplane and marveled at the mystery of a ponderous machine taking you aloft? What could possibly make this enormous device fly? The answer is a complex series of events, but if one word had to be used to describe why an airplane flies, that word would be shape. The shape of the airplane's wing, like the shape of the bird's wing when moved through the air, causes lift.

The forward or leading edge of a bird's wing, as well as an airplane wing, is blunt and thick, which causes the wing to part the air more effectively. The back or trailing edge of the wing thins dramatically to speed the wing through the air.

The shape of the upper surface of the wing is more rounded and air moving over the top has more surface and distance to cover which creates low pressure.

The shape of the underside of the wing is flat or slightly concave and air has less distance to travel, therefore moving slower and causing high pressure.

Lift is produced as the high pressure on the under surface of the wing attempts to occupy the low pressure on the upper surface.

If the wing is held at too high an angle of attack, the air cannot smoothly flow over the wing's surface. An interruption or "burble" forms at the trailing edge of the wing, which causes loss of lift and the wing stalls.

Airplanes and birds take off into or facing the wind because it expedites the air that must move over the wing surface to create lift. They land into the wind as well because at slow landing speed, air must continue to move over the wing's surface.

An airplane has an engine and propeller to provide thrust and movement. The bird has enormous pectoral muscles attached to its keel, which power twenty propellers, or

FIGURE 37
Canada goose primary feather.

ten primary flight feathers per wing, which twist and propel it through the air.

Aeronautical engineers have a name for curvature of a wing. That cross-section shape is called *camber*, and both an airplane and a bird can change the angle in which this shape moves through the air. This adjustment is called the wing's *angle of attack*. When an airplane comes in for a landing, notice how the nose comes up allowing the shape and resistance of the

fuselage to slow the airplane. When the landing gear is lowered, creating more drag, it slows the airplane as it descends. The pilot continues pulling the nose up, or increasing the angle of the wing's attack, until the wing stalls or stops flying, placing the machine on terra firma.

Why is all of this important to a bird sculptor? In two words: pose and gesture. Principles of flight and the shapes involved are the same for airplanes as they are for birds. A bird changes the angle of attack of its wings, uses the drag and resistance of its body and feet, or landing gear, to slow itself down thus permitting the flaring and stalling of wings which results in a landing.

The shape of an individual flight feather has camber and the characteristics of the wing. It is the wing in miniature. The feather is the precursor to flight, and it is the superb shape and design of the bird's wing that causes flight.

An exact description of airplane and bird flight is complex but general information about feathers, wing shapes and aerodynamics will open the door to seeing, feeling, understanding and expressing nature's masterpiece.

FIGURE 38
The aerodynamics of a wing.

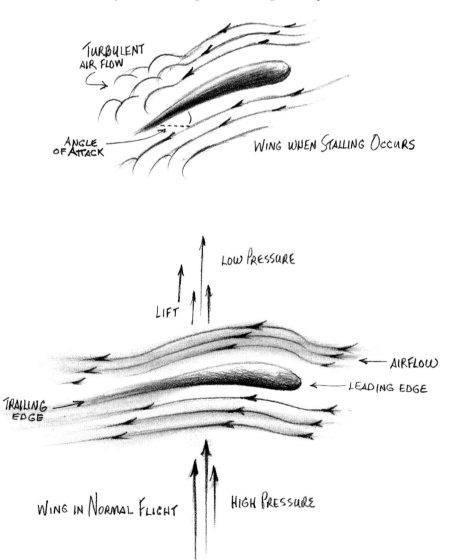

TURBULENT AIR FLOW

ANGLE OF ATTACK

WING WHEN STALLING OCCURS

LOW PRESSURE

LIFT

AIRFLOW

LEADING EDGE

TRAILING EDGE

WING IN NORMAL FLIGHT

HIGH PRESSURE

PLATE 68
Spoonie Coming In, bronze, h 22
I took lavish artistic license modeling this awkward duck careening in for a landing.

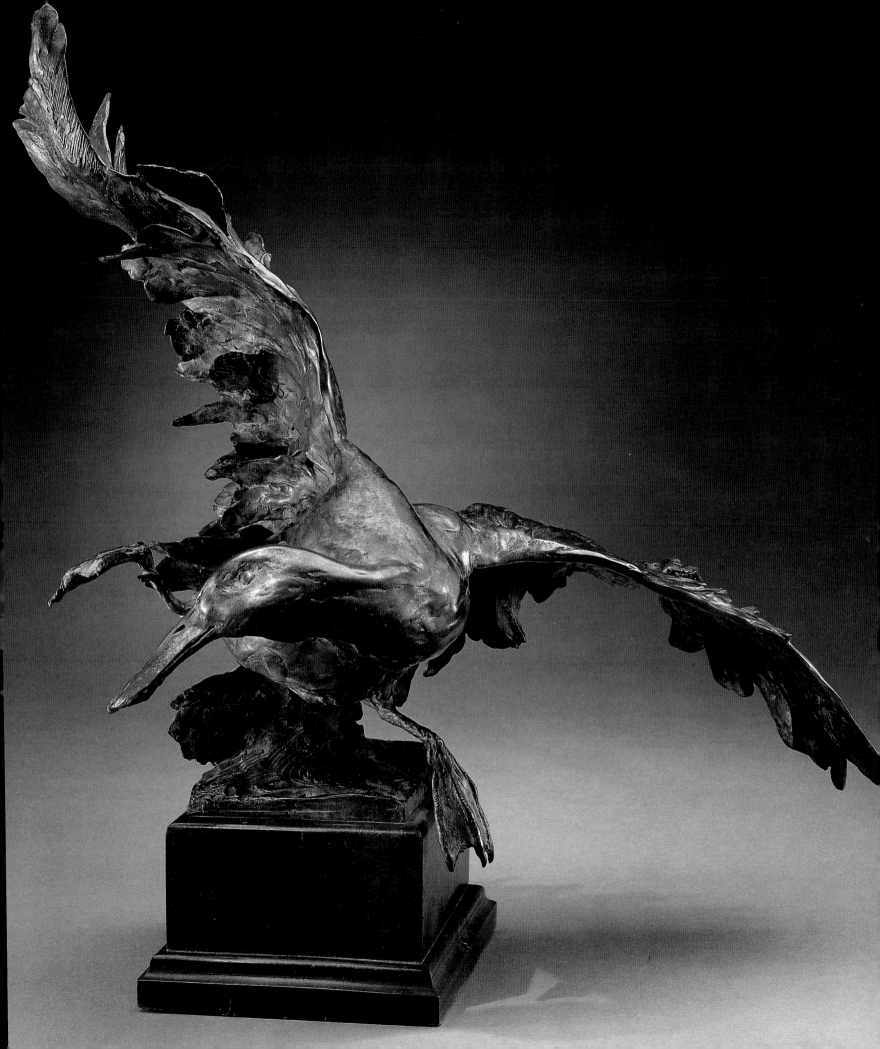

Birds descended from reptiles and the earliest known bird was the *Archaeopteryx*. Pronounced *arky-OP-tuh-ricks*, the word means "ancient wing" in Greek. It flourished 150 million years ago, and a fossil discovered in Bavaria shows that the creature had feathers, claws and other features that proved that it is the link between reptiles and birds. A bird's scaly legs are the last reminders of its reptilian ancestor.

Feathers—not flight—set birds apart from other animals. Feathers originated as reptilian scales and are made from the same horny substance of which fingernails are made. Since Arky, more than 1.5 million species of birds have existed on this planet. Of these, 8,580 species remain. The rest vanished as the earth has changed and the remaining species have evolved.

Ornithologists organized and classified birds into twenty-seven major groups called *orders*. Each order contains a number of entities called *species*. Species refer to all the birds within an order that are like one another; robins, for instance, belong in one species.

As a general rule, the species that evolved first are ranked as the primitive orders. Primitive orders include flightless birds such as penguins and ostriches and diving birds such as loons and grebes. These are the birds that have remained more similar to Arky ... keeping in mind that Arky was not a true flyer but a glider.

PLATE 69
Fountain of the Rain Forest,
bronze, h 114.
My goal was to create stimulating textures and give the impression that this sculpture was extracted from the floor of the Mediterranean after centuries of laying dormant.

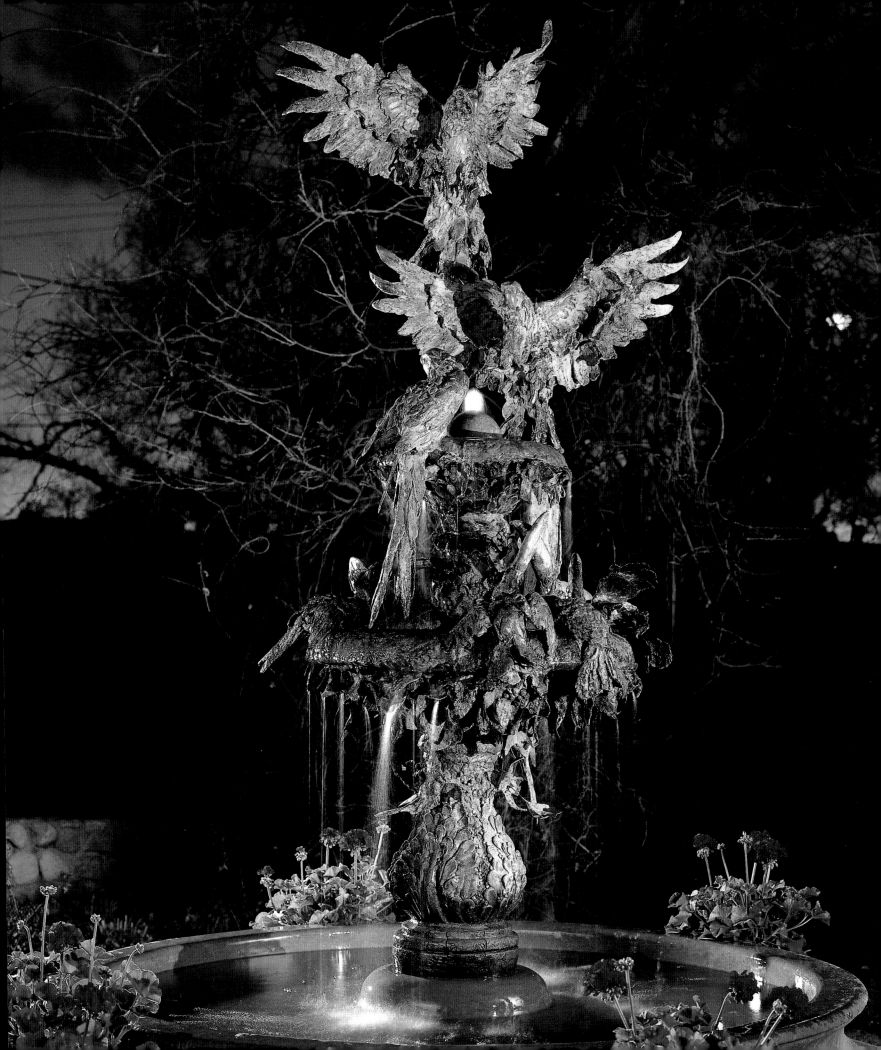

THE 27 ORDERS OF BIRDS (LIVING SPECIES)

Source: *Birds* (Time-Life Books)

Order

1	*Sphenisciformes:* penguins	15
2	*Struthioniformes:* ostriches	1
3	*Casuariiformes:* cassowaries, emus	4
4	*Apterygiformes:* kiwis	3
5	*Rheiformes:* rheas	2
6	*Tinamiformes:* tinamous	42
7	*Gaviiformes:* loons	4
8	*Podicipediformes:* grebes	17
9	*Procellariiformes:* albatrosses, etc.	81
10	*Pelecaniformes:* pelicans, cormorants, etc.	50
11	*Ciconiiformes:* herons, flamingos, etc.	117
12	*Anseriformes:* ducks, swans, geese, etc.	149
13	*Falconiformes:* eagles, hawks, etc.	274
14	*Galliformes:* grouse, turkeys, etc.	250
15	*Gruiformes:* cranes, rails, coots, etc.	185
16	*Charadriiformes:* sandpipers, gulls, etc.	293
17	*Columbiformes:* pigeons, doves	301
18	*Psittaciformes:* macaws, parrots, etc.	317
19	*Cuculiformes:* touracos, cuckoos	143
20	*Strigiformes:* owls	132
21	*Caprimulgiformes:* nightjars, frogmouths	92
22	*Apodiformes:* hummingbirds, swifts	388
23	*Coliiformes:* mousebird	6
24	*Trogoniformes:* trogons	35
25	*Coraciiformes:* rollers, kingfishers, etc.	192
26	*Piciformes:* toucans, woodpeckers, etc.	377
27	*Passeriformes:* sparrows, larks, jays, etc.	5,110

Total 8,580

Each bird falls into one of the 27 orders and is arranged in a sequence that indicates its closest relative. Outward appearance does not always place birds in the same order as ornithologists look beyond appearance and rely on factors such as anatomy, skeletal structure, etc.

The highest ranked order, the *passeriformes* or perching birds are the most adaptable and are considered the highest evolved. Some of these birds, such as the finches, are so highly evolved that nature has dropped a primary and they have only nine instead of ten like other birds. Over half of all birds on earth—5,110 species—belong to this order.

Why is all of this important to the bird sculptor? The importance can be summed up in one word ... *research*. Research about each bird as a sculptural subject is mandatory. Most artists are not ornithologists, but knowing how scientists have organized and classified birds is an enormous help to the bird sculptor while researching the individual species.

Sculptors usually use the larger birds as sculpture subjects but knowing how to obtain data about all birds, even though that information might be rather bland and scientific, arms the artist with knowledge—it is the starting place. The sculptor's knowledge of their subject is more important than the technical ability to model clay.

PLATES 70, 71 AND 72
Details from *Fountain of the Rainforest.*

What are human beings without animals?

If all the animals ceased to exist,

human beings would die of great

loneliness of the spirit.

Chief Seattle

FIGURE 39
Geese Swimming.

A field guide such as Peterson's is an essential tool for starting a sculpture. Although it gives rather bland information, it's an essential, well-tested, practical system for learning species descriptions, shapes and sizes. It is my starting place.

From there, I accumulate everything that can serve as reference: field sketches, notes, photos, videos, books and my most important source—my clip file. Over 35 years ago, in art school, I started collecting magazine tear sheets, photos and general information about individual species. I pin up as much reference about that animal—clips, photos

and sketches and surround my sculpture with open books.

The role of reference is to inspire thoughts and help solve anatomical problems and proportions. I become as familiar as I can with the creature through live models, taxidermy mounts, videos, zoo specimens, study skins, skulls and bones, whatever I can find that makes me live, think, dream, see, feel, understand and express the animal I'm working on.

Each individual animal has unique shapes and characteristics. The sculptor who recognizes this individuality can achieve, for instance, an unmistakable "eagle-ness," a "raven-ness" or a "macaw-ness" in their sculpture. If it's a goose, it must shout GOOSE! and not duck or swan.

The most important characteristic of an animal must be grabbed and perceived by the viewer at once. The secret to the "grab" is to choose a pose or gesture that is typical of or even unique to that animal.

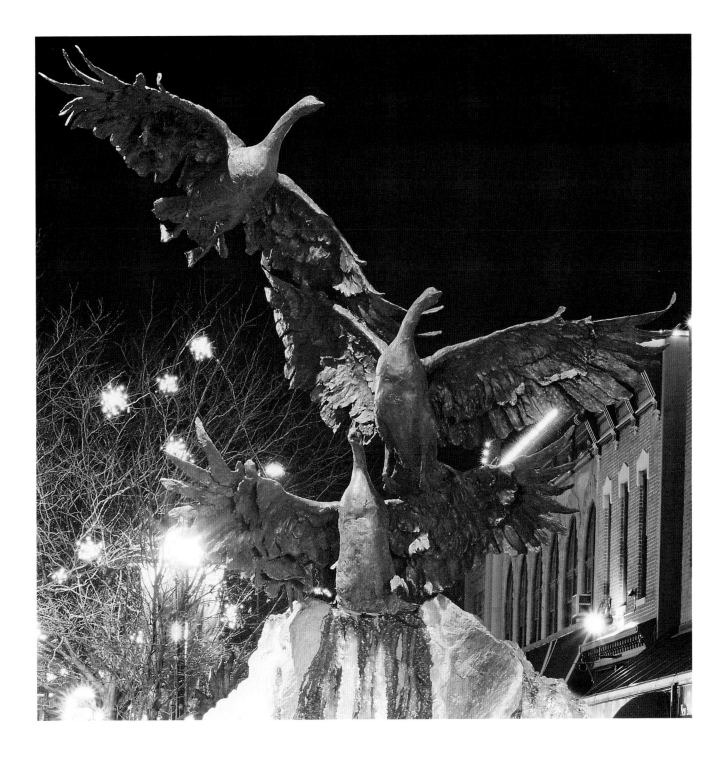

PLATE 73
Spirit of the Wild Things, bronze, h 84.
Foremost among the subjects that connect
me to the wild are Canada geese.

In January 1983, I received a call from Dr. Bob White, who explained that he had followed my career in *Southwest Art* magazine and *Gray's Sporting Journal*. He wanted to know if I would be interested in cruising Southeast Alaska aboard his boat the following summer. I had been to Alaska twice and wasted no time answering with an emphatic "Yes!" That summer I met Bob and his Canadian-born wife Diane in Juneau and embarked upon the first of many adventures aboard their beautifully restored 68-foot trawler, Sea Comber.

PLATE 74
Sea Comber.

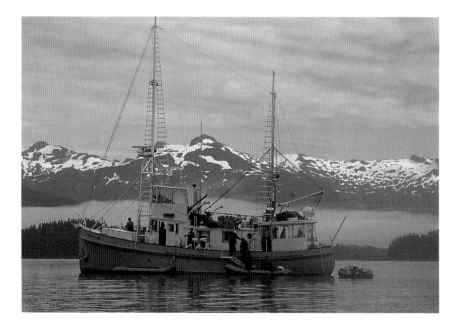

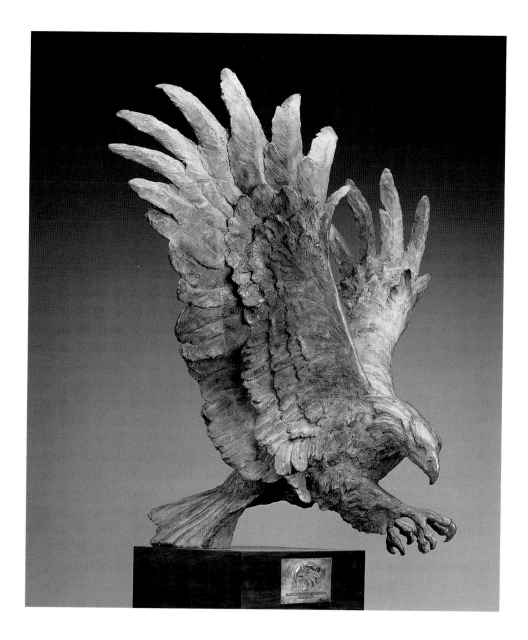

PLATE 75
Bald Eagle Off Cannery Point, bronze, h 44.
Near the abandoned waterfront cannery in Hoonah, Southeast Alaska,
I sketched and photographed resident bald eagles.

The scenery and the pure wildness of Alaska is so hopelessly beyond description that I can only convey snippets and impressions from my journal on that first cruise:

*A*laska *is best explored by boat! … Inaccessible snow-topped mountains rocket out of the sea…. Jagged peaks crowd together in compositions that only nature can invent…. Pod of humpback whales heaving into view…. Eagles perched on dead branches along the edge of a dripping spruce and hemlock forest…. Silvery fingers of glacier-fed waterfalls plunging from a height of perhaps 4,000 feet into the sea…. Snotty weather (an Alaskan term) and rugged chop in Chatham Strait…. Anchored for the night behind Morris Reef in sheltered Sitkoh Bay. Nosed into the narrow, deep cove and was surrounded by a sudden quiet. I can hear the croaking of ravens on shore; plenty of good light left in the long northern day; scouted inlet in the Zodiac after supper. Thousands of sockeye crowding against one another struggling and churning upstream with their backs out of the shallow stream. Must wake up early, bear sign everywhere…. Helped Bob set out pots last night and what a feast we had for lunch today. A pot of crab, a glass of wine, and thou, Alaska! Aurora borealis drapes across the sky tonight. Upright bars of bright prismatic colors march from east to west along the northern horizon…. Wet and misty morning, fresh sea-brine smell. Water calm like polished marble reflects countless forest-clad islands…. Dreamy vastness of snowfields and glaciers in the distance. Nature reigns here, all-powerful and wild.*

In the following years, many artists, writers, collectors and gallery owners were invited aboard the Sea Comber to experience the emerald paradise known as the Alaskan Inside Passage. We all savored Diane's gourmet cooking, served with vintage wines, and were charmed by Captain Bob's laid-back competence. As shipmates we became attached to one another in a way that only those walloped and overwhelmed by nature could possibly relate to.

PLATE 76
Mallard Wine Bucket, bronze, h 9.
My *Mallard Wine Bucket* was put to good use in the Sea Comber galley.

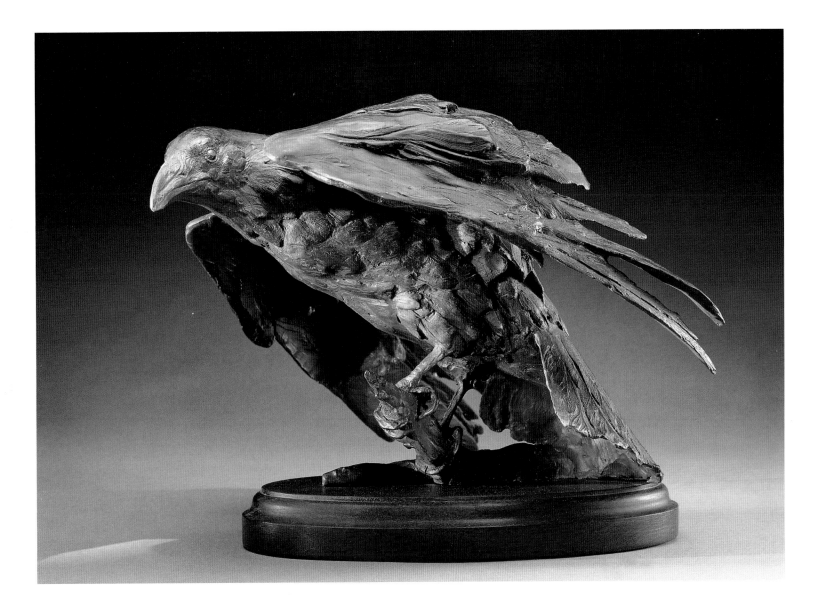

PLATE 77
Kakagi (Raven), bronze, h 12.
Kakagi is the Ojibway word for raven. The bird is and was held sacred
by native peoples of the Americas and is considered to be a
messenger between the living and the spirit world.

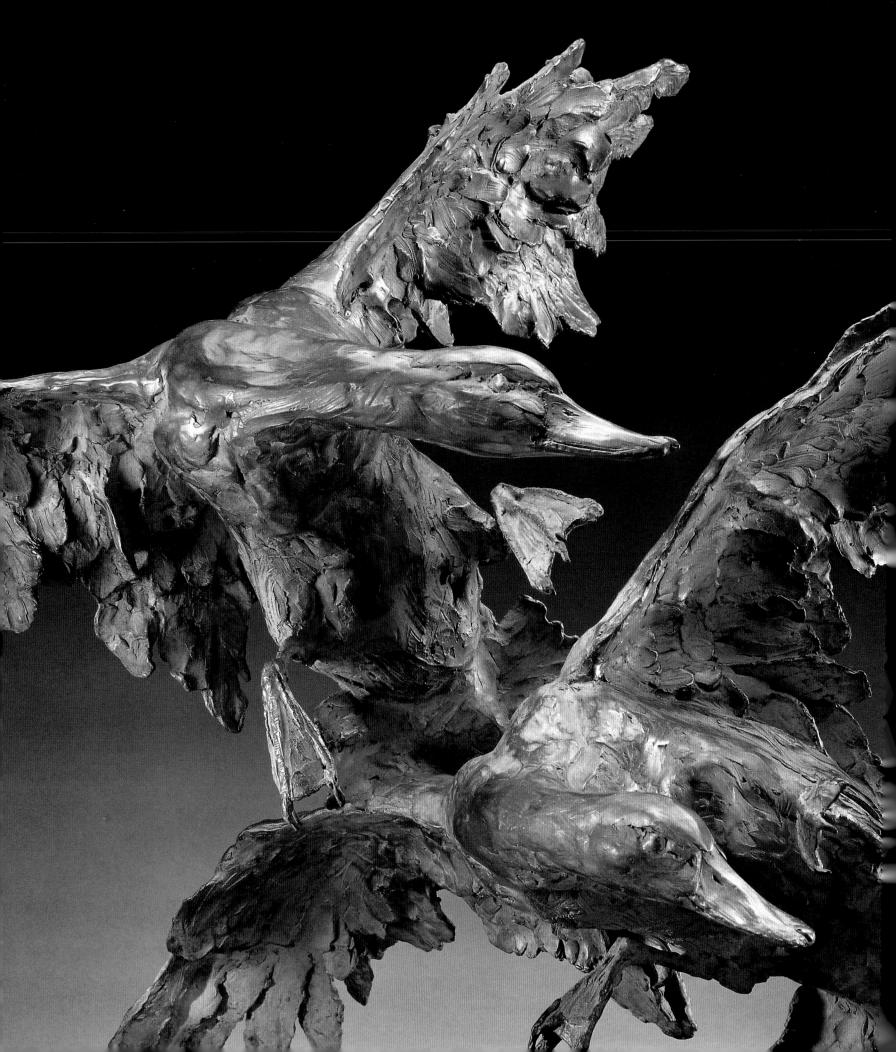

Chapter 4

E X P R E S S I N G

Sculpture is but a language among the various languages whereby the eloquence of the arts expresses nature. It is a heroic language just as the tragic style is the heroic one among the languages of poetry.

Antonio Canova

PLATE 79
Painter Richard Schmid interpreted
Scott's *Mallard Duet* in oils.

When an experience has become a vivid memory, when the emotions from the experience demand to be seen, when the problems of how to show the experience are solved, the artist must ask, "How can I give form to what is in my heart and mind? What language will I use to express my idea?"

Expressing is choosing a medium—whether bronze, etching, paint or drawing. Here is where years of practice facilitate both the evaluation and selection of materials that are receptive to the idea and expedient in realizing it. The medium is an extension of the artist's personality, the channel through which the mind connects to the fingers.

As with a language, expression takes many forms. It can be literal and narrative, relying upon a combination of details to tell the story. Or it can borrow from the realms of poetry and haiku wherein shape and substance are one in the same. Over the years, Scott has learned and put into practice what sculptor Malvina Hoffman describes in *Sculpture Inside and Out* as, "The artist must learn the difference between the appearance of an object and the interpretation of this object through his medium. Imitation is better done by photography, but to infuse reality with life and startle the observer into a new state of consciousness is to create something of one's own."

To express "something of her own," Scott understands the formal qualities of drawing,

composition, proportion, form, mass and shape. How these are used and when the artist has said enough to convey the idea is the magic of communication. Some pieces communicate quickly. In sculptures such as *Chickens on the Wind* [Plate 84] and *Goat Ringing a Bell* [Plate 82], Scott expressed herself in a single sitting. Other pieces, like the birds in *Peace Fountain* [Plate 8] require studied construction each time the sculpture is assembled—a slight rearrangement of wings can throw off the design of the entire work.

When the idea has been described in its largest elements, the final factor that makes or breaks the impact is the surface. For Scott, surface is a matter of touch and light. The "touch" of her hand is her thumbprint. It is literally seen in striations left in the clay that follow the sweep of a horse's withers or the curve of a cat's tail. These striations and the entire surface reflect or capture light, creating transparent shadows that come alive not only with the spirit of the creature, but with that of the artist and the times she represents.

As Hoffman so eloquently states it: "The artist records the spiritual history of his time. His work lives on to tell the future generations of the inner workings of man's conscious and subconscious mind. Be it realistic or abstract, nonobjective or cubistic, it is still a record of evolution or revolution, a soaring of wings or a slipping downward, and this responsibility must be accepted and revered."—SHM

LOST AND FOUND

It is a sculptor's job to create a tangible form in space, while a painter creates an illusion. Be that as it may, I continue to learn from great painters and apply this knowledge to my sculpture.

In nature one does not see every detail. If the animal is in motion, depicting very little detail causes the illusion of motion just as one observes in nature. Conversely, if the animal is still, the surface can be modeled more closely resulting in a studied or quiet impression.

Detail results in hard, found edges and the eye moves slowly to perceive these passages.

No detail causes soft or lost edges, and the eye moves quickly and is stopped by a hard or found edge or detail.

Furthermore, hard edges occur where shapes make an abrupt change or extreme transition. A sculptor must not use edges to indicate mass, for if strong shapes are modeled, the edges take care of themselves.

Artists are manipulators of the eye and control the manner in which the viewer moves into, through and around a work of art. The strongest works of art are those where the main idea is caught in a single glance and the artist holds you there as long as possible.

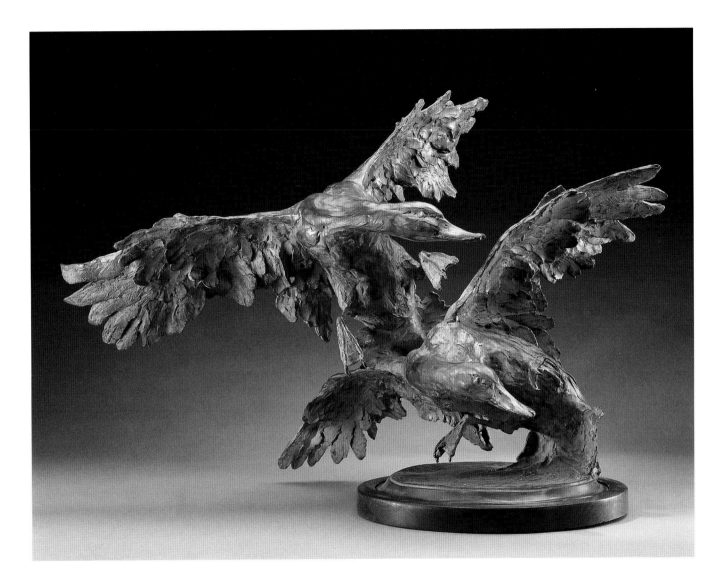

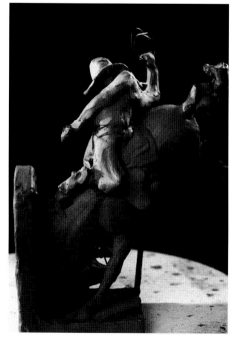

Most sculptors today use an oil-based modeling clay called plasteline which, unlike water-based clay, never dries out and can be used over and over again. There are many types and brands of plasteline and each has distinctive characteristics such as softness, stickiness, pliability and color.

I choose specific clay for individual projects depending upon the surface and texture that I wish to create. A spontaneous and loosely modeled technique requires soft, warmed clay. A studied, detailed treatment may call for harder, carvable clay. Sticky clay adheres to armature wire, aluminum foil and pipe, and therefore makes the task of modeling birds easier.

While the great masses and planes of a sculpture reveal the animal's construction and essence, an expressive surface can convey character, truthfulness and style.

FIGURE 40
Whippet at Ease, clay, h 16.
Jolly King is a very soft clay, which is particularly useful for quick sketches or it can be refrigerated and carved.

FIGURE 41
Remembering Will James, clay, h 13.
I make a plasteline using powdered clay, wax and oil, but unlike Le Beau Touché, it is not sticky enough for bird-wing armatures.

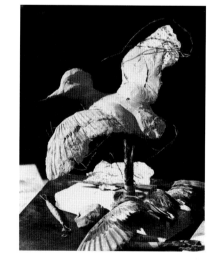

FIGURE 42
Bufflehead Duck, h 15.

FIGURE 43
Breezy, clay, h 16.

Chavant's Le Beau Touché is the most versatile plasteline.

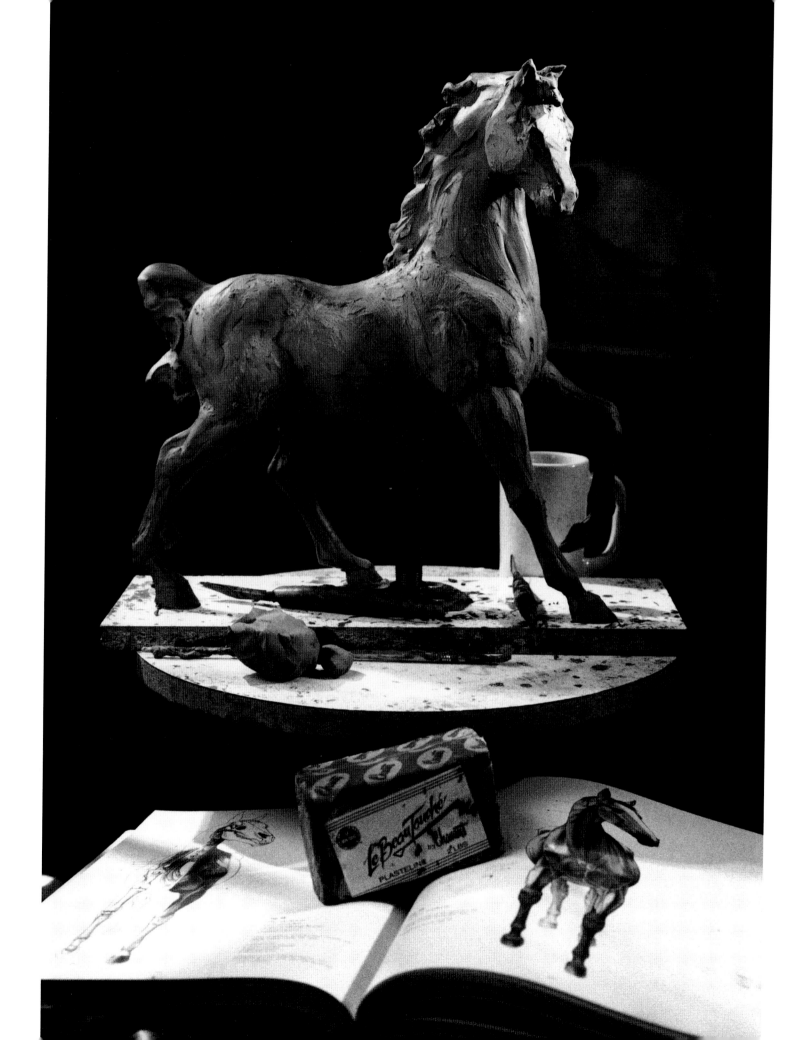

L O O S E

After teaching numerous workshops and being told countless times by participants that "I'm here because I want to loosen up my technique and learn a loose modeling style," I've finally come up with a definition for the word *loose* as it applies to sculpture:

Loose is the ability to give an accurate impression in clay without precise modeling.

But there's more: To model in a loose manner and make it work necessitates a highly developed sense of shape and form. Random shapes, marks and lines are meaningless.

Quick clay sketches from life can have honestly and vitality, but spontaneity is not possible without planning and structuring. Knowing the subject intimately and having a good plan and design enable you to make the sculpture intuitive and spontaneous. More often than not, happy accidents are rare, and without a thorough knowledge of the animal, what the artist may perceive as being loose and spontaneous is not understood and is really sloppy modeling.

There is no technical trick for modeling in a loose manner. The sculptor must simply feel or sense that he or she has created a meaningful shape and surface passage. This cannot be accomplished without understanding the subject's anatomy.

I've observed sculpture that hopes to be spontaneous, free and loose, as if the artist is trying to make it look easy, but there is no message, no understanding, nothing is happening!

There must be meaningful, strong and understood structure and shape—only then can one edit and simplify. The more that is known, the more that can be eliminated.

PLATE 81
Goat Ringing Bell, bronze, h 8.

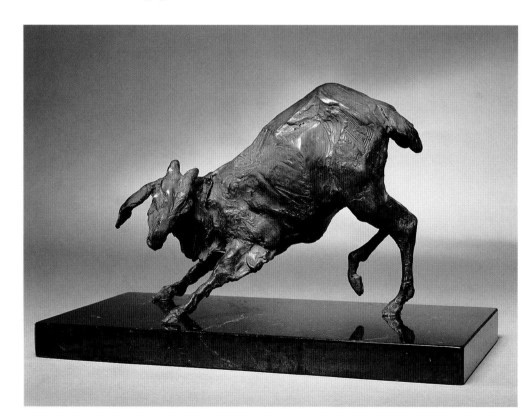

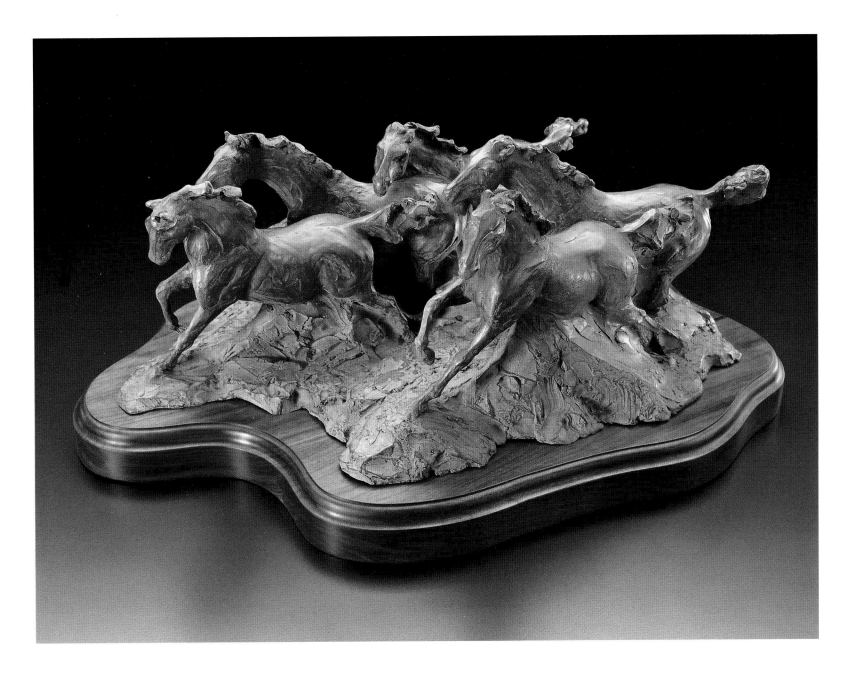

PLATE 82
Ahead of the Storm, bronze, h 12.
A vigorously modeled surface can produce flickering,
ever-changing patterns of light and dark.

PLATE 83
Chickens on the Wind, bronze, h 15.
A fiercely exaggerated surface can pulsate
with sculptural energy.

PLATE 84
Little Red Rascal, bronze, h 20.
A fox is lavishly beautiful—intense gaze, triangular head and
a look that a cartoonist would give to the devil.

As children, we loved drawing. Then we grew up and realized that our drawings didn't look like what we wanted them to represent. Most people stop drawing as they leave childhood, threatened by failure and shrugging off their adult frustration by claiming that they have no talent for it.

The answer to the question, "How does one learn to draw?" is irritatingly simple: You must learn to see your subject. If you can see your subject, you can draw it and therefore express it by modeling clay.

Drawing is a skill that can be taught and learned, and like any skill, it takes practice.

Simple shapes are the foundation of drawing, and to draw accurately we must use all these shapes—circles, squares, triangles, rectangles, ovals, etc.—in correct relation to each other. If you can draw an egg, you can draw a leg.

The handling of clay and other sculptural material can be taught and learned. Sculpture involves the consideration of three dimensions—width, height and depth. Simple shapes are also the foundation of sculpture. These basic shapes are: the pyramid, the cube, the cone, the cylinder and the sphere. A sculptor learns to think in terms of these basic shapes. Details are simply decorations on the surface of these shapes.

A sculptor knows that drawing strengthens observation skills. Understanding the subject enables the sculptor to see, draw and model the animal. Furthermore, drawing forces careful observation causing the sculptor to understand and know the creature.

A drawing can do the work of thousands of words, defining something that cannot be described in words. Through drawing, the sculptor transforms an intangible idea into an understood design.

FIGURE 44
Horse as cones, circles, etc.

FIGURE 45
Hisan Unrestrained, clay, h 16.

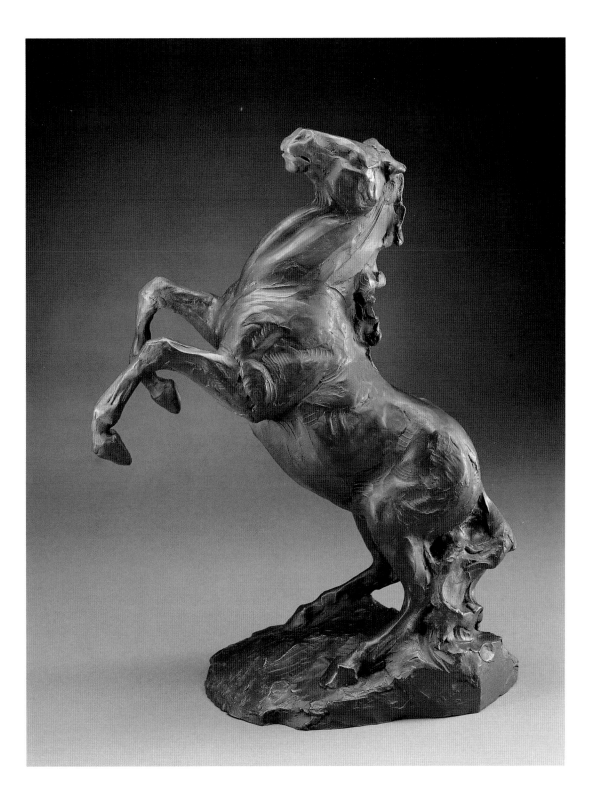

PLATE 85
Hisan Unrestrained, bronze, h 16.
The unique virtue of sculpture is its tangible, space-filling reality.

FIGURE 46
Dots as composition.

I attended the Kansas City Art Institute in the early 1960s, and it was the most far-reaching event of my life. To this day, I view the time spent there as the awakening of my senses. My eager young mind absorbed the rudiments of what would become a lifelong journey in the arts. Nothing since has equaled the enthusiasm in which I immersed myself in the study of art, art history, literature and world history. To this day I thrive upon the confidence instilled in me by competent instructors who inspired and directed me toward achievement.

Now, when I teach bird sculpture workshops, I rely on the solid principles of design, drawing and technique that I learned as a young art student.

Two of my instructors, Mr. and Mrs. DuCoin, taught color theory and composition respectively at the institute. It is Mrs. DuCoin—or Mrs. DuDot as we irreverently referred to her—that I remember so vividly. Her method of teaching composition, using dots to illustrate her point, is a permanent part of my oeuvre.

She began by stressing the three main principles of composition:

1. Composition is a harmonious arrangement of two or more elements, one of which dominates all others in interest. The dominant element becomes the focal point or center of interest.

2. There should be as few secondary elements as possible and these should be arranged to support the main interest.

3. The position of the center of interest depends upon the feeling of balance created by the distribution of the different elements in the composition.

She illustrated her simple thesis with dots: In the first box the dot is centered, static and not interesting. This is not good composition. In the second box, the dots are symmetrical and not interesting, and therefore not a good composition. In the third box we're getting there. The space seems to balance the dot. The Japanese call this "formal sparseness of design." The fourth box has a composition: There are minor elements of interest that support the main dot. This gives movement and visual activity.

Painters add the elements of value, tone, color, etc. to these basics, but the design principles presented here apply to painters and sculptors. The strongest compositions are those where the main idea is comprehended in a single glance. Instinctively we acquire the basics of good design from nature and we have absorbed these gifts since childhood. Art is not an imitation of nature. Art is surrounded by the artist's personal evaluation and response to nature, and great art has an eternal and universal appeal.

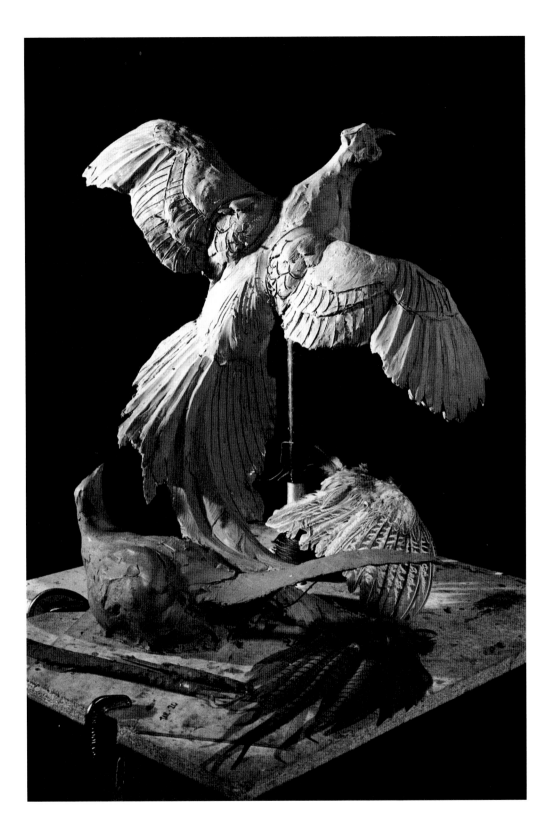

FIGURE 47
Treasures of the Heartland, clay, h 26.
Composition in sculpture is different from that in painting. Sculptors must consider the relationship
of mass to space and arrange these solids to create good design.

Sculpture is the study of

a thousand silhouettes.

Rodin

In sculpture the subject represented is the positive shape. The empty space around the subject is the negative shape.

The viewer usually does not think about or consider the space around the sculpture. The sculptor, however, is constantly aware of both positive and negative shapes as they are a device for designing and organizing the sculpture.

The viewer should practice seeing sculpture in this way, and here's how to do it: Select a sculpture of an animal and direct your gaze intently on the figure itself. Choose a sculpture with a quiet and simple pose. Then, concentrate on the negative shapes or the space surrounding the sculpture. You must wait until your vision accepts the negative shape and think of it as a totally separate form.

Now imagine that the sculpture vanishes. What is left? You will find that the negative shapes have become distinctive shapes in their own right, and if you focus on these shapes, they become forms.

The sculpture that you are looking at has drawn you into it visually and almost physically. The realization of negative shapes adds a new dimension to the image before you, adding to your appreciation of its beauty and content. You will realize that sculpture is not a reproduction or duplicate of the animal but positive and negative shapes that the artist has arranged to form a design.

FIGURE 48
Sculpture silhouettes suggest positive and negative shapes.

There really are no hard, fast rules or principles of design, but simplicity, harmony and subtlety can be a guide. Sculpture does not have to shout—it can whisper.

It's possible to put as much if not more vitality into a sculpture of an animal in a tranquil pose as in one depicting violent action. The viewer can get tired of the latter. The French have a word for the flamboyant and turbulent contortions so often seen in some equestrian sculpture: *tormente*, which means tormented.

A work of art combines composition, proportion and the arrangement of shapes to lead the viewer to an artistic conclusion.

The greatest expression is communicated through the largest shapes. The sculptor must say as much as possible with the large forms before being concerned with detail.

There's no technique or trick that can be taught to explain how to create a good, strong shape. The theory must be felt or sensed to be understood by both the viewer and the sculptor. Just as a whisper makes one listen more closely, one looks with greater understanding at uncomplicated sculptural statements. Power is gained through simplicity and simple shapes tell greater truths.

PLATE 86
Cat in the Creamery,
bronze, h 18.

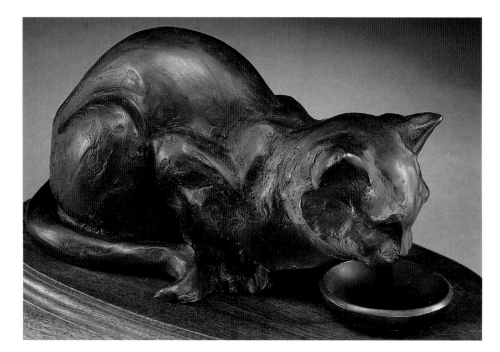

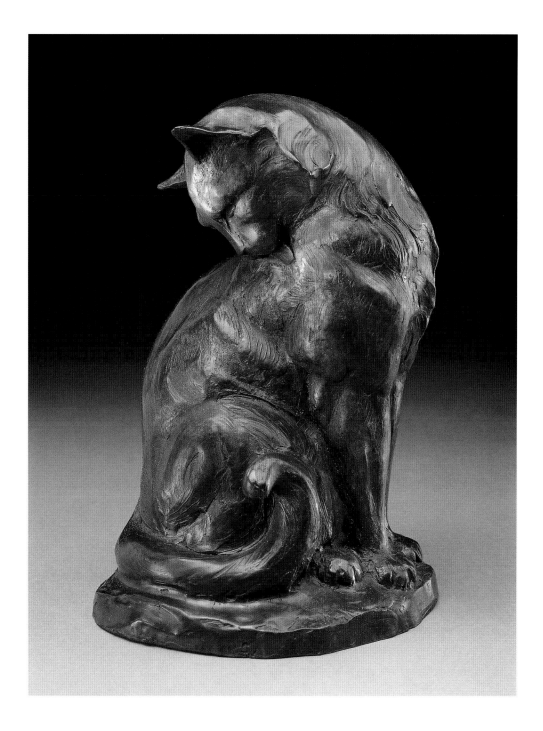

PLATE 87
Preening Cat, h 14.
These quiet poses were modeled from life—the style,
sentiment and spirit were derived from the subject.

A sculptor is a builder and must get to the principles of construction. Yet art is an experience rather than an object, and sculptors leave imprints of themselves on their works ... how they feel about their subject. As sculptors grow they settle down to sound technique and find themselves under the influence of their subject's shape.

There is no realization in sculpture that is more important than SHAPE.

The sculptor must find and define the big SHAPES and help the viewer by keeping the SHAPES simple.

The obvious big SHAPES and what catches the sculptor's initial attention should be established first.

All that can be said with large SHAPES should be expressed before indicating detail. Don't search for detail, it must be obvious.

Details are part of and can augment SHAPE. They should be modeled as a gradual transition and should not leap out at the viewer.

PLATE 88
How the West Was Won, bronze, h 27.
The sculptor must determine what shapes are important for identification and assemble the larger shapes first.

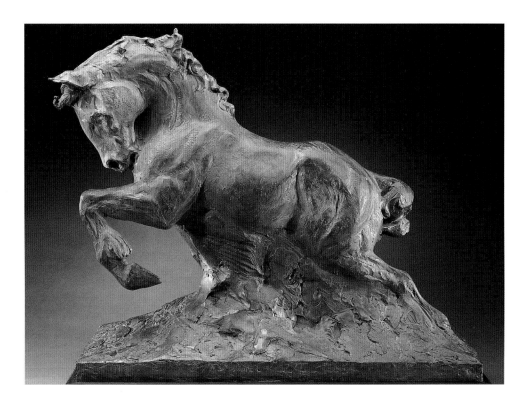

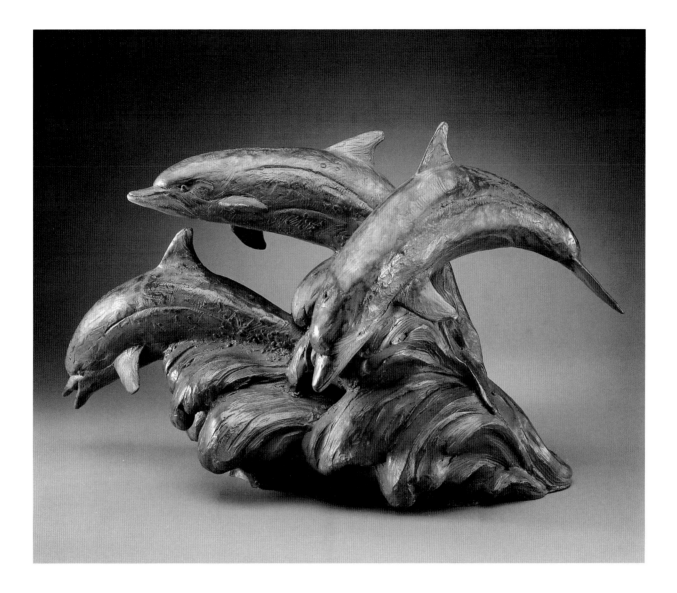

PLATE 89
Off Port Bow (Dolphins), bronze, h 17.
The clarity of the overall shape should be
retained when modeling detail.

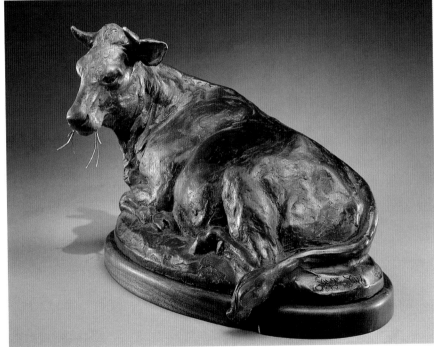

PLATE 90
Trish's Rabbit, bronze, h 7.
Trish's rabbit is a delightful little thunderbolt which abandons this
compact shape whenever I come near.

PLATE 91
Pescado, bronze, h 14.
I enjoy observing the endless shapes of the tropical fish
I see while snorkling in Puerto Vallarta.

PLATE 92
Recumbent Cow, bronze, h 10.
This pose depicts the tension of skin stretched over the internal
anatomy and a bulbous stomach counterpointing the planes.

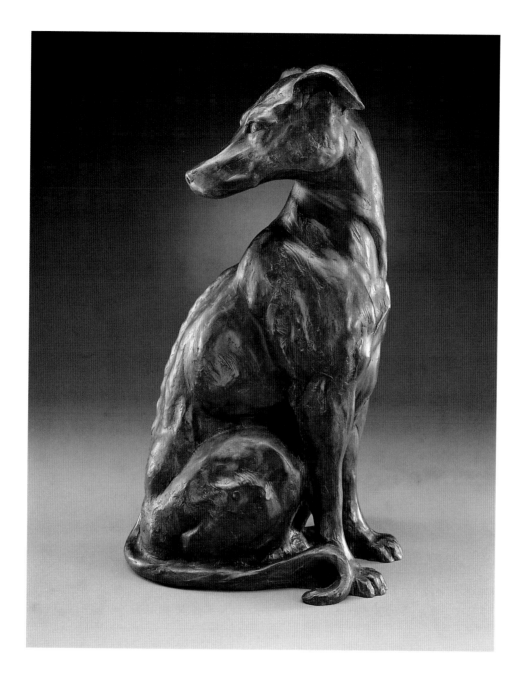

PLATE 93
Whippet at Ease, bronze, h 18.
This dog is the greyhound in miniature, and its dainty
appearance presents a decorative shape for the sculptor.

Every artist who evolves a style does so

from illusive elements that inhabit his or her

visual storehouse, but the actual break-

through in the privacy of the studio, when

one dares to [sculpt] in a new manner, is a

solitary thrill, dependent upon no one else.

It is the individual artist who must act

courageously in an effort to grow.

Mary Carroll Nelson

A person is the sum total of his or her interests, experience, knowledge and feelings. Artists and their styles evolve naturally while searching and exploring various possibilities of design. Style, like feelings, cannot be forced.

Sculptors develop their individual way of seeing an animal's natural characteristics. The imprint of the artist's personality, the manner in which the animal is presented is the artist's style.

Style manifests itself as artists discover that which interests them most about the subject. Nearly all artists have been influenced by the work of preceding artists or their contemporaries. Awareness of great art helps artists evaluate their own work with a clearer and more discerning eye. When you are deeply involved with and understand your subject, an original style develops automatically.

FIGURE 49
On Point, clay, h 8.
I have spent priceless days afield with my father hunting
upland birds behind a good dog.

In years past, art students learned in academies and continued their education under the direction of a master in ateliers and working studios. In the academic tradition the student would assist the master by making plaster casts from life, taking endless measurements and making accurate draw-

ings. He would learn mold-making, resizing, point-up and carving. His responsibilities would surely include keeping the clay models covered and moist as well as sweeping the floors, watering the plants and looking after the studio cats.

In exchange, the apprentice received a small amount of money, if any, and an occasional critique of his own work by the master. Most would advance no further than a technician and would have to be content with their lot in the studio.

The Italian Renaissance masters encouraged their students to "*Impara l'arte e mettila da parte.*" (Learn your art and then put it aside.) The artist should know sound technique but never stop experimenting, seeking and taking chances.

PLATE 94
Passages, bronze, h 24.
New subjects keep me where I want to be …
the perpetual student. Modeling the female
figure is my biggest challenge yet … the delicate
planes are almost imperceptible.

PLATE 95
Stars, bronze, h 16.

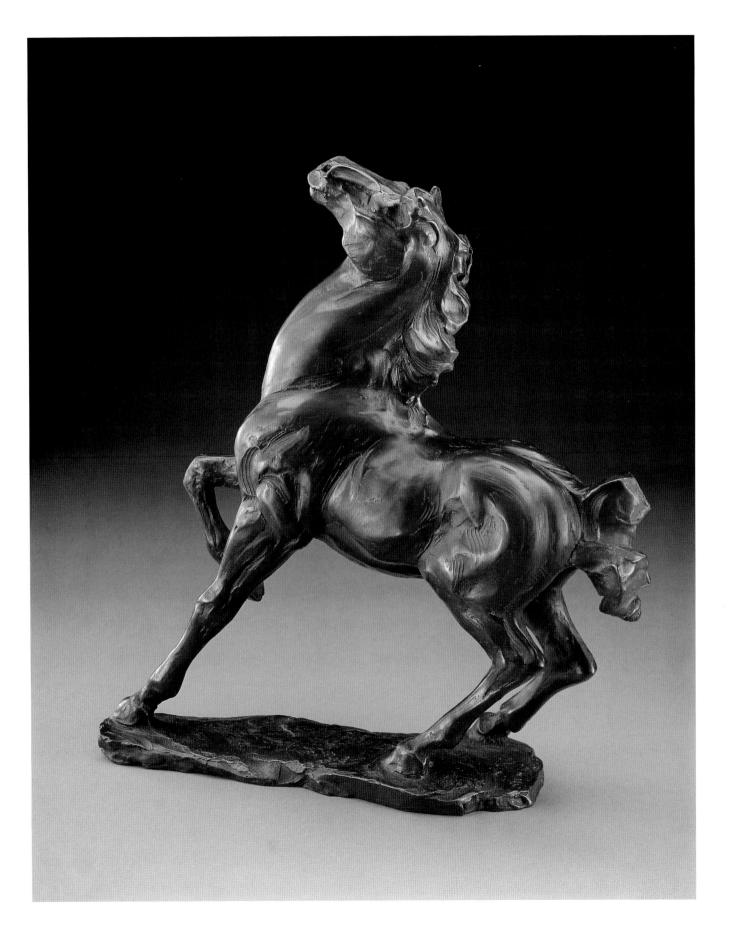

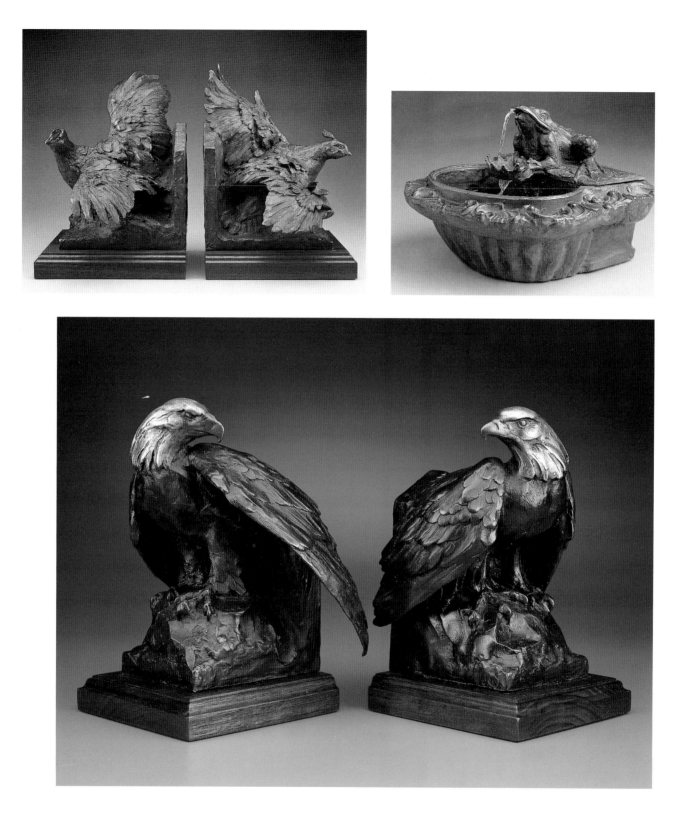

PLATE 96
Quail Bookends, bronze, h 12.

PLATE 97
Frog Formerly Known as Prince, bronze, h 7.

PLATE 98
Eagle Bookends, bronze, h 10.

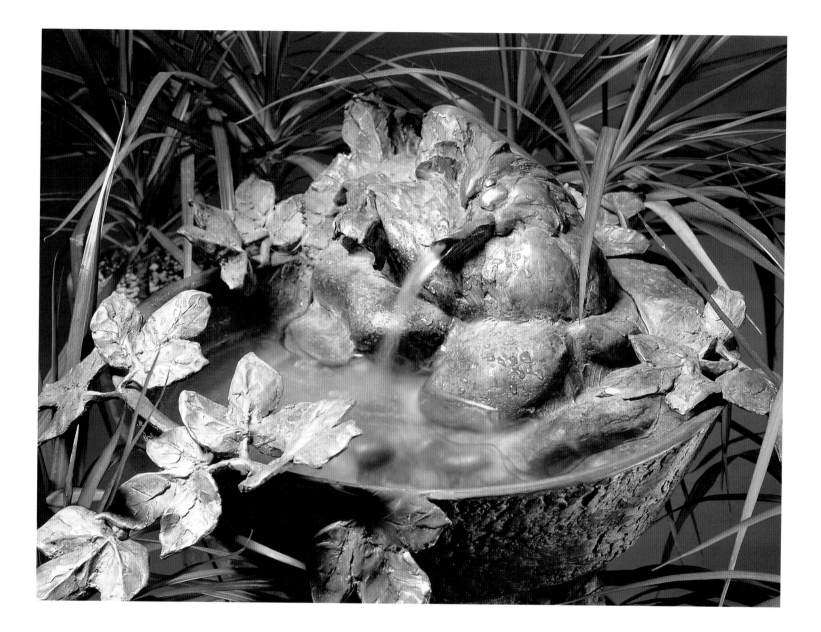

PLATE 99
Sleepy Duck Fountain, bronze, d 25.
Traditionally sculptors have been called upon to create
functional art for indoor and outdoor use.

At the end of the 18th century, America had beaten the British and needed its leaders and its battles monumentalized. Jean-Antoine Houdon (1741–1828) was France's leading sculptor. Houdon was influenced by the Italian carver Antonio Canova (1757–1822) whose marble works recall the spirit and style of the ancient Greek sculptors. American patrons wanted our heroes sculpted in the Canova-Houdon style.

At the beginning of the 19th century, academies of art modeled after those in Europe were created in New York and Philadelphia. These academies were influential in establishing the European tradition of sculpture in this country. Monuments to our war heroes were patterned after those in Europe.

The new wealth and the grand age of the Beaux-Arts style provided sculptors extraordinary opportunities to create figurative monuments in America. The French Beaux-Arts style of the mid-1800s is a blend of Greek, Renaissance and baroque styles.

The great era of the Beaux-Arts mode of expression dominated and influenced this country's public works until the 20th century when abstraction replaced naturalism. Today, there is a resurgent interest in realism and a revival of traditional sculpture techniques.

Throughout history, the horse, eagle and lion have been successfully depicted larger than life. In equestrian sculpture, horses have primarily been used as the means of conveyance for the subject of the monument—the rider. However, there are many stunning heroic-sized sculptures depicting only the horse in all its glory. The eagle is one of the world's oldest symbols of power, resurrection and victory, and it, along with the lion, has been monumentalized.

Sculptors today are expressing powerful environmental statements by using different animals as subjects—specifically wild animals—to symbolize and celebrate ecological issues and the wonders of nature.

Awareness of animals and nature has awakened sculptors and collectors alike. Large, outdoor sculptures in public places and private residences express affection, approval and veneration of animal imagery. But, only time will reveal the historical value of the animal sculpture being created today.

FIGURE 50
Transporting the 22-foot-wide
Wings of Freedom for installation
at Grand Canyon Airport.

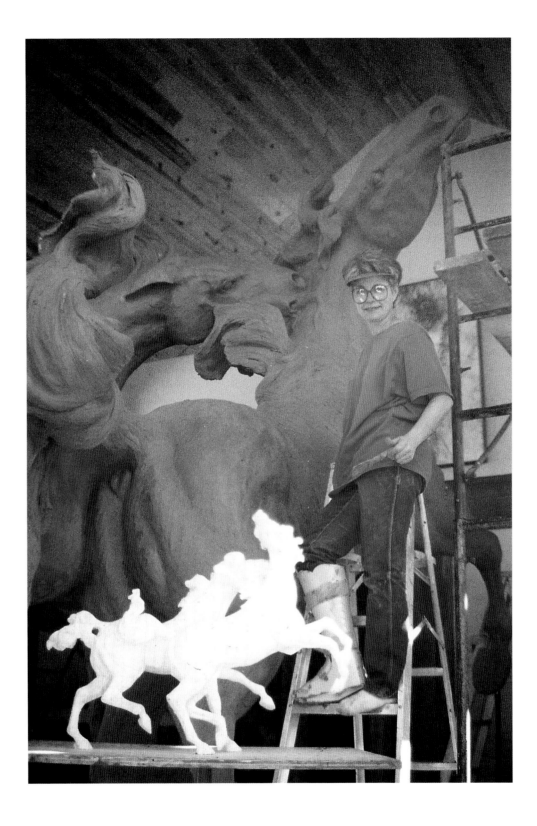

PLATE 100
Scott working on the center two horses of *Rite of Passage*.
The additional three horses will be completed
in 1999 for the City of Avon, Colorado.

TOUCH

The imprint of an artist's touch cast in bronze on the surface of a sculpture has a living presence, as fingerprints and tool marks are a source of fascination for the viewer.

Run your hands over the surface of a beautifully modeled sculpture—feel the form, see with your hands.

Walk around the sculpture and use your hands and eyes to feel your way in and out of the shapes. New forms appear at every angle—smooth, curved shapes, vigorously modeled passages, hard edges ... a source of endless discovery as the sculptor leads you through space, giving you an experience inspired by nature.

PLATE 101
Detail from *Earthbeat*, bronze, h 10.

When I sign my work and send it out into the world, I think of a bird leaving the nest or perhaps a child leaving home. I wonder how what I saw, felt, understood and expressed will affect the viewer. The most profound realization of my life is that there are people I have never met who live with my art, and therefore I share with them a personal, if not intimate relationship.

FIGURE 51
Downwind, clay, h 20.

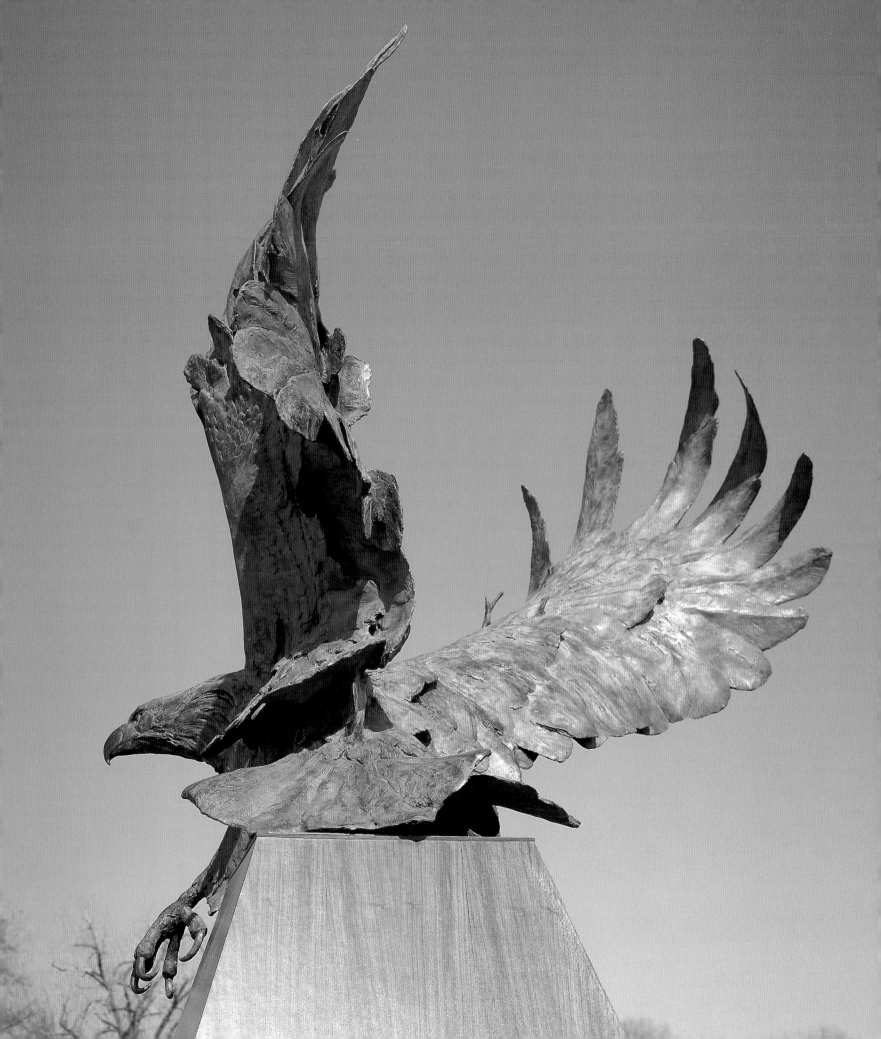

PART III

Epilogue

Chronology

Selected Collections

List of Illustrations

PLATE 103
Cherry Mill east studio garden
area with Scott sculpting *Trish's
Rabbit* while Toby looks on.

PLATE 104
Scott with horses Hisan
and Boz in the stable.

PLATE 105
Cherry Mill studio grounds
with old pottery-making
studios and kilns.

PLATE 102
Preceding Page
Sovereign Wings, bronze, h 90.

Susan Hallsten McGarry

Fresh snow edges the tree limbs like piping on a newly upholstered couch. Stubbled furrows contrast with the glazed lakes surrounding the corrugated steel buildings of the Cherry Mill. Scott's horses Boz and Hisan stare from the corral wearing dense coats of reddish brown. Deer tracks follow the driveway, heading west toward the Front Range, warmed by yellow daybreak. Magpies dart in treetops and geese fly silently overhead.

Everything is bathed in brilliant calm this December morning—except in Scott's 1,800-square-foot north studio where activity began at dawn. Studio director Trish Smith is surrounded by sculptures in various states of creation. Wires and pipes protrude through the tail of a bufflehead duck. A wooden rack supports an eagle's extended wings. A 6-foot-tall clay pig is missing an ear, and a sundial of horses is being cut apart and shimmed in preparation for applying several coats of gooey rubber. Horse legs from *Stallions of the Sun* kick out like a Las Vegas chorus line on one side of the worktable, while a passel of horse heads strains to escape from the clay boulders that encase them.

Where's Sandy? Walk across the patio, where the chickens, ducks and rabbits are nestled into a fenced hutch, and you'll find her working in the vaulted east studio.

Warmed by a fireplace, she is surrounded by several worktables, each with one or more pieces in progress. Stacks of books teeter on one table. Wood-handled tools with wire loops litter a sculpting stand where a moose has been blocked-in in two different sizes. Mirrors reflect the backside of a pink-colored clay eagle, a yellow-clay horse and a white plaster model of a horse's muscles. A pigeon skeleton perches behind Plexiglas on a shelf over the desk, its neck bones arching delicately to a small pointed beak. Clippings, wildlife magazines, picture montages, taxidermist mounts and plaster models squabble for attention.

For Scott, all this clutter sinks into the background. When she is working on a sculpture, she's totally focused. If she's lucky, she can block-in an animal's form and model its gesture in a few hours of intense work. "That's when I tell Trish to mold it or I'll ruin it," Scott says. Other times, she works for weeks on a clay animal, slightly adjusting the angle of a leg, the turn of a head or the curve of a wing. These are the times when she waits for nightfall to view the clay in the dark. Borrowing a technique she learned from Rodin, Scott uses a candle or low-voltage bulb to caress the sculpture's forms with light, assessing the surface patterns and textures and adjusting the flow of line and transition of masses. The goal: Transform an accurate interpretation of an animal into an exciting aesthetic experience.

How does this happen in bronze? And how did an etcher make the transition from

In etching, Scott carves away the ground in a variety of lines, then she immerses the plate in acid which attacks the areas of the metal that have been exposed. The acid eats into the metal creating a pattern of depressions that will hold ink, which is transferred to paper when the plate is run through a printing press. The illusion of form is interpreted through juxtapositions of light and dark ink—the areas etched the deepest print the darkest.

In sculpture, the artist builds up masses of clay and then begins to carve them into shapes. Rather than creating the illusion of form on a two-dimensional plane, Scott recreates actual three-dimensional planes in a sculpture. Here is where etching and sculpting part company. Whereas etching is a medium of close scrutiny, requiring tremendous sensitivity to the smallest details and textures that will *suggest* form, sculpting focuses on the larger masses, using details and textures only to *enhance* form.

In both cases, however, once the plate drawing and clay are sufficiently realized, Scott turns over the artwork to the experts for manufacturing multiple editions: a printer in the case of etching and mold makers, wax chasers and foundry men in the instance of a sculpture. For etchings, the original is the plate itself, which is used to create an edition of ink images. For sculpture, a rubber mold is taken off the clay original. The mold, supported by a second, more rigid mold of plaster or fiberglass, is used to create wax replicas. Each wax replica is cov-

two-dimensions to three? The parallels between etching and sculpting are amazing and feed off of on one another in a number of ways. Both begin with an idea that is initially expressed in a pencil drawing or a clay sketch. These preliminary efforts capture the essential proportions and the meaning underlying the idea. They are rarely detailed, and Scott may create several versions looking for the one that communicates most directly.

Both sculpture and etching next require the construction of a support or a metal structure upon which Scott will realize the idea. In etching the artist selects a metal plate and covers it with a ground. In sculpture, she builds an armature of pipes and wires that will carry the clay. In both cases, tools—whether it be her hands or specialized needles, burrs and acids or wire loops, knives and paddles—are essential to achieving the desired effects.

ered with a ceramic shell that preserves the original shape. The wax is then melted out and replaced with molten bronze, which hardens, allowing the shell to be chipped and sandblasted away.

Significant in this process are the people who follow Scott's instructions in creating an original etching or bronze. For years David Bonnell has printed her work, striving for the subtleties of line that she prefers. Trish has been making Scott's molds for almost a decade and has devised methods that allow her to mold the clay with the least amount of dismembering, resulting in fewer welds and a surface that is truer to the original. Her wax chasers and foundries are also selected for the areas in which they specialize.

While an etching's wonderful range of values is perfectly adequate to express the idea of color or tone, Scott often enhances them with hand tinting in watercolor. The bronze sculpture also receives color in a process called patination. Like the chemicals that etch the metal plate, a recipe of chemicals is applied to the bronze surface, then heated, wiped and polished to enhance the metal's ability to capture and reflect light.

As with the many areas of the Cherry Mill that have been renovated, then changed again and again in response to Scott's evolving aesthetics, her sculptures and etchings have taken on afterlives in a variety of sizes.

Years ago when she was focused on her etchings, it was not unusual for an edition to

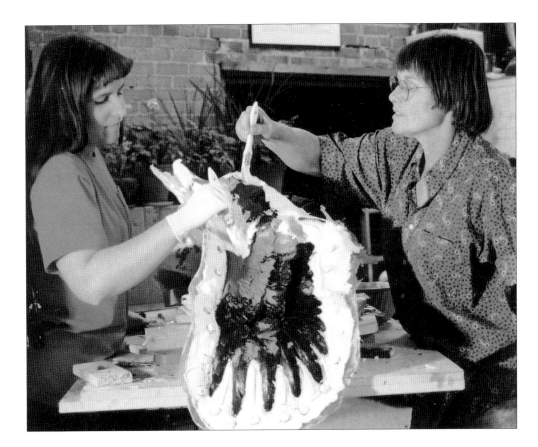

quickly sell out. In order to keep up with demand, Scott would review her cancelled editions, finding interesting and sometimes improved compositions within the larger etchings. These she would cut down and print, creating small vignettes.

Conversely, in a tradition as old as sculpting itself, Scott creates maquettes or smaller sized sculptures that she uses as models for larger sculptures or monuments. The process of "pointing up" or enlarging a piece such as *Wings of Freedom* or *Rite of Passage* from a 2-foot model to a 16-foot sculpture can be accomplished in a number of "scientific" ways, including measuring, sectioning and calibrating by numbers. As most professional sculptors quickly learn, however, "science" isn't art, and numbers cannot replicate the eye and touch of the artist. Accordingly, Scott prefers to build the larger works pretty much from scratch, using her inherent sense

FIGURE 53
Trish Smith (right) and Linda Veylupek paint a rubber mold on the wing of *Above Eagle Island*. The rubber mold creates the first negative mold of the sculpture, which is filled with wax. The wax positive is covered with a ceramic shell. The shell is heated, allowing the wax to run out, creating a second negative mold, which will be filled with molten metal to create the positive, finished bronze.

of proportion and placement to guide the creation of the new version.

New versions is a phrase close to Sandy Scott's heart, and she has been very successful in reviewing her work and recognizing when an idea might have another life in a more functional format. Her tabletop fountains, bookends, bronze-topped boxes and ice buckets make art functional in daily life. And her personal love of gardens has resulted in sundials that read the light and outdoor fountains and water treatments that soften the edges of urban environments with the sounds of water.

No two ways about it, life is art and art is life in Sandy Scott's view of the world. At the heart of this connubial relationship is discovery, which Scott accomplishes by arranging space so that our eye is sensitized to contrast.

What a potent tool! Contrast of one form to another, of infinite shades of dark against light, of one emotion to myriad others is the crux of all things. Contrast brings Sandy Scott's sculptures to life, imbuing them with an existence all their own. Whether she is delving into the fluid, art-nouveau lines of a whippet or the scruffy textures of a mule's ears, the range of contrast in every square inch, at every conceivable angle of the bronze cries out to be fondled, loved, admired or respected—to be touched with the hand and the eye, with the mind and the heart.

We find that contrast in the broad curving forms of the *Preening Cat* [Plate 87] and its small gesture of licking. Contrast is also at the heart of the determined effort of the foal in *Little Nipper* [Plate 13] to itch itself despite gangly, uncooperative legs. In *Ram of Mendes* [Plate 57], a smooth, dignified muzzle contrasts with the tight curls of hair and the evocative wave patterns in its horns. In *Above It All* [Plate 63] the eagle's magnificent angled wings contrast with the bird's keenly focused head.

But the contrast runs deeper. Underlying the surface and gestures of her work is not only the suggestion of bones and muscles. There is also something that speaks of the creature's instinctual spark, its reason for living. The powerful movement of the geese in *Spirit of the Wild Things* [Plates 1, 73 and 106] resonates with the revelation that migration is a primal expression of a wild and beautiful spirit. Through Sandy's work we connect to that spirit: We sense the exhilaration of lifting into the air with geese, of running at breakneck speed with horses or steadying our grip on a tree limb with a raven. We luxuriate in a warm spot in the sun with a borzoi and revel in the loon's oneness with nature's eternal rituals.

Through Sandy Scott's art, we recognize that if we open our minds, our eyes and our hearts, we will find places where wilderness and civilization meet … and joyfully coexist.

FIGURE 54
Goose Watching.

PLATE 106
Spirit of the Wild Things, bronze, h 84.

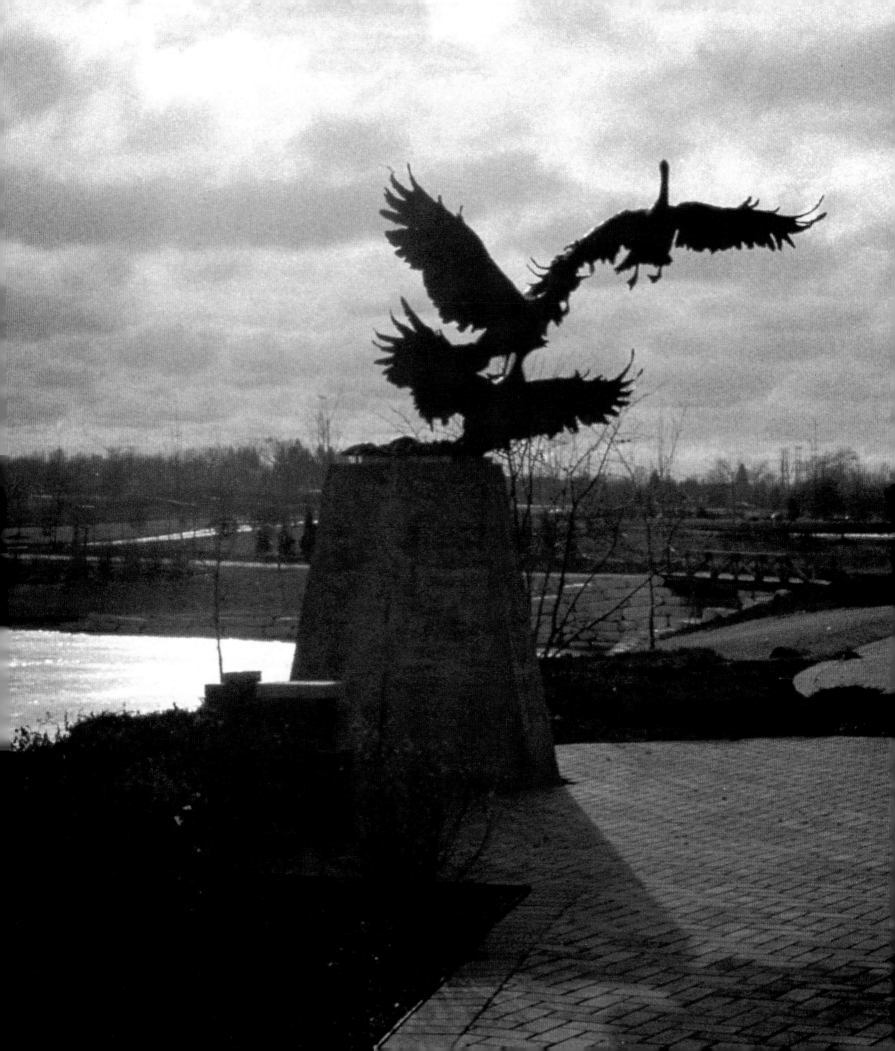

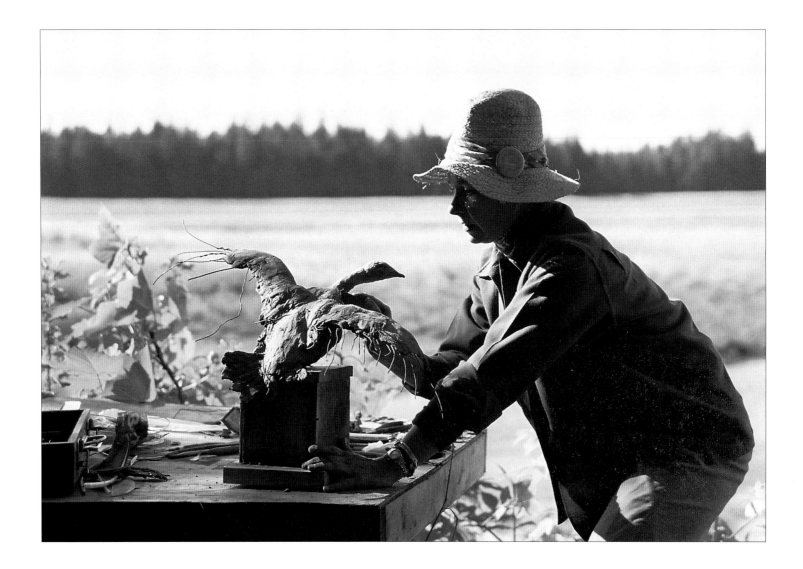

PLATE 107
Sandy Scott sculpting geese on location
in Big John Bay, Alaska.

1943 Born to Dolly and Jim Scott in Dubuque, Iowa. Has a younger sister, Nancy.

1945 The family moves to a rural area north of Tulsa, Oklahoma. Father works at a dairy while raising and breeding quarter horses.

1950 Develops an interest in drawing and is encouraged by her parents and art teachers.

1958 First trip to Yellowstone area.

1959 Sue Johnson, her high school art instructor in Tulsa, assists her in a three-year plan of preparing a portfolio and applying for acceptance at Kansas City Art Institute.

1961-65 Attends Kansas City Art Institute and works part time as an architectural delineator. Completes Famous Artists Correspondence School, Westport, Connecticut. First of numerous trips to Canada.

1963-65 Works as an animation background artist at Calvin Motion Pictures.

1965-69 Obtains pilot's license, and buys first of three planes. Employed by Eastern Airlines as a flight attendant based in Miami. Freelances as a commercial artist during numerous airline strikes. Pursues an interest in music and playing guitar.

1969 Moves to the Kona Coast of Hawaii, then to San Francisco, California, to work as a portrait artist and illustrator. Crews on off-shore sailing vessels and spends time in the California wilderness areas of Big Sur and Yosemite.

1970 Spends a month in Europe visiting Madrid, Rome, Athens, Paris and London with mother. Moves to father's Lenapah farm and ranch in northeastern Oklahoma. Rekindles childhood interest in horses. Introduced to western American art through *Western Horseman* and other ranch magazines.

1972 Returns to San Francisco and continues commercial art and portraiture. Begins a drawing portfolio, which is a precursor to an etching portfolio. Continues interest in boats and sailing.

1975 Moves to a rural area north of Austin, Texas. Rekindles an early interest in the etching medium. Creates a portfolio of etchings and presents them to Ann Haygood of the Gallery at Shoal Creek in Austin; Diane McGraw, Quandrangle Gallery in Dallas; Linda McAdoo and her gallery in Scottsdale, Arizona; and to Pam Driscol, DeColores Gallery, Denver, Colorado. Tony Altermann, Texas Art Gallery, Dallas, handles original drawings.

1976-83 Eight additional portfolios are marketed to as many as one-hundred galleries. Has numerous one-artist shows for

FIGURE 55
Dolly Scott in Cabin No. 9
at Red Deer Lodge.

FIGURE 56
Jim Scott, a pencil drawing done
on his ranch in 1971.

FIGURE 57
Scott enjoying shore lunch in the
rain at Camp Bay.

graphics, and publishes *Sandy Scott Etchings* [Doe Run Press].

1978 Commissioned by the National Cowboy Hall of Fame, Oklahoma City, to create a suite of rodeo etchings. Has one-artist show of more than 60 etchings at the National Cowboy Hall of Fame. Buys cabin on Lake of the Woods.

1979 Moves to El Paso, Texas. First of many trips to Alaska.

1980 Starts working in stone lithography in Santa Fe. Included in Mary Carroll Nelson's book, *Masters of Western Art* [Watson-Guptill].

1981 Participates in the first *American Western Art* exhibit of contemporary artists in Beijing, China, organized by Pam Driscol and Deane Knox. Travels to China for a month. Buys farm in north-central Maine and begins construction of a large printmaking studio.

1982 Completes first sculpture *Fantail* [Plate 12]. Enters juried competitions in New York and is awarded a prize for sculpture from the American Artists Professional League and the Anna Hyatt Huntington Award from the Catherine Lorillard Wolfe Art Club. Listed in *Who's Who in American Art*.

1983 Juried into competitions in New York and is awarded prizes for sculpture

from Allied Artists, Catherine Lorillard Wolfe Art Club, Salmagundi Club and American Artists Professional League. Completes Portfolio Number 9, last of the series of etchings. Continues publishing portfolios of miniature etchings. First trip with Bob White aboard Sea Comber in southeastern Alaska—annual trips continue for the next decade.

1984 Sculpture juried into the National Academy of Design, New York. Awarded prizes for sculpture from Pen and Brush, New York, and Knickerbocker Artists, New York.

1985 Guest Artist at the National Academy of Western Art, Oklahoma City, and shows again in 1990 through 1994. Guest artist at annual exhibition of Northwest Rendezvous Group, Helena, Montana. Voted membership American Artists Professional League and the Society of Animal Artists and participates in annual traveling exhibitions through 1998. Travels throughout Europe and South America. Buys the Cherry Mill and begins renovation, commuting between El Paso and Ft. Collins. First trip to Brookgreen Gardens, Murrells Inlet, South Carolina.

1986 Sculpture juried into the National Academy of Design. Voted membership in Pen and Brush and in Northwest Rendezvous Group. Shows in annual NWR exhibitions through 1998.

1987 Sells El Paso property and moves to the Cherry Mill. Joins teaching staff of Scottsdale Artists' School, Arizona. Recipient of Northwest Rendezvous Group Merit Award for Sculpture.

1988 Recipient of Ellen P. Speyer Prize at the National Academy of Design for the sculpture *Mallard Duet* [Plate 80]. Recipient of Northwest Rendezvous Group Merit Award for sculpture. Voted membership Catherine Lorillard Wolfe Art Club. One-artist show for sculpture at Pen and Brush in New York.

1990 Awarded commission for The Hubbard Equestrian Fountain, Ruidoso, New Mexico. Sells farm in Maine. Trish Smith becomes studio director of the Cherry Mill.

1991 Guest Artist at the *Hubbard Art Award for Excellence*. Recipient of an award for sculpture from the American Professional Artists League. Buys mountain property in Colorado. Father passes away.

1992 Invited artist at the Cheyenne Frontier Days *Governor's Invitational Western Art Show and Sale*, Wyoming, and shows annually through 1998. Invited artist at the Loveland Rotary's *Colorado Governor's Invitational Art Show and Sale*, and shows annually through 1998. Recipient of the Gold Medal for Sculpture from the National Academy of Western Art. Guest artist at the National Wildlife Museum *Invitational Art*

Show, Jackson, Wyoming, and shows annually through 1998. Joins the teaching staff of the Loveland Academy of Fine Arts. Travels to Europe for five weeks.

1993 Completes a portfolio of 14 graphics. Guest Artist at the *American Women Artists & the West Show* at the Tucson Museum of Art, Arizona. Invited artist at *Artists of America*, Denver Rotary Show, and shows annually through 1995.

1994 Travels to Europe and two weeks in Russia.

1995 Invited artist at the *Prix de West Invitational Art Show* at the National Cowboy Hall of Fame and shows annually through 1998. Begins work on sculptures for the Gilcrease Museum *Rendezvous '98.*

1996 Sculpture juried into Leigh Yawkey Woodson's *Birds in Art* exhibition, Wausau, Wisconsin, and Dayton Museum of Natural History, Ohio. Sculpture juried into National Academy of Design.

1997 Dedicates *Peace Fountain* at Brookgreen Gardens.

1998 Participates in *Rendezvous '98* with Steve Hanks at the Gilcrease Museum, Tulsa, Oklahoma. Publishes *Spirit of the Wild Things—The Art of Sandy Scott* (Stony Press, Ft. Collins).

FIGURE 58
Sandy Scott with Bob White in Alaska.

FIGURE 59
Trish Smith fishing in Alaska.

FIGURE 60
Sandy Scott in China with Chinese interpreter.

PLATE 108
Sandy Scott with bird friends in
Puerto Vallarta.

National Cowboy Hall of Fame, Oklahoma City, Oklahoma

Trammel Crow Corp., Chicago, Illinois

Bill and Joffa Kerr, Jackson, Wyoming

Bobby and Joanie Holt, Midland, Texas

Margaret Thatcher, Great Britain

Museum of Arts and Crafts, San Antonio, Texas

Opryland Hotel, Nashville, Tennessee

R.D. Hubbard Collection, Ruidoso, New Mexico

Miramichi Salmon Museum, New Brunswick, Canada

Sebastiani Vineyards Collection, Napa, California

City of Albuquerque, New Mexico

Western Art Exhibit, People's Republic of China

El Paso Zoo, El Paso, Texas

Vickers Oil Corp, Denver, Colorado

Mustang Oil Corp., Oklahoma City, Oklahoma

David Robinson Collection, San Antonio Spurs

Arnold Schwarzenegger, Los Angeles, California

William Shatner, Los Angeles, California

President and Mrs. George Bush, Houston, Texas

Gerald and Shannon Michaud, Derby, Kansas

Ritz Carlton Hotel, Aspen, Colorado

Hillsdale College, Hillsdale, Michigan

National Wildlife Art Museum, Jackson, Wyoming

City of Fort Collins, Colorado

Brookgreen Gardens, Murrells Inlet, South Carolina

R.W. Norton Museum, Shreveport, Louisiana

University of Texas, Law School, Houston, Texas

President and Mrs. Gerald Ford, Beaver Creek, Colorado

Grand Canyon Airport, Grand Canyon, Arizona

Frank and Kathie Lee Gifford, Connecticut

Ford Family, Grosse Point Farms, Michigan

City of Avon, Colorado

Fred Meijer Collection, Detroit, Michigan

Alphabetical index of plates and figures by Sandy Scott.

Note: All dimensions are stated in inches, height preceding length and depth. The letter "h" indicates height, and "d" indicates diameter. Photography credits are in parentheses. Edition sizes do not reflect an additional 10 percent of artist's proofs.

Above Eagle Island, 1998, bronze, 35 x 27 x 20, edition 35 (Mel Schockner), Plate 24, Page 59

Above It All, 1995, bronze, 57 x 95 x 52, edition 35 (Jafe Parsons) Plate 63, Page 111

Ahead of the Storm, 1995, bronze, 12 x 26 x 20, edition 35 (Mel Schockner), Plate 82, Page 141

Bald Eagle Off Cannery Point, 1993, bronze, 44 x 28 x 39, edition 35 (Jafe Parsons), Plate 75, Page 131

Basin Bird, working drawing for Peace Fountain, pencil, 12 x 9, Figure 10, Page 23

Beyond Wind River (Antelope), 1998, bronze, 22 x 22 x 8, edition 50 (Mel Schockner), Plates 30 and 32, Pages 68 and 71

Big Bruiser (Grizzly), 1998, bronze, 10 x 12 x 7, edition 65 (Mel Schockner), Plates 25 and 26, Pages 60 and 61

Birch Tree, Figure 63, Page 184

Bones of a Chicken, Figure 29, Page 108

Bird Bones in Relationship to Body and Wing, Figure 36, Page 118

Breezy, 1998, clay, 16 x 16 x 7 (Wes Pouliot), Figure 43, Page 139

Bufflehead Duck, 1998, clay, 15 x 12 x 17 (Wes Pouliot), Figure 42, Page 138

Bull and Bear Sundial, 1998, bronze, 20 x 18 x 18, edition 50 (Mel Schockner), Plate 60, Page 106

Bull Moose, etching, 8 x 13, edition 100, Figure 19, Page 52

Camp Bay, 1998, bronze, 6 x 11 x 6, edition 50 (Mel Schockner), Plate 20, Page 47.

Canada Goose Primary Feather (Wes Pouliot), Figure 37, Page 121

Cat in the Creamery, 1998, bronze, 8 x 16 x 7, edition 50 (Mel Schockner), Plate 86, Page 150

Cherry Mill

 Barn and horses (Trish Smith), Plate 104, Page 170

 East Studio garden (Trish Smith), Plate 103, Page 170

 East Studio exterior view (Trish Smith), Figure 13, Page 42

 East Studio interior view (Trish Smith), Figure 15, Page 44

 Library still life (Wes Pouliot), Plate 56, Page 101

 North Studio interior view (Trish Smith), Figure 14, Page 44

 Studio grounds and old pottery mill (Trish Smith), Plate 105, Page 170

Chickadee, etching, 4½ x 4¼, edition 100, Plate 36, Page 76

Chickens on the Wind, 1998, bronze 15 x 14 x 10, edition 50 (Mel Schockner), Plate 83, Page 142

Chum Run at Irish Creek (Grizzly), 1998, bronze, 19 x 35 x 21, edition 35 (Mel Schockner), Plates 9 and 10, Pages 24 and 27

Cockatoo, 1984, bronze, 17 x 7 x 7, edition 25 (Warren Blanc), Plates 65 and 66, Page 117

Country Couple, 1996, bronze, 11 x 9 x 6, edition 50 (Mel Schockner), Plates 6 and 17, Pages 15 and 43

Cutthroat Trout—Yellowstone, 1981, watercolor, 5 x 7, Plate 31, Page 70

Descending Ducks, Figure 27, Page 92

Dirty Days, etching, 6 x 12, edition 100, Figure 20, Page 56

Dominick, etching, 9 x 6¾, edition 100, Plate 18, Page 45

Dots as Composition, Figure 46, Page 146

Down From Bull Mountain (Elk) 1998, bronze, 21 x 15 x 15, edition 50 (Mel Schockner), Plate 42, Page 83

FIGURE 61
Flamingo.

Downwind, 1998, bronze and clay, 20 x 18 x 11, edition 35, Plate 28 (Mel Schockner) and Figure 51 (Wes Pouliot), Pages 65 and 166

Dusking Ducks, 1997, bronze, 10 x 9 x 9, edition 50 (Mel Schockner), Plate 51, Page 93

Eager, pencil, 10 x 9, Figure 25, Page 88

Eagle Bookends, 1995, bronze, 10 x 12 x 7, edition 100 (Jafe Parsons), Plate 98, Page 160

Eagle Talon, Figure 26, Page 90

Earthbeat, detail, 1993, bronze, 10 x 44 x 11, edition 25 (Joe Coca), Plate 101, Page 165

Eat More Beef, 1995, bronze, 37 x 34 x 24, edition 50 (Mel Schockner), Plate 45, Page 87

Equus Caballus Tondo, 1997, bronze, 16 x 19 x 10, edition 50 (Mel Schockner), Plate 58, Page 104

Expecting, 1998, bronze, 11 x 24 x 10, edition 50 (Mel Schockner) Plate 44, Page 86

Fantail (Pigeon), 1982, bronze, h 12, edition 21 (Warren Blanc), Plate 12, Page 29

Feather Groups, Figure 34, Page 115

Flamingo, 1984, bronze, 19 x 8 x 8 (Warren Blanc), Plate 67, Page 119

Flamingo Sketch, Figure 61, Page 182

Fount from *Peace Fountain*, 1985, bronze, 19 x 8 x 10, edition 25 (Warren Blanc), Plate 7, Page 16

Fount, working drawing for *Peace Fountain*, pencil, 12 x 9, Figure 9, Page 22

Foxhound Study, 1998, 8 x 4 x 4, edition 50 (Mel Schockner), Plate 46, Page 89

Fountain of the Rain Forest, 1987, bronze, h 114, edition 12, Plates 69, 70, 71 and 72, Pages 125 and 127

Frog Formerly Known as Prince, 1997, bronze, 7 x 8 x 10, edition 100 (Joe Coca), Plate 97, Page 160.

Geese Swimming, Figure 39, Page 128

Goat Ringing Bell, 1990, bronze, 8 x 11 x 7, edition 18 (Mel Schockner), Plate 81, Page 140

Goat in China, Figure 62, Page 183

Golden on Chimney Rock, 1998, clay, 16 x 29 x 16 (Wes Pouliot), Figure 30, Page 109

Goose Watching, Figure 54, Page 174

Green-winged Teal, 1984, bronze, 9 x 12 x 10, edition 25 (Warren Blanc), Plate 2, Page 8.

Gull Wing, Figure 33, Page 114

Height of Land (Loon), 1998, bronze, 12 x 23 x 15, edition 50 (Mel Schockner), Plate 33, Page 73

Hisan Unrestrained, 1998, clay and bronze, 15 x 14 x 10, edition 50, Plate 85 (Mel Schockner) and Figure (Wes Pouliot), Pages 144 and 145

Horse as Cones and Spheres, Figure 44, Page 144

How the West Was Won, 1994, bronze, 27 x 31 x 10, edition 25 (Mel Schockner), Plate 88, Page 152

Hummer II, etching, 4 x 7$\frac{1}{2}$, edition 100, Plate 38, Page 78

Hummers-June 1981, pencil, 11 x 8, Figure 66, Page 188

Hummingbird, 1984, bronze, 10 x 4 x 4, edition 25, (Warren Blanc) Plate 39, Page 79

It's a Beautiful Day, 1995, bronze, 18 x 14 x 10, edition 50 (Mel Schockner) Plate 35, Page 75

Kakagi (Raven), 1995, bronze, 12 x 17 x 10, edition 35 (Mel Schockner), Plate 77, Page 133

Kate, 1988, bronze, 12 x 11 x 11, edition 25 (Mel Schockner), Plate 48, Page 89

Kodiak Bear, etching, 12$\frac{1}{4}$ x 17$\frac{3}{4}$, edition 100, Plate 27, Pages 62

Late Arrival (Canada Geese), etching, 8$\frac{1}{2}$ x 12, edition 100, Figure 16, Page 48

Lawrence Cottam, his father Harvey Cottam and Chuck Rhodes, Figure 21, Page 64

Little Nipper (Horse), 1997, bronze, 12 x 13 x 10, edition 65 (Mel Schockner), Plate 13, Page 31

Little Red Rascal, 1998, bronze, 11 x 14 x 10, edition 50 (Mel Schockner), Plate 84, Page 143

Lunch (Brown Trout), etching, 4$\frac{3}{4}$ x 3, Figure 24, Page 85

Macaw, pencil, 7$\frac{1}{2}$ x 8, Figure 28, Page 98

Macaw II, 1984, bronze, 21 x 8 x 8, edition 25 (Joe Coca), Plate 5, Page 12

FIGURE 62
Goat in China.

Mallard Duet, 1985, bronze, 23 x 32 x 22, edition 18 (Mel Schockner), Plates 78 and 80 Pages 134 and 137

Mallard Wine Bucket, 1986, bronze, h 9, edition 240 (Joe Coca), Plate 76, Page 132

Mares of the Sun Sundial, 1998, bronze, 62 x 16 x 16, edition 50 (Mel Schockner), Plate 61, Page 107

Monarch of the Boreal, 1996, bronze, 19 x 21 x 16, edition 50 (Mel Schockner), Plate 22, Page 55.

Moose in Muck, 1998, bronze, 18 x 21 x 9, edition 50 (Mel Schockner), Plate 21, Page 53

Morning, 1991, h 24, edition 25 (Dave Marlow), Plate 64, Page 113

Mules of Bright Angel Trail, 1998, clay, 20 x 18 x 15 (Wes Pouliot), Figure 18, Page 51.

Muskie, etching, 7 x 5, edition 100, Plate 34, Page 74

Nice Catch, 1997, bronze, 15 x 11 x 20, edition 100 (Mel Schockner), Plate 50, Page 91

Off Port Bow (Dolphins), 1998, bronze, 17 x 28 x 12, edition 50 (Mel Schockner), Plate 89, Page 153

On Point, 1998, clay, 8 x 12 x 11 (Wes Pouliot), Figure 49, Page 157

Owl Bookend, 1993, bronze, 12 x 7 x 7, edition 65 (Mel Schockner), Plate 55, Page 100

Page from a workbook (overturned boat), pencil, 9 x 11, Figure 23, Page 80

Passages, 1993, 24 x 10 x 7, edition 35 (Joe Coca), Plate 94, Page 158

Peace Fountain (Doves), 1985, bronze, h 84, edition 12 (Steve Wilson), Brookgreen Gardens, Murrells Inlet,
 South Carolina, Plate 8, Page 18

Pelican Bookends, 1997, bronze, 9 x 10 x 6, edition 100 (Joe Coca), Plate 16, Page 41

Pescado, 1986, bronze, h 14, edition 35 (Joe Coca), Plate 91, page 154

Pintail Rising Bas Relief, 1986, bronze, 11 x 14, edition 100 (Mel Schockner), Plate 40, Page 81

Preening Cat, 1998, bronze, 14 x 9 x 8, edition 65 (Mel Schockner), Plate 87, Page 151

Quail Bookends, 1993, 12 x 18 x 10, edition 65 (Joe Coca), Plate 96, Page 160

Rainbow Trout at Trail Creek, watercolor, 5 x 7, Plate 41, Page 82

Ram of Mendes, 1995, bronze 13 x 14 x 10, edition 50 (Mel Schockner), Plate 57, Page 103

Red Canoe (Ruffed Grouse), etching, 6½ x 11, edition 100, Plate 19, Page 46

Recumbent Cow, 1998, bronze, 9 x 14 x 9, edition 35 (Mel Schockner), Plate 92, Page 154

Remembering Will James, 1998, clay, 13 x 20 x 7 (Wes Pouliot), Figure 41, Page 138

Rita, Figure 64, Page 185

Roasting Hen from the Local Grocery (Wes Pouliot), Figure 32, Page 112

Russian Beauty (Borzoi), 1997, bronze, 10 x 17 x 10, edition 50 (Mel Schockner), Plate 52, Page 95

Scott, Dolly, at Red Deer Lodge Figure 55, Page 177

Scott, Jim, at his ranch, pencil, Figure 56, Page 177

Scott, Sandy
 at Camp Bay (Jim Scott), Figure 57, Page 178
 in China (Cheryl Rossi) Figure 60, Page 179
 in Puerto Vallarta, Plate 108, Page 180
 pulling the etching of *Wild Turkeys* (David Bonnell) Figure 52, Page 172
 signature in clay (Wes Pouliot), Page 167
 transporting *Wings of Freedom*, Figure 50, page 162
 with Bob Kuhn and Susan McGarry, Alaska, 1989 (Walter Matia), Plate 3, Page 9
 with Bob White in Alaska (Cheryl Rossi), Figure 58, Page 179
 working on the Gilcrease Eagle (Wes Pouliot), Figure 2, Page13
 working in Alaska (Cheryl Rossi) Plate 107, Page 176
 working on *Right of Passage*, Plate 100, Page 163
 working on *Stars*, clay, 15 x 14 x 5 (Wes Pouliot), Figure 1, Page 2

Sea Comber (Jim Scott), Plate 74, Page 130

FIGURE 63
Birch tree.

Scottie, 1992, bronze, 8 x 8 x 6, edition 50 (Ed Muno), Plate 109, Page 106

Sculpture Silhouettes (Wes Pouliot), Figure 48, Page 149

Setter, 1986, bronze, 7 x 10 x 8, edition 35 (Mel Schockner), Plate 49, Page 89

Sky Passage, 1998, bronze, 16 x 16 x 14, edition 65 (Mel Schockner), Plate 59, Page 105

Sleeping Cat, etching, 8 x 10, edition 100, Plate 11, Page 28

Sleepy Duck Fountain, 1989, d 25, edition 35 (Fabrice) Plate 99, Page 161

Smith, Trish

 fishing in Alaska (Sandy Scott) Figure 59, Page 179

 painting a rubber mold (Susan McGarry) Figure 53, Page 173

Sound of the North Country (Common Loon), etching, 4¼ x 8, edition 100, Figure 12, Page 40

Sovereign Wings, 1992, bronze, 90 x 68, edition 18, National Wildlife Art Museum, Jackson, Wyoming,

 Plates 4 (Ted Wood) and 102 (Fabrice) and Pages 10 and 168

Spirit of the Wild Things, working drawing, pencil, 11 x 13, Figure 17, Page 49

Spirit of the Wild Things, 1986, bronze, h 84, edition 12, Trammel Crow Collection, Dallas, Texas, Plates 1 and 106 (Sandy Scott),

 Pages 10 and 175, and Old Town Fort Collins, Colorado, Plate 73 (Milt Borchert), Page 129

Spooked (White-tailed Deer), etching, edition 100, Figure 22, Page 66

Spoonie Coming In, 1983, bronze, 21 x 20 x 12, edition 25 (Mel Schockner), Plate 68, Page 123

Stallions of the Sun, 1998, bronze, 62 x 20 x 20, edition 50 (Mel Schockner), Plate 62, Page 107

Stars, 1998, bronze, 16 x 15 x 6, edition 65 (Mel Schockner), Plate 95, Page 159

Stretching Teal, 1991, bronze, 11 x 12 x 10, edition 25 (Warren Blanc), Plate 23, Page 57

Takers of Anasazi Sun, 1994, bronze, 52 x 17 x 17, edition 35 (Mel Schockner), Plates 53 and 54, Pages 96 and 99

Too Cute, 1998, bronze, 6 x 8 x 5, edition 100 (Mel Schockner), Plate 47, Page 89

Trail Creek Brownies, 1998, handpainted bronze, 5 x 15 x 5, edition 100 (Mel Schockner), Plate 43, Page 84

Treasures of the Heartland, 1998, clay, 26 x 26 x 26 (Wes Pouliot), Figure 47, Page 147

Trish's Rabbit, 1998, bronze, 7 x 9 x 5, edition 65 (Mel Schockner), Plate 90, Page 154

Trophy Bookends, 1993, bronze 12 x 14 x 5, edition 65 (Mel Schockner), Plate 29, Page 67

Whippet at Ease, 1998, clay and bronze, 18 x 12 x 8, Figure 40 (Wes Pouliot) and Plate 93 (Mel Schockner), Pages 138 and 155

Wind Master, 1994, multipatinaed bronze, 32 x 16 x 9, edition 50 (Jafe Parsons), Plates 14 and 15, Pages 36 and 39

Wing Aerodynamics, Figure 38, Page 122

Wing Compared to the Human Hand and Arm, Figure 31, Page 110

Wing Feather Groups, 1997, pencil, Figure 34, Page 115

Wing Shapes, Four Basic, Figure 35, Page 116

Winter Birds, etching, 6 x 7½ , edition 100, Plate 11, Page 32

Winter Birds, 1986, bronze, 10 x 8 x 5, edition 35 (Mel Schockner) Plate 37, Page 77

Illustrations other than Scott's

Dunwiddie, Charlotte, *Tete-a-Tete*, Figure 5, Page 20

Fenton, Beatrice, *Seaweed Fountain*, Figure 3, Page 20

Huntington, Anna Hyatt, *Fighting Stallions*, Figure 7, Page 21

Lathrop, Gertrude Katharine, *Little Lamb*, Figure 4, Page 20

Schmid, Richard, *Mallard Duet*, oil, Plate 79, Page 135

Shonnard, Eugenie, *Marabou*, Figure 6, Page 21

Weems, Katherine Lane, *Greyhounds Unleashed*, Figure 8, Page 21

FIGURE 64
Rita.

PLATE 109
Scottie, bronze, h 8.

This book would never have taken its present form without the sensitive direction of Susan Hallsten McGarry. Her insight contributed to the substance and structure of this publication, and I am profoundly indebted to her guidance.

I deeply appreciate the generous input of Brooks Joyner, Bill Kerr, Bob Kuhn and Robin Salmon. I am proud to be associated with these extraordinary people.

The cooperation and talent of two professional photographers deserve special mention: Mel Schockner and Wes Pouliot. Their brilliant and aesthetic imagery captured the full breadth of what I try to present in my work.

I am grateful to those who responded to the project from the beginning and provided essential material and met critical deadlines. They include: John and Judy Kinkade, Jim and Bonnie Dickson and the staff at Artist's Service Center, Lee West, Mari Schenkeir, Monte and Bev Paddleford at Eagle Bronze, Loveland Sculpture Works, Bill Konicek, Dale Cisek, Cheryl Dueck and the staff at Friesens, Felicia Nassi and Marv Olson. Those who help Trish and me at the Cherry Mill: Bill and Mary Ann Connelly, Jay Eighmy, Linda Vessey and Harl Sowder have become indispensable friends.

Many individuals in one way or another have impacted my life and work in a positive way. They are: Norine Ahlbrandt, Tony Altermann, Dennis Anderson, Linda Anderson, Judy Hughes Archibald, Andrea Arevian, Clyde and Carol Aspevig, Roger Paul Bailey, Eddie and Carolyn Barlock, Fleming Beasley, Melvin Belli, Hap Bledsoe, Brian and Gail Bex, Tena Bocciarelli, David Bonnell, Delmar Brewer, Ken and Mary Bunn, Shari Carman, Jim Clark, Jackie Coles, the Cottams, Alonza and Etha Dillon, Joe and Charlotte Dodson, Pam Driscol, Allan Duerr, Michael Duty, Doug Erion, Joni Falk, Elka Falkenberg, Dick Flood, Bill Freckleton, David French, John Garrett, Veryl Goodnight, Ed and Becky Gray, the Staff at Greenhouse Gallery, Dick and Stephanie Greeves, Wally and Judy Grewe, Larry Grisham, Lynn Guernsey, Jack and Valerie Geunther, Janet and Tom Greenleaf, Nancy Guzik, Denis Hagan, Holly Hamby, Teresa Hansen, Bill and Marge Harrison, Betty Harvey, Ann Haygood, Gene Hill, R.D. and Joan Dale Hubbard, A. Huney, Mary Hunter, Ann Iocca, Ned Jacob, Sunny Jenkins, Bud Jennings, David and Alice Johnson, Sue Johnson, April Jones and the staff at Cheyenne Frontier Days, Joffa Kerr, John Kettle, Mark Kihle, Fred King, Ray and Peggy Kinstler, Pat Kipper, Diane Kirchner, Deane Knox, Bob Koenke, Dean Krakel, Jack Kreutzer, Libby Kuhn, Dick and Mary Lawrence, Robin Laws, Craig and Linda Lee, Maryvonne Leshe, Tuppi Long, John Manson, Linda McAdoo, George McLean, Diane McGraw, Danny Medina, Gerald and Shannon Michaud, Lanford Monroe, Viola Moore, Ed Muno and the staff and docents at the National Cowboy Hall of Fame, Bob Nelson, Mary Carroll Nelson, Helen Nilson, Tom Nygard, Paul and Peg O'Neil, Mabel Owens, Vic Payne, Olga Pellow, Phil Perryman, Jan Pierce and the Colorado Governor's Invitational, Wayne and Herma Puckett, Dick and Susan Reed, Duane and Cheryl Rennels, Chuck Rhodes, Sue Rice, Jim Rikhoff, Nancy Riddell, Derek Roberts, Elpidio Rocha, Barbara Rodregues, Thom Romeo, Aurora Rossi, Noreen Rossi, Wayne and Barbara Rumley, Dan Rusing, Jack Samson, Sherry Salari Sander, Richard Schmid, John and Liz Seibold, Sharles, the Staff of *Southwest Art* magazine, Gerry and Velma Swanson, Jack Swigert, Shirley Thomson-Smith, DeCourcy Taylor, Chipper Thompson, Tom Tierney, Linda Veylupek, Grace Vowell, Tunie Vowell, Bob and Diane White, Jim and Narda Wilcox, Jeff Wilcox, Bubba Wood, Greg Wyatt, and Bob and Mary Zimmerman.

I particularly want to acknowledge the care and support of my dear friend Cheryl Rossi, and of my sister and nephew, Nancy and Cole Perryman.

In conclusion, I want to recognize with affection all of the dogs I've loved in my life: Penny, Nickel, Betty, Liz, Bonnie, Emmitt, Sadie, Kate, Blacky and Toby.

Thank you
Sandy Scott

AUTHOR'S ACKNOWLEDGMENTS

Many people contributed to the creation of *Spirit of the Wild Things*, and indeed, it is a joint effort. Bob Kuhn, a widely respected artist, penned his foreword from his home in Arizona and in the limelight of his newly released book *Wild Harvest—The Animal Art of Bob Kuhn* [Live Oak Press, Columbia, South Carolina]. Bill Kerr, an art collector and founder of the National Museum of Wildlife Art, took time out of a foot surgery and a very busy holiday season to contribute his foreword from the wilds of Jackson, Wyoming.

J. Brooks Joyner, who became director of the Gilcrease Museum, Tulsa, Oklahoma, in 1996, brings years of expertise to his essay. His previous directorships include the Vancouver Art Gallery, British Columbia, the Montgomery Museum of Fine Arts, Alabama, and the South Bend Art Center, Indiana. He took his bachelor's and master's degrees in history and art history from the University of Maryland, and did his doctoral studies at the Institute of Fine Arts, New York University. He has contributed to numerous books and catalogues on contemporary painters and sculptors and serves on the boards of the Tulsa Historical Society, the Vancouver Cultural Alliance and the Landmarks Foundation of Montgomery.

Robin R. Salmon's credits are equally impressive. A scholar on American sculpture and particularly Anna Hyatt Huntington, Salmon joined Brookgreen Gardens in 1975 where she is senior vice president and curator of sculpture. She took her degrees in history and art history from the University of South Carolina and is a graduate of the Museum Management Institute, sponsored by the American Federation of Arts and the J. Paul Getty Trust at the University of California-Berkeley. She has authored numerous articles and essays in addition to publications on the subjects of American figurative sculpture, women artists and the care of outdoor sculpture. She serves on the Board of Directors of the National Sculpture Society and on the editorial board of its publication, *Sculpture Review*, and chairs its Gallery Exhibition Committee.

Thanks to Northland Publishing, Flagstaff, Arizona, for use of Mary Carroll Nelson' quote from the book *The Art of Beth Ames Swartz* (page 156). And a special thank you to Elena Wortham and Antonio Manega for their design efforts and to Grace Galloway, whose diligence on the computer made the words and pictures fit perfectly.

Susan Hallsten McGarry

FIGURE 66
Hummers—June '81.

CREDITS

Design Concept: Gazer Design Group, Houston, Texas

Text Stock: McCoy, Silk, 100 pound

Typeface: New Caledonia

Typography and Layout: Grace Galloway/On the Bayou Enterprises, Houston, Texas

Color Separations, Printing and Binding: Friesens, Altona, Manitoba, Canada

S·T·O·N·Y
PRESS